The EXPLORER'S GUIDE to DRAWING FANTASY CREATURES

by EMILY FIEGENSCHUH

IMPACT
CINCINNATI, OHIO
www.impact-books.com

CONTENTS

What You Need

SURFACE

140-lb. (300gsm) cold-pressed watercolor paper
acid-free art paper

GOUACHE PIGMENTS

Alizarin Crimson, Burnt Sienna, Burnt Umber, Cerulean Blue, Cobalt Blue, Ivory Black, Lemon Yellow, Olive Green, Permanent Green Middle, Permanent White, Permanent Yellow Deep, Prussian Blue, Raw Umber, Scarlet Lake, Spectrum Red, Ultramarine, Yellow Ochre, Zinc White

BRUSHES

nos. 000, 18/0 liners
nos. 4, 8, 12, 24 rounds
nos. 0, 10/0, 4, 6, 10 shaders
nos. .5, 1, 1.5 washes

OTHER

eraser
pen
pencil
spray bottle
straight edge

Bonus Materials

Get a bonus demo and free desktop wallpaper at **http://ExplorersGuide.impact-books.com**.

Free downloads when you sign up for our newsletter at **impact-books.com**.

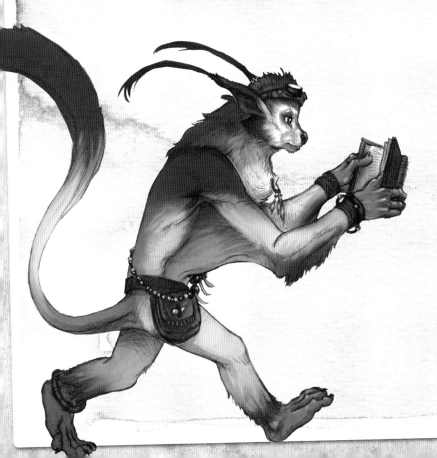

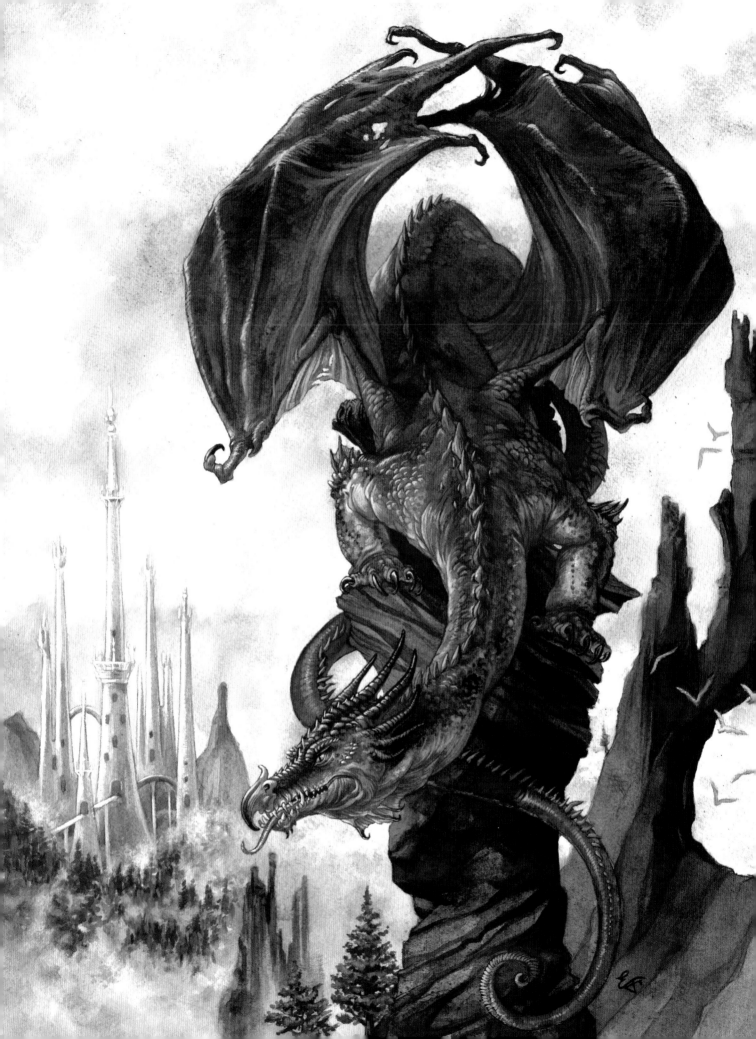

Introduction

Fantasy sparks the imagination.

Fantasy stories draw from traditional mythology and fairy tales and often explore themes important to the real world in an otherworldly setting. While fantasy tales may transport us to different worlds, they inform our own world as well. They also can be simply a wonderful way to pass the time, to find a creative outlet through things that don't exist in this mundane world.

Chances are, if you've picked up this book you're a creative person who loves art and fantasy settings—and most importantly, fantasy creatures! Why not tag along on a fantasy art adventure?

This book will be your study guide as we follow our friend Paki to discover some amazing creatures in their natural habitats. From critters that glide through the air to dangerous behemoths that lurk beneath the sea, the landscape is teeming with unique life. Together we'll take a record of these fascinating beings, making sketches and jotting down notes to find out just what makes them tick.

This volume can be used in many ways: as step-by-step instruction for drawing the individual fantasy creatures Paki discovered on his adventures, as a guide to important basic concepts and techniques applicable across a wide range of art genres, or as a stepping stone to your own creations. It's all up to you!

If you've ever longed to escape from the ordinary world to explore a fanciful realm, see exciting new places, and discover strange species, take this book with you, bring your sketchbook and get ready to let your imagination be your guide as you draw some astonishing creatures.

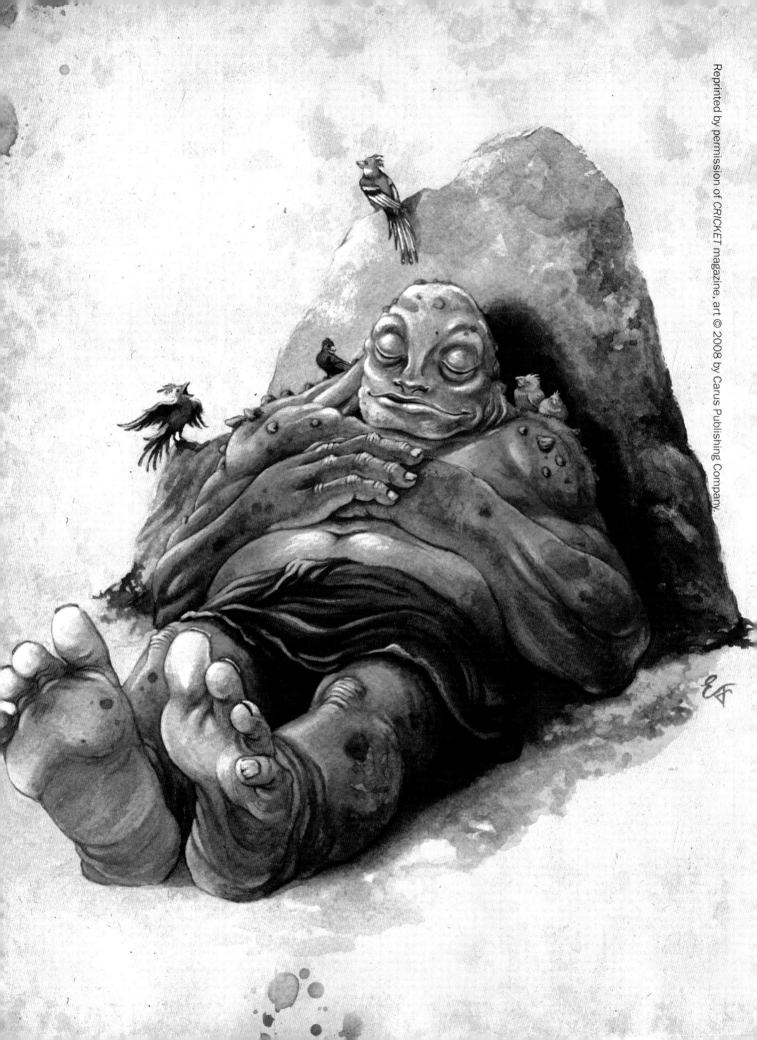

CHAPTER ONE

Exploring the Basics

Before you dive headlong into brainstorming a bevy of beasts, it's good to familiarize yourself with some artistic tools and tips. Knowledge of important basics such as anatomy, proportion and perspective will go a long way toward helping you design believable creatures.

The helpful lessons in this chapter will guide you through the creature-drawing process, from simple and expressive gesture drawings to detailed finished artwork. Check out the tips on the process of design so that you can let your imagination run wild exploring your own creature creations. Grab your favorite art supplies and some paper. You'll be drawing fantastic creatures before you know it!

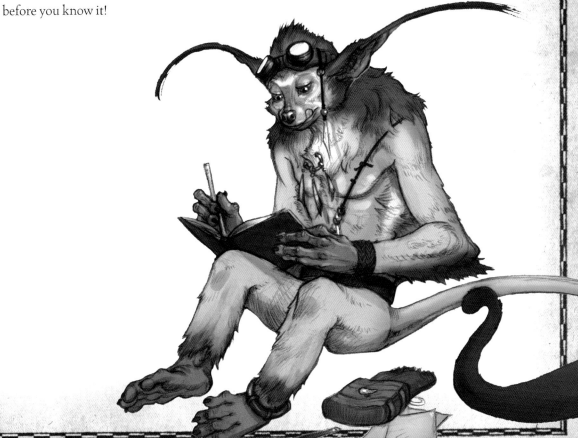

Workspace and Tools

Workspace

Your workspace can be anywhere— your favorite chair, the kitchen table, a well appointed drawing desk or even outside. The most important thing is that it's a place you feel comfortable.

If you use lots of supplies and reference materials, you might need to set up a special place, like a little art studio. Choose a room with as much natural light as possible. Try to keep your workspace tidy and organized, though this isn't always realistic. Studio clutter is often inversely proportionate to the amount of time left until a deadline!

Pencils and Pens

Pencils and pens create a variety of different effects depending on the technique you use— and they can be carried anywhere.

Mechanical pencils are useful when you're on the go, as you don't need to carry a pencil sharpener. The lead comes in several diameters.

Traditional wooden pencils are great for rendering and different types of marks. They range from soft (B) to hard (H) leads. Soft leads are great for rough sketches and gestures as they make dark marks with less effort, leaving more graphite behind on the paper. Hard leads make lighter marks, easier for fine and technical work or for laying something in very lightly.

Ink pens come in many shapes and styles. Traditional pen nibs used with India ink can allow for a variety of line widths with just one nib.

Technical pens are available in several different tip diameters that create lines of varying weight. These are easy for drawing on the go, but you might need to carry several.

Erasers

Kneaded erasers are the most versatile and so are essential to your toolkit. They can be stretched and shaped for erasing in different areas. You can also "draw" with them, cutting areas of negative space into your drawing or pulling highlights out of a shaded area.

White plastic erasers erase very cleanly and are good for obliterating dark lines on paper. The drawback is that they leave crumbs behind.

Paper

Paper is categorized by surface texture and weight, which refers to the thickness of the paper.

Newsprint is a cheap option for studies. Some artists prefer the smooth surface of simple printer paper. Bristol board is great for pen and ink. If you like to draw on the go or enjoy curling up in a chair with your artwork, a sketchbook is a great option.

There are many types of painting surfaces, from hot- and cold-pressed watercolor paper, to illustration board, to canvas. The paintings in this book were created on 140-lb. (300gsm) Arches cold-pressed watercolor paper, a medium-thickness paper with a slightly rough texture that is able to hold heavy amounts of water and paint.

Paint

Most of the color artwork in this book was painted using gouache, a special type of opaque watercolor paint. Gouache is water based, so no solvents or paint thinners are needed. It dries quickly and can be thinned down with water to create washes, or applied in thick layers with very little moisture added. Popular brands include Winsor & Newton and Holbein.

Brushes

Brushes are categorized based on the type of paint to be used, diameter or width, and brush tip shape. Flats and shaders are used to block in large areas of a painting. Round and liner brushes come to a point and are used for detail work. I prefer to use synthetic watercolor brushes.

Palette

A good palette is important for mixing paint. White palettes allow you to most accurately gauge the colors you're mixing. Metal butcher trays are easy to clean, provide a large mixing surface and have high edges so paint won't run off the sides. These can be found at well-stocked art supply stores. White plastic palettes with wells are good for watercolor and gouache artists. Disposable paper palettes are great for on-the-go oil and acrylic painters.

Extras

There are a variety of extras you can use for your art-making. Dab pieces of sponge in paint to create textures for rocks and trees. Splatter paint on paper with a toothbrush for effects like water spray, a starry sky or sandy textures. Sprinkle salt on wet watercolor for a pebbly, rough texture.

My Workspace
My studio space consists of a drawing table with a split adjustable top, a flexible daylight combo lamp, and various shelves and drawers to hold my books, reference materials and art supplies. There is also a flat file cabinet to store paintings and drawings and important paperwork for assignments.

Constructing Creatures

One of the most important techniques this book will show you is how to build up your creatures using basic shapes. If you imagine shapes as the building blocks of your creations' bodies, you will be better able to draw them in different poses and from many angles.

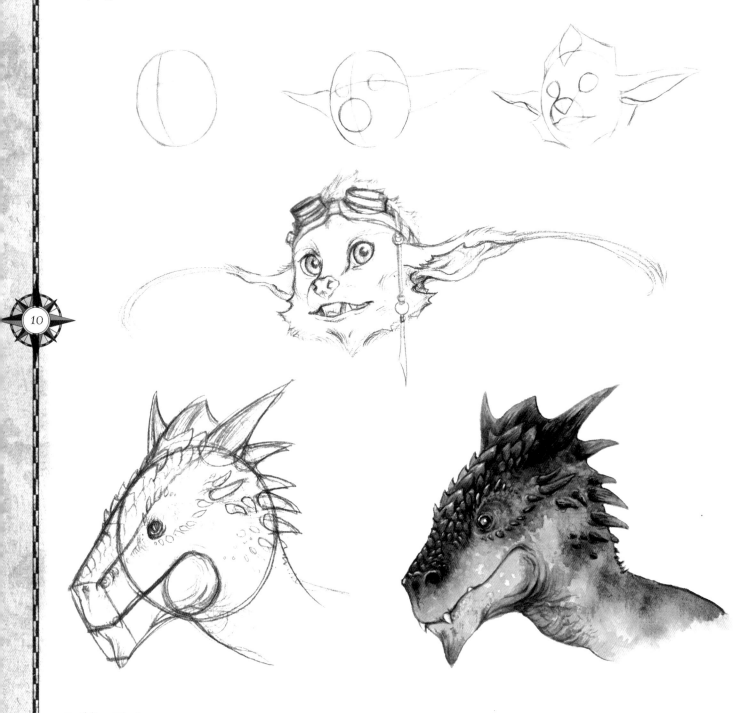

Building Blocks
Use basic shapes to create your creatures. Steps like these will guide you through the book.

Drawing Dynamic Gestures

The gesture drawing is a quick sketch meant to put the feeling of a pose down on paper. It is the foundation of your creature. Gesture drawings are about movement and action. The more you exaggerate the pose, the more life your drawing will retain as you begin to tighten it up and add details. It's OK to scribble and "find" your lines as if freeing your creature from the paper.

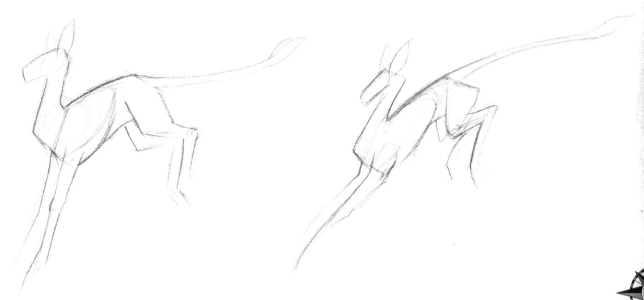

Strike a Pose

If you think you've got an energetic pose, push it even more. It's OK if whatever you are drawing wouldn't realistically bend or stretch that way. The beauty of art is that you can alter reality to capture a viewer's imagination.

The drawing on the left could be exaggerated more. The angles used distract from and break up the flow of the action. The shapes and angles of the drawing on the right follow a sweeping action line.

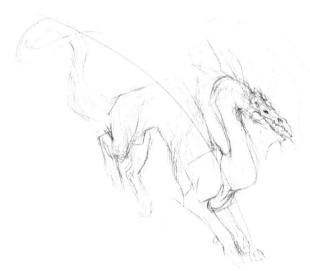

TIPS FOR OUTSTANDING GESTURES

✳ Emphasize angles

✳ Follow a bold action line

✳ Suggest movement through hair, fur or clothing

✳ Pay attention to distribution of weight

Action Lines

Action lines are essential to good gesture drawing. Many cartoonists and animators base their drawings around such a line of action.

Outfitting Your Creature Features

The foundation for drawing fantasy creatures comes from the fantastic real-life creatures we already know. Taking inspiration from nature can add realism to your ideas and designs and helps to make even the most unbelievable creatures believable.

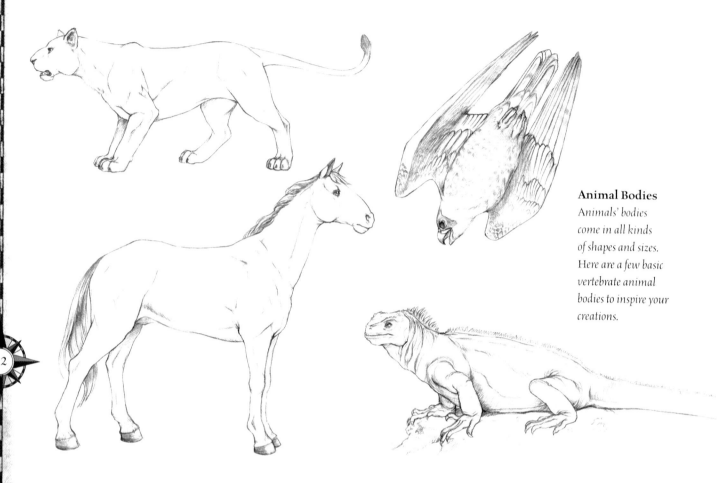

Animal Bodies
Animals' bodies come in all kinds of shapes and sizes. Here are a few basic vertebrate animal bodies to inspire your creations.

Get a Leg Up
When drawing animals, keep in mind whether that animal is plantigrade or digitigrade. Plantigrade means the animal walks on the soles of the feet from toes to heel, like a human. Digitigrade means the animal walks on its toes, or digits. Some of them, like many hoofed mammals, actually walk on their tiptoes. What might appear to be a backwards bending knee on these animals is really their ankle.

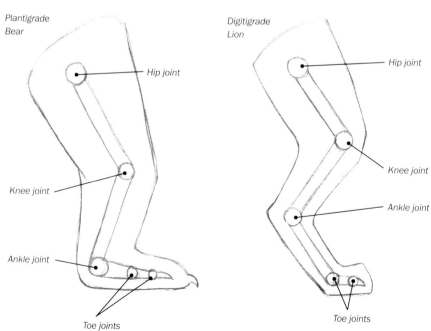

Plantigrade
Bear

Hip joint

Knee joint

Ankle joint

Toe joints

Digitigrade
Lion

Hip joint

Knee joint

Ankle joint

Toe joints

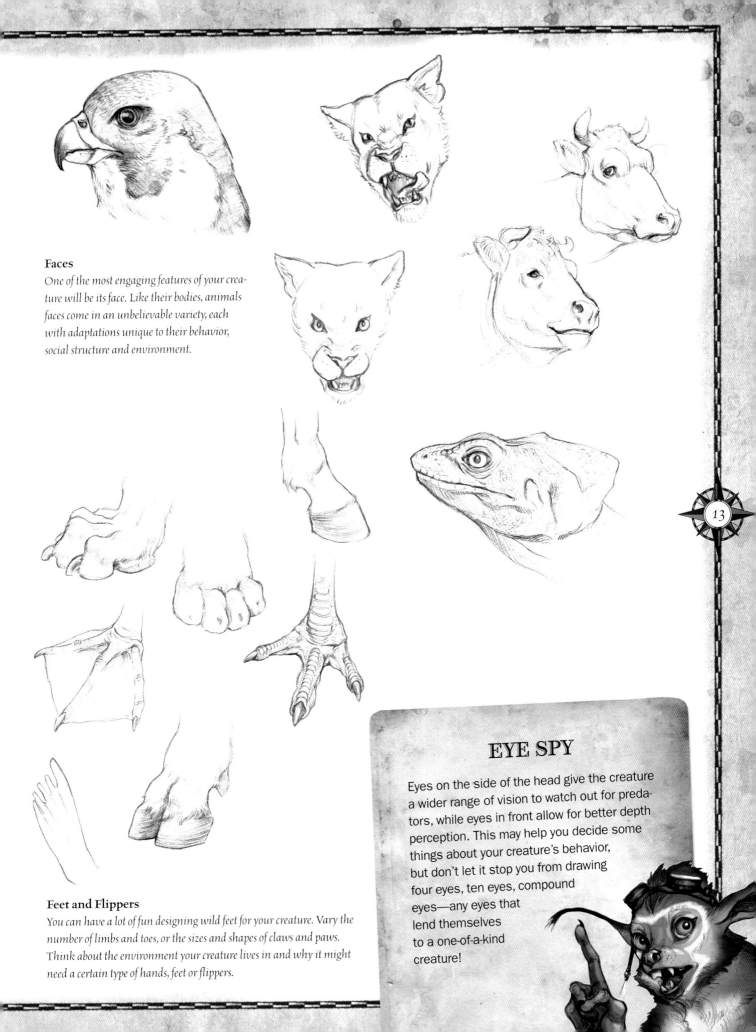

Faces

One of the most engaging features of your creature will be its face. Like their bodies, animals faces come in an unbelievable variety, each with adaptations unique to their behavior, social structure and environment.

Feet and Flippers

You can have a lot of fun designing wild feet for your creature. Vary the number of limbs and toes, or the sizes and shapes of claws and paws. Think about the environment your creature lives in and why it might need a certain type of hands, feet or flippers.

EYE SPY

Eyes on the side of the head give the creature a wider range of vision to watch out for predators, while eyes in front allow for better depth perception. This may help you decide some things about your creature's behavior, but don't let it stop you from drawing four eyes, ten eyes, compound eyes—any eyes that lend themselves to a one-of-a-kind creature!

13

Human Bodies and Proportion

Although this book is about drawing fantasy creatures, it's still a good idea to have some basic knowledge of human anatomy and proportion. You can apply that knowledge to drawing humanoid monsters.

Humans range in height and proportion from about 6½ to more than 8 "heads" tall. To measure in heads, divide the body in half at the hip socket or pubic bone. Points of reference on the body are all about a head's length apart: the nipple line, belly button, hip socket/pubic bone, mid-thighs, knees and ankles.

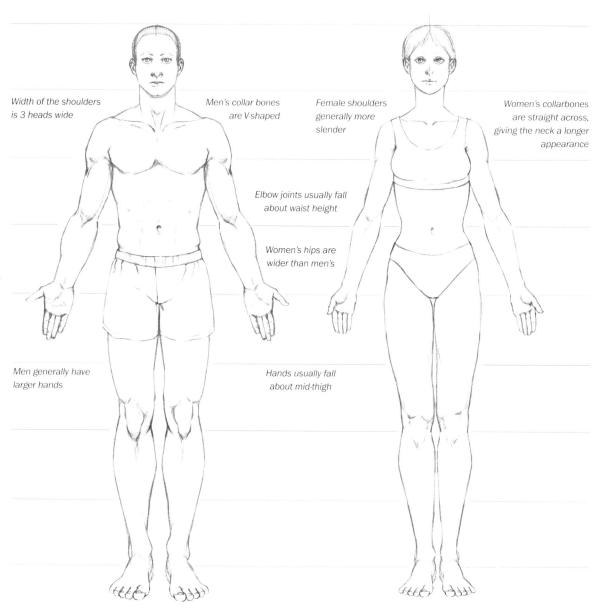

Width of the shoulders is 3 heads wide

Men's collar bones are V-shaped

Female shoulders generally more slender

Women's collarbones are straight across, giving the neck a longer appearance

Elbow joints usually fall about waist height

Women's hips are wider than men's

Men generally have larger hands

Hands usually fall about mid-thigh

Measuring Up

This drawing shows what might be considered a "heroically" proportioned person at just over 8 heads tall.

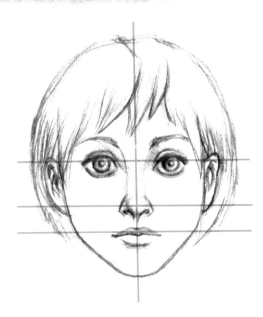

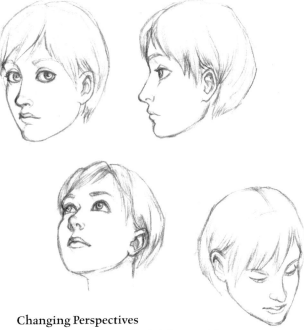

Facial Proportions

It's also a good idea to have a foundation in drawing human heads and faces.

- It's useful for placement of facial features to divide the head in half vertically with a center line.
- Almost halfway down the head is the horizontal line upon which the eyes are placed.
- Divide the lower half of the face into thirds with two more horizontal lines for the nose and mouth.
- As a general rule when drawing a person's head, the top of the ears will line up with the eyes and the bottom of the ears will line up with the nose.
- The eyes are about one eye-width apart.

Changing Perspectives

The features of the face will look different at different angles. With enough practice, you will be able to master even the trickiest perspectives!

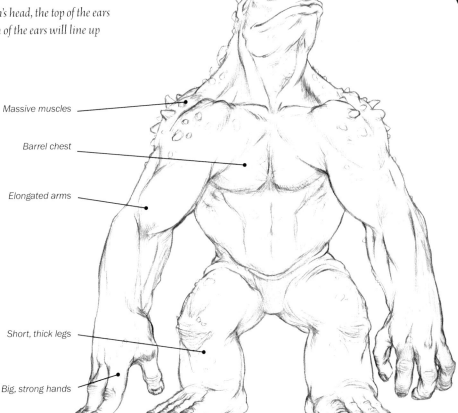

Massive muscles

Barrel chest

Elongated arms

Short, thick legs

Big, strong hands

Fun With Exaggeration

Remember all those proportion rules we just talked about? Now it's time to break those rules, or at least bend them a little bit!

Perspective

Perspective is the representation of a three-dimensional space on a flat surface. Without perspective, art can appear flat and lifeless. (Not that there's anything wrong with that, if that's what you're going for!) The illusion of space can be shown in many ways. Objects closer to the viewer are drawn larger while those in the distance will appear smaller. When objects overlap one another, a sense of space is created between them.

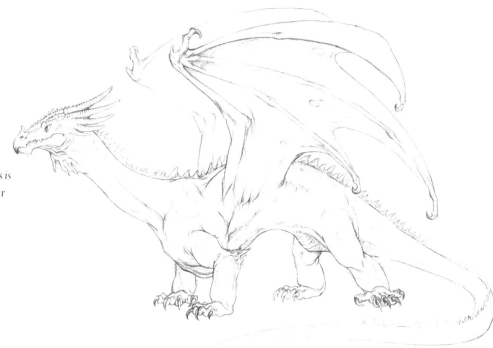

Side View

This view offers minimal illusion of three-dimensional space. We still get some sense of space from the overlap of the dragon's wings and the placement of the legs and tail on the ground plane. The drawing is flat so the focus is over the entire image rather than a particular point. This view is useful when you want to show a lot of information, especially if you're designing a creature.

Three-Quarter View

This view of the same dragon offers more three-dimensional depth, giving a sense that the dragon is coming at you. Placing the hind legs higher on the ground plane extends the body back into space. The body is foreshortened, drawn as if the shapes from front to back are stacked behind one another. The overlap of the head over the wing pops the head out from the background. The dragon's face becomes the focal point because it appears closer.

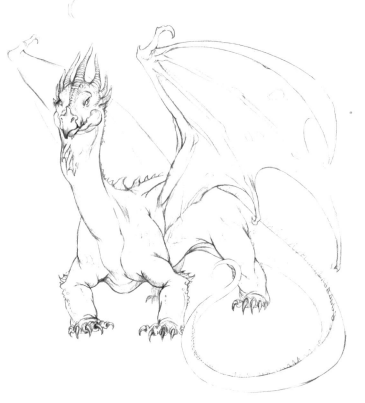

ATMOSPHERIC PERSPECTIVE

Use atmospheric perspective to create a sense of distance by changing the saturation and value of an object. You can also soften the edges of an object to push it back in space.

Foreshortening

Foreshortening is the illusion that an object appears shorter than it actually is as it tilts away from the viewer's eye. Learning how to draw these squished shapes can be tricky, but it's an important tool to use to create the sense that your creatures are turning in space.

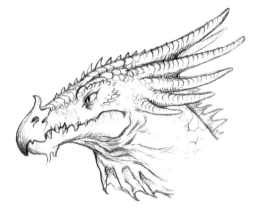

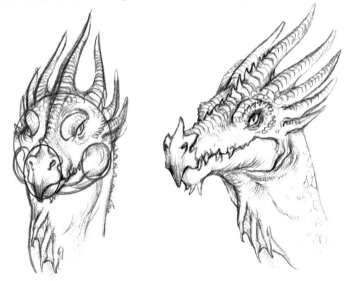

Foreshortening Facial Features
The shape of the dragon's head changes as it turns toward and away from the viewer. The length of the snout is shortened and the shapes of the face appear to stack on top of one another.

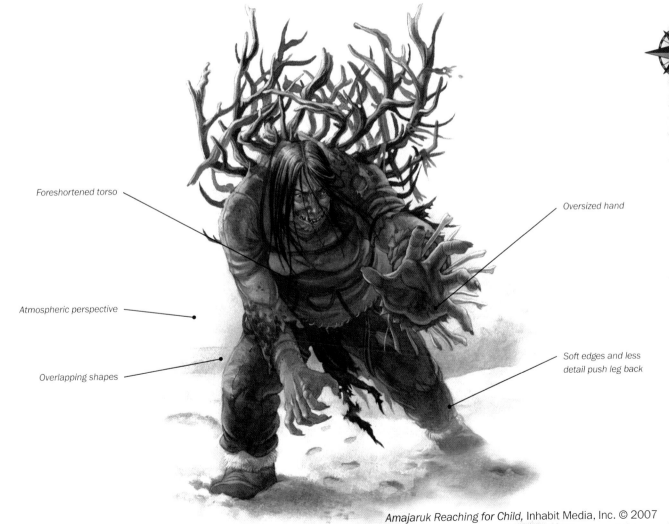

Foreshortened torso

Oversized hand

Atmospheric perspective

Overlapping shapes

Soft edges and less detail push leg back

Amajaruk Reaching for Child, Inhabit Media, Inc. © 2007

Pencil-Rendering Techniques

The time will come when you need to decide how you want to finish your drawing. You might like the look of a clean line drawing, where the interest comes from the pose and details rather than shading. Perhaps you plan to paint your drawing, and want to save the rendering for the color stage. If you do choose to render your pencil drawing, here are some techniques to help you.

Showing Form With Pencil

Hatching
series of lines made next to each other

Crosshatching
hatch marks crisscrossing over one other

Stippling
series of dots placed close together or far apart to indicate varying values

Blended Tone
very tight circles made with a pencil, blended with blending stump or finger

Random Hatch Lines
haphazard marks of various length and direction, good for creating a textured appearance

Line Weight

Varying your line weight creates more interest in a drawing. Thinner, lighter lines recede. Thicker, darker lines come forward in space. They draw the eye and emphasize part of a drawing. You can also suggest the texture of a form with line weight.

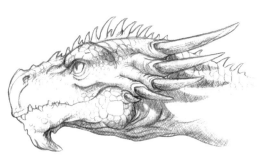

Crosshatching

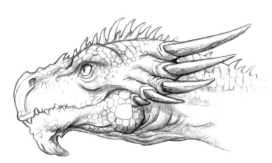

Blended Tone

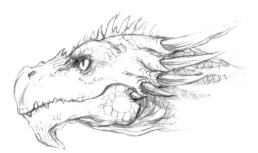

Hatching Plus Texture

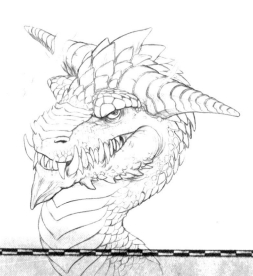

Using Color

Color is one of your most powerful tools. It can affect a viewer's emotions and set the mood for your piece of artwork. A bright splash of color can be used to draw attention to an area of a muted, desaturated painting. Warm colors seem to vibrate right off the canvas, while cool colors may bring a wave of calm over an observer.

Consider what role you want color to play when creating a creature. Perhaps he sports bright, beautiful colors to attract others of his kind, or to warn predators that he is poisonous and shouldn't be messed with. A critter that needs to blend into her surroundings could be camouflaged by colors or patterns that mimic the local environment.

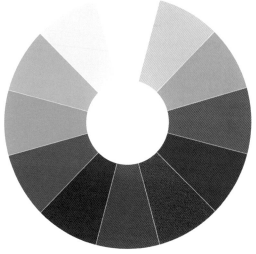

Complementary
High contrast scheme using colors opposite one another on the color wheel. Colors intensify and pop out from one another.

Analogous
Use colors right next to each other on the wheel for a pleasing and harmonious combination

Monochromatic
Simple scheme using tints and shades of the same color.

Color Wheel

A color wheel can help you plan out a color scheme for your image, whether it's a complementary, analogous or monochromatic palette.

Color Schemes

Color schemes are a good way to plan out an interesting color combination for a creature or an illustration.

Highlights　　Opaque paint　　Transparent shadow area

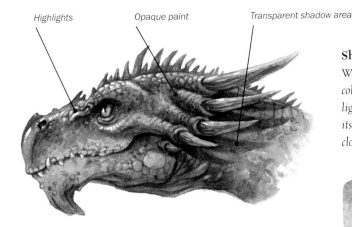

Showing Form With Paint

With transparent mediums such as gouache and watercolor, value and color are often built up in layers. Watercolor paints are built up from light to dark. The same technique is useful with gouache, but because of its ability to be used opaquely, you don't have to follow this rule quite so closely.

TECHNIQUE TIP

A good technique while painting (often used with oil paints) is to keep the shadow areas transparent and the brightest parts of the painting opaque.

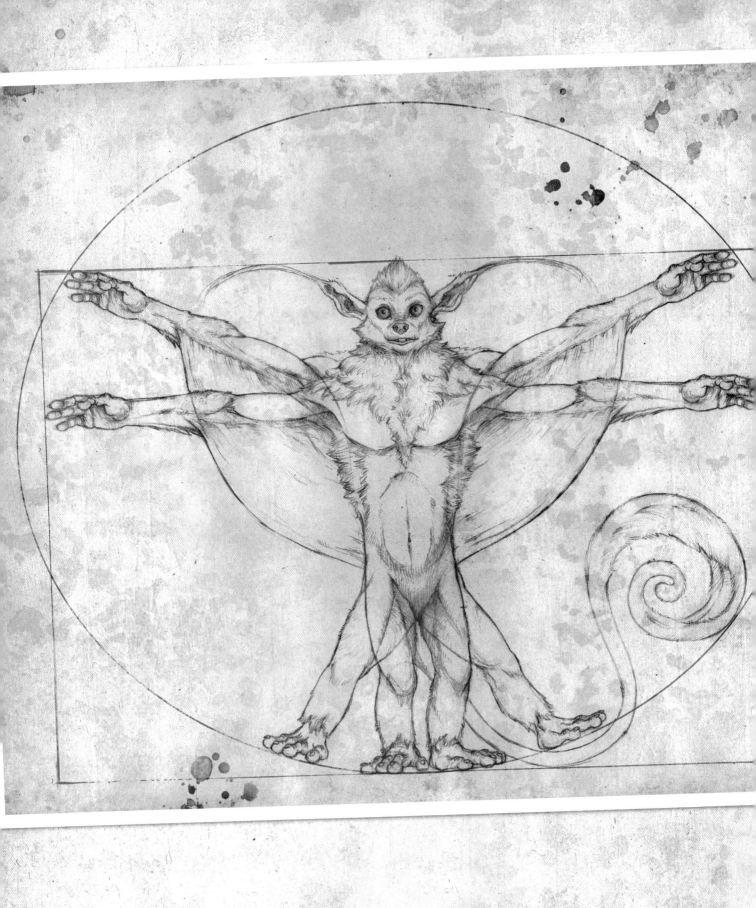

CHAPTER TWO

Creating Your Creature

Now that you've practiced some of the basics, it's time to apply your hard

work to the creation of your very own fantasy beasts. You might already have

a concrete idea for your creature creation. That's great! But if you have a whole

bunch of ideas swimming around in your head that you'd like to organize into a

coherent critter, following some steps may help you to create a stronger image

rather than jumping in headfirst with your final composition. While there are

no absolute rules that must be obeyed when coming up with your ideas, this

design process may help you.

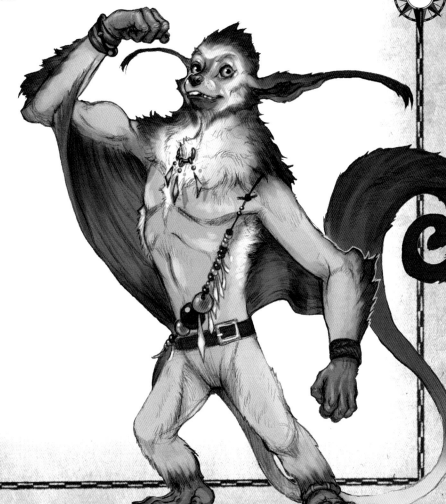

Finding Inspiration

Inspiration comes in many forms. You might be energized by watching your favorite movie or feel compelled to create when listening to a moving piece of music. Perhaps you have absorbed some influences that enhance your work without even knowing it. Many artists are inspired by fellow artists, either their contemporaries or old masters. Or you might deliberately seek out inspiration for a specific project. Whatever the case, taking a moment to find creative works that energize you can help jumpstart your ideas.

Brainstorming

If you're stuck, put your pencil to paper somehow, someway. Whether you're drawing or writing, just scribbling will begin to yield some kernel of an idea, no matter how small. If you're working on a particular type of creature, list features you think you might want it to have. If you're working on a more complicated project, you could connect your thoughts by making one of those uber-exciting spider-web diagrams you might remember from creative writing class at school. Whatever works!

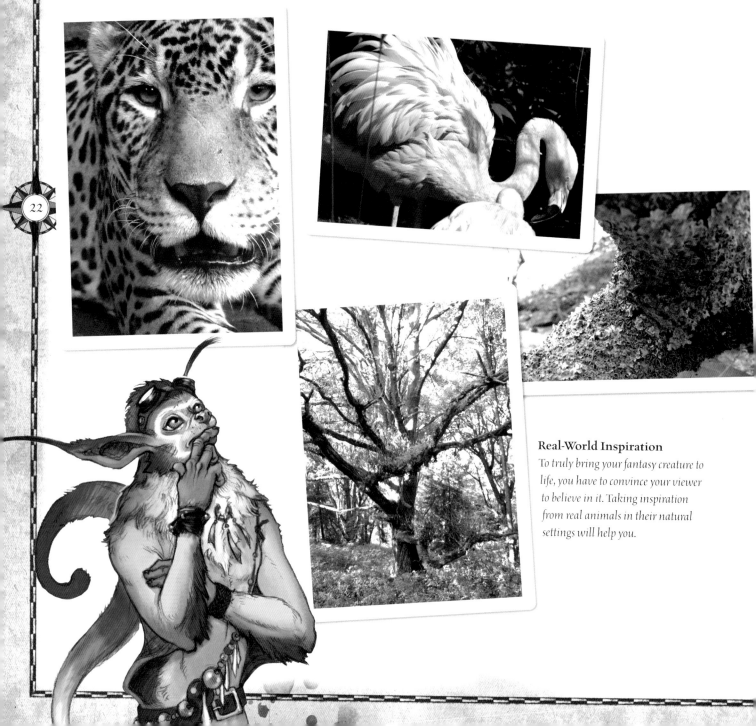

Real-World Inspiration

To truly bring your fantasy creature to life, you have to convince your viewer to believe in it. Taking inspiration from real animals in their natural settings will help you.

Using Reference

The ability to picture forms in your head and translate them faithfully to paper is part of what makes you an artist. Build up a visual library in your mind to help translate your ideas into tangible images. Use reference for those things you can't picture as easily in your head.

Using reference is not cheating. You can't remember everything you've ever seen, or know what everything that has ever existed (or never existed) looks like. Taking the knowledge you gained from your reference and applying it to a fantasy creature will make your work better and your creature more believable.

Reference is everywhere. It can be anything you learn from visually. Draw studies from life using animal or human models. Look through art and photo books and collect pictures from magazines. Pose in front of a mirror and sketch, or ask a friend or family member to pose for you and take some photos. Many artists keep a file of photos and magazine clippings for use as reference later.

Obviously no one can go out to some trans-dimensional savannah to take pictures of unicorns in their natural habitat. The most important part of creature creation happens in your imagination. Using reference is like putting a puzzle together in your head. When designing a creature, pay attention to how an animal's body works, moves and looks from certain angles.

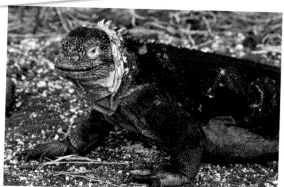

The Reference
Don't feel compelled to copy the reference exactly. True art comes from the way you interpret the images by injecting emotion and dynamism into the piece.

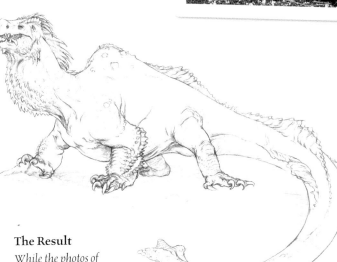

The Result
While the photos of the reptiles were not copied directly, they inspired the look of this Venom-Spitting Sand Dragon's scales, frills and stumpy legs.

REFERENCE

DO'S
* Use photos or draw studies from life
* Keep a file of pictures that inspire you
* Collect reference from as many sources as possible
* Use your imagination to enhance your reference

DON'TS
* Trace another artist's or photographer's work
* Copy a photo directly without the copyright owner's permission
* Copy bad or confusing reference

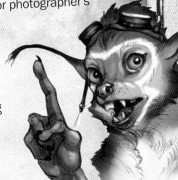

Sketching

Now that you're good and inspired, it's time to put pencil to paper and start working on your designs.

The rough sketch stage is one of the earliest steps of the design process. This is the part where your imagination will shine as you scribble out forms. Use some of the ideas you brainstormed earlier. Sketch them down on paper quickly. Let your ideas flow from one to the next. Keep your drawings small and manageable. This will help you to get a lot of ideas on paper in a short amount of time.

Here you should be concentrating on the shape and form of your creature. Rough sketches can be tiny thumbnails showing shape, proportion and pose, or close-ups of a part of a creature to figure out a particular feature.

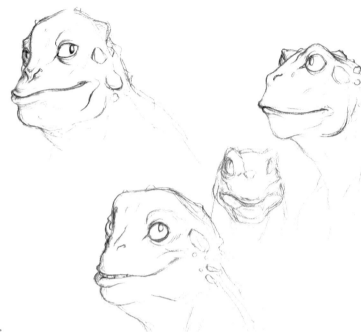

Play With Features
Notice how different each face is from the next based mostly on changing the placement and proportion of the facial features.

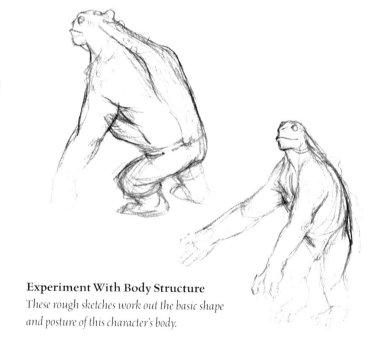

Experiment With Body Structure
These rough sketches work out the basic shape and posture of this character's body.

A NEW PERSPECTIVE

Try flipping your drawing by holding it in front of a mirror or holding it up to a bright light or a window to look through the back. (You can achieve the same mirror-image effect by flipping the canvas in Photoshop® if that's your tool of choice.) This trick might help you to notice shapes you didn't see before and lead to new ideas. This technique is also used to find mistakes later in the drawing stage.

Grabbing a sheet of tracing paper and overlaying variations to your design can offer new insights, too.

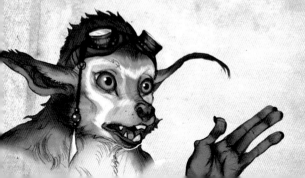

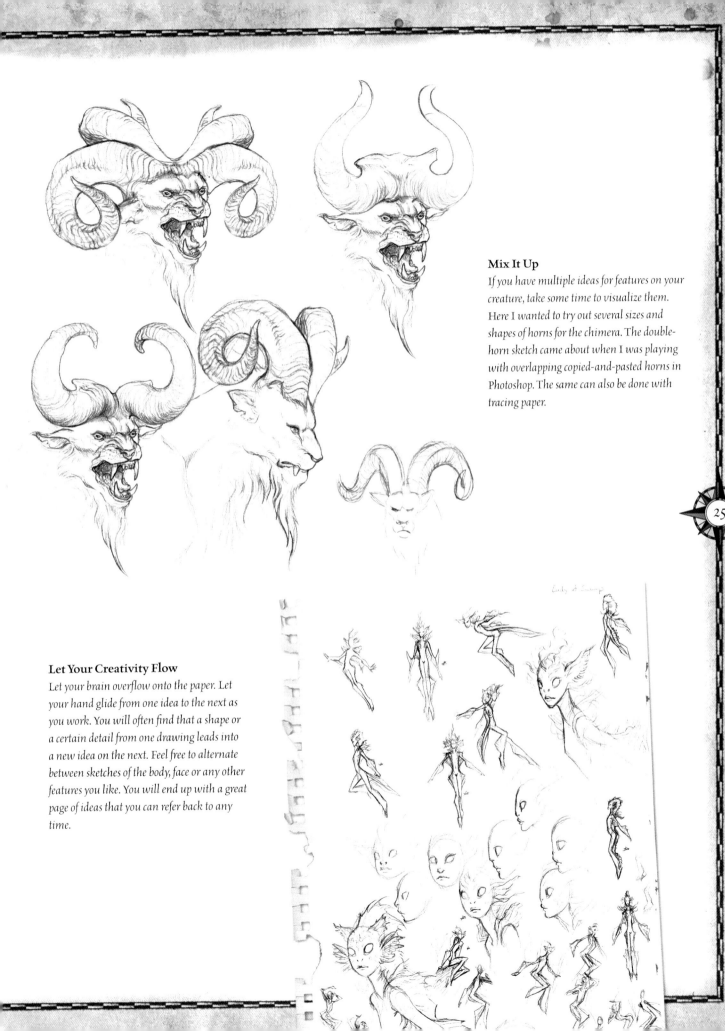

Mix It Up

If you have multiple ideas for features on your creature, take some time to visualize them. Here I wanted to try out several sizes and shapes of horns for the chimera. The double-horn sketch came about when I was playing with overlapping copied-and-pasted horns in Photoshop. The same can also be done with tracing paper.

Let Your Creativity Flow

Let your brain overflow onto the paper. Let your hand glide from one idea to the next as you work. You will often find that a shape or a certain detail from one drawing leads into a new idea on the next. Feel free to alternate between sketches of the body, face or any other features you like. You will end up with a great page of ideas that you can refer back to any time.

Designing

Now that you've become familiar with rough sketches, let's move on to the process of drawing and designing our friendly little guide, Paki.

Sketch Ideas

I had a general idea of where I wanted to go with our guide critter. I wanted him to look intelligent, energetic and expressive. He needed to be able to write and draw, so I knew he needed opposable thumbs. I tried a few different ideas, but kept returning to a lemur-like primate. The variations on this body shape give an inkling of the final design in some of these drawings.

Choose a Look
The rough sketch I selected.

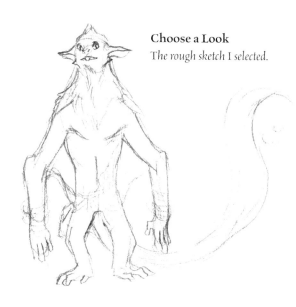

HEADS UP

If you get stuck while designing your creature, one of the best ways to get unstuck is to draw a bunch of creature heads. It can be hard to get a feel for a creature if you haven't yet defined his or her personality. Drawing the face will help you shape your creature's attributes, and might lead you more quickly to ideas that echo those features over the rest of the body. There were a variety of ideas I tried when coming up with a look for Paki.

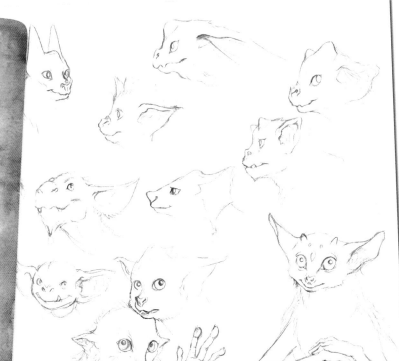

Silhouette Value

A great technique to assess the strength of your creature design is to take a look at the silhouette. Block out all the little details of your drawing and look at the outline of the form you have created. How well does it "read?" That is, how easy is it to decode the shape of the creature and know instantly what it is?

Nature has equipped the eyes of animals (including humans) with the ability to easily pick out shapes in an environment, which is why stripes and spots are so helpful to animals. The patterns help break up the shape of the silhouette so that it's harder for predators to separate the shape of their prey from other shapes around it, and harder for prey animals to detect the predators stalking them. Use this tendency to search for a silhouetted shape to your creative advantage.

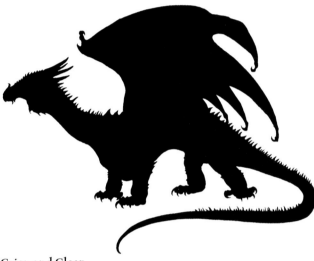

Crisp and Clear
It is clear instantly that this is a dragon. Notice the bold shapes of the head, wings and tail. Negative space separating the legs clearly illustrates their shape and shows where they attach to the body.

Paki
This silhouette of our guide reveals an iconic triangular shape to his design.

Avoid Confusing Silhouettes
Can you tell what this creature is? Me neither! There is not enough negative space to help break up the shape and allow the eye to decode what is there.

Use Negative Space
Bringing the arms away from the body creates negative space between the torso and the arms. With a simple change to the drawing, we instantly understand the shape of the body.

MANY TECHNIQUES AID DESIGN

Using well-defined silhouettes is not a hard and fast rule. When doing an illustration, there are many ways to focus a viewer's eye on the story you're trying to tell. Value, color, composition and many other nifty artistic terms factor into a great piece of art. Silhouette is just one of many techniques to help you create a strong design.

Developing Personality

Your creature's personality and the way he lives his life are just as important as his looks. You can define personality through the use of facial expressions, body language and behavior.

Habitat

Think about what adaptations your creature might need to survive in the place where he makes his home. Adaptations can include all kinds of features, from body shape to color and pattern to behavior.

Creatures that live on a vast open plain might be built for running. They may walk long distances and use speed or stamina to capture prey or evade predators. Or they might be beings that burrow underground with a vast network of tunnels where they hide from predators and store food.

A critter that lives in a dark environment like a cave might not have any need for eyes, but will need other sensory organs that don't require light to make their way in the dark.

Diet

Animals are built to survive, and finding food is, of course, a huge part of their survival.

Herbivorous animals might have adaptations for grazing on the ground or up in the trees, and mouths adapted to grinding and breaking open tough foods. They also need good defense mechanisms for escaping their predators.

Meat-eating animals are often built for speed or ambush. If they can't chase down their prey, they need to be able to snatch unsuspecting victims. Most predators have sharp teeth and strong jaws, but some might kill with venom or other scary secretions that can incapacitate or even dissolve their prey.

You Are What You Eat
Diet plays a big part of the physical makeup of a creature.

Home Sweet Home
Where does your creature live? Is the climate harsh or mild? Give your creature whatever adaptations he will need to survive in his environment.

Behavior

Animals have developed many ways of living. Some remain solitary throughout most of their lives, and others live in groups, working together to collect food, raise young or keep close for protection. Some animal species have even developed their own distinct cultural behavior, such as discovering ways of cracking open nuts and passing those techniques from adults to the young, that might not exist in another group of the same species living in a different area.

Think about the type of social behavior your creature might have. Maybe he's part of a fully developed culture that includes music, language and writing, like our friend Paki.

Movement

A huge part of imbuing your creature with life is through the use of body language and expression. Draw your creature with distinct mannerisms unique to them. Think about how you might depict the way your creature moves and what that says about his personality. Pose and posture can convincingly indicate his emotional state.

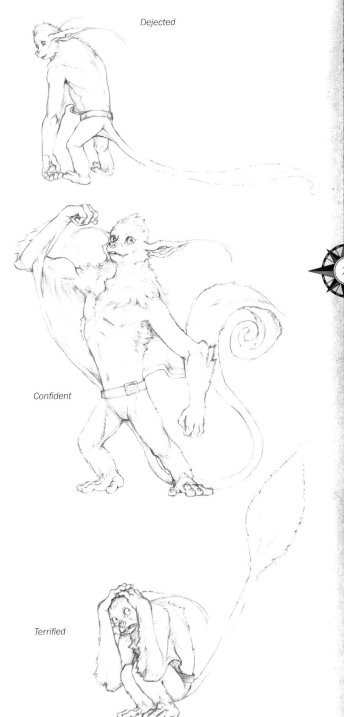

Dejected

Confident

Terrified

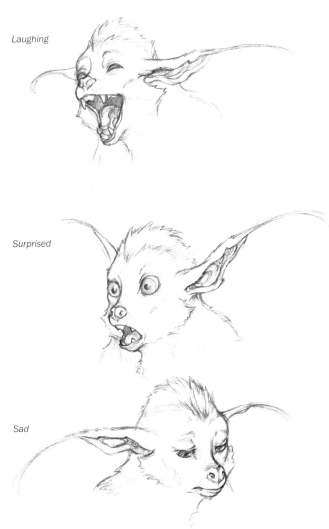

Laughing

Surprised

Sad

Express Yourself

The most expressive parts of a face are the eyes and mouth. You can also convey a lot of feeling with a creature's ears. Many animals communicate through the positioning of their ears.

Finalizing Your Creature

Use your favorite aspects from your rough sketches and studies to develop a finished drawing of your creature.

Final Line Art
This is Paki's final design with all the details of his costume. The combination of handcrafted and manufactured accessories shows that Paki has mixed and matched different items he collected during his travels.

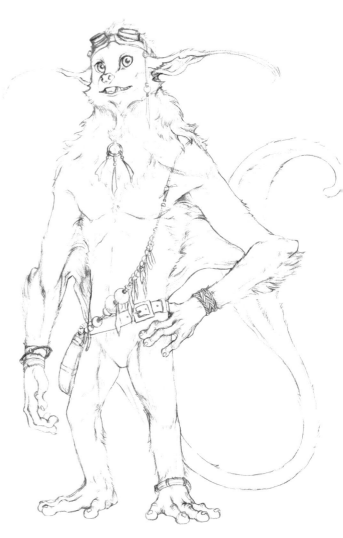

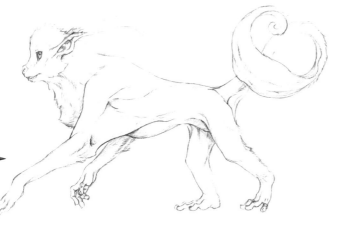

Side View
A flat side view will help you put everything in its place without having to worry about foreshortening or tricky perspectives.

Color Studies
Once you've finished your hard work at the drawing stage, you might want to color your creature. Maybe you knew from the beginning what color he should be, but if not, it can be helpful to try a few different options with some quick color studies. Color studies are about trying different color combinations, not about producing a perfectly rendered finished piece of art.

Many artists do color studies in the same medium as the final art. I used Photoshop in this case because it's fast and easy to lay down big blocks of color.

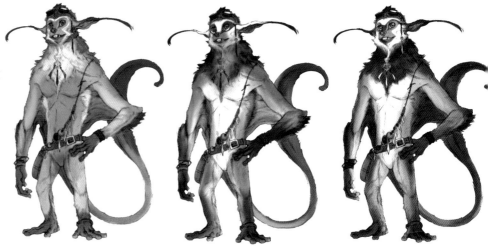

Paki

Paki is a spiral-tailed glider who lives in a complex societal group that makes its home in the rainforest. Evolutionary cousins to the pancake glider, they live on the same continent. Paki and his friends are very comfortable high in the forest canopy, and are adept at climbing and swinging from tree to tree. Through the use of strong, stretchy skin flaps underneath the arms, and a prehensile tail that can open like a parachute, Paki is able to glide short distances. He and his fellow spiral-tailed gliders prepare their meals with fruit, nuts, leafy vegetation, bugs and grubs. They craft their own clothing and accessories. Tame pancake gliders might be found hanging around the spiral tails' forest villages begging for food, and they are sometimes kept as pets. Paki enjoys adventuring and records his experiences in the sketchbook he keeps with him at all times.

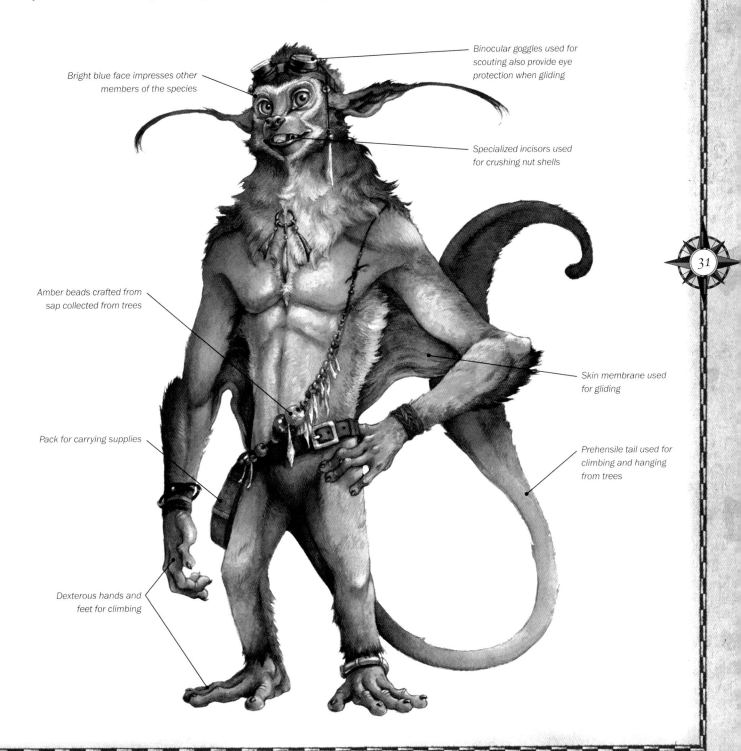

Bright blue face impresses other members of the species

Binocular goggles used for scouting also provide eye protection when gliding

Specialized incisors used for crushing nut shells

Amber beads crafted from sap collected from trees

Skin membrane used for gliding

Pack for carrying supplies

Prehensile tail used for climbing and hanging from trees

Dexterous hands and feet for climbing

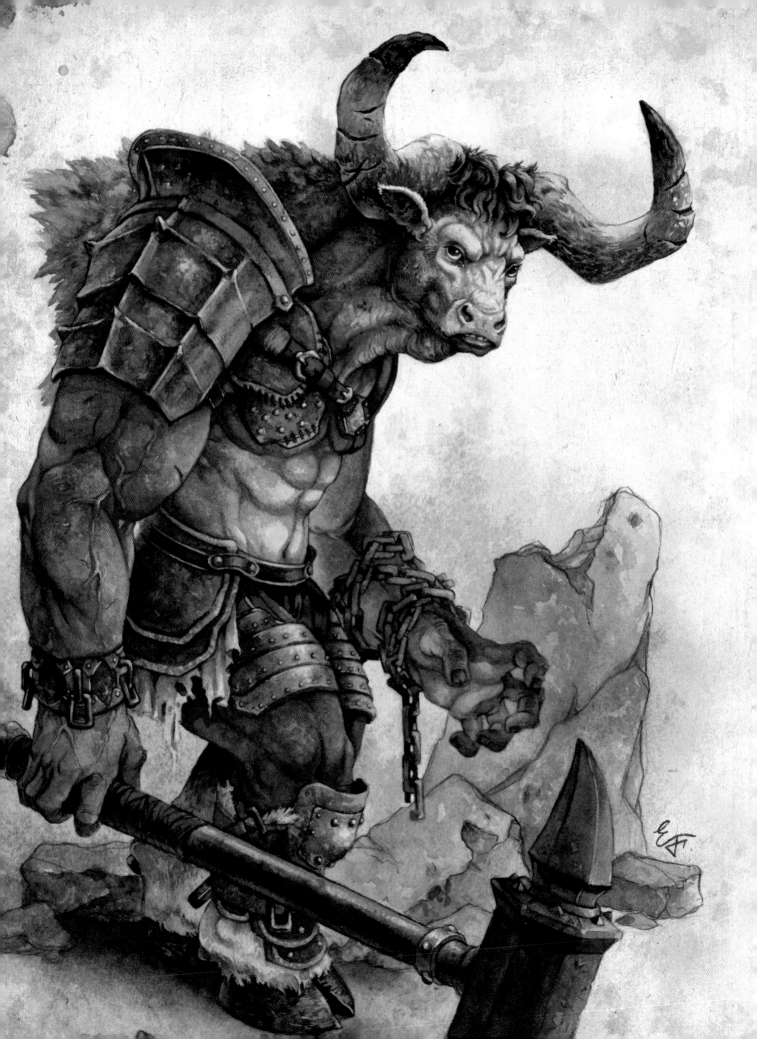

Chapter Three

Creatures of Myth

Storytellers are always looking for ways to capture the imagination of the listener. Popular legendary tales have found engrossing ways to convey a historical event, pass on traditions or teach a moral lesson. These myths are often filled with stories of astonishing feats and fascinating creatures. Some of these beasts are so fearsome that storytellers have passed down their tales for generations. They have become creatures of legend. They symbolize powerful natural forces, and sometimes our deepest fears. Some are benevolent, some cruel, but all are mystifying and powerful. Tread carefully as we seek to capture some of the most striking creatures in history—with our pencils, of course.

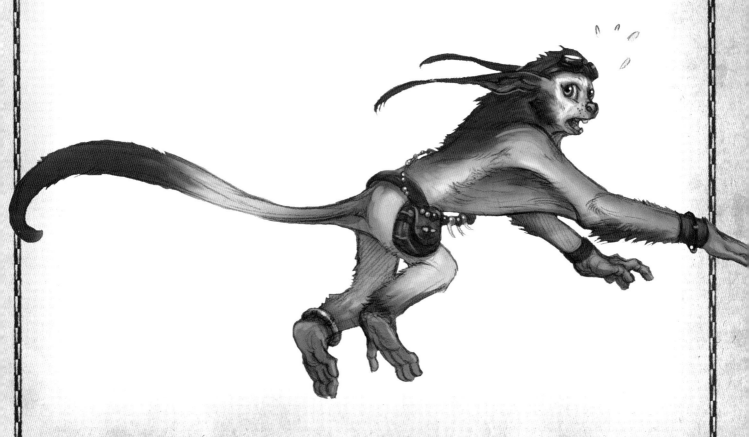

Bringing Legend to Life
DRAW A CHIMERA

The chimera is a fearsome monster that has been described in many different ways. It always boasts the features of a lion, goat and serpent. Some people have claimed that it has the heads of all three creatures. Others have said that the front of the body is that of a lion, the middle is a goat and the tail is a serpent's. I'm not sure what the confusion is all about. Maybe they were too busy running away to get a good look!

Materials

acid-free art paper

eraser

pencil

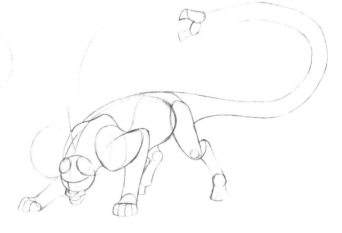

1 CREATE A GESTURE DRAWING
Creating a powerful pose starts with the gesture. Begin with a strong, sweeping center line. Don't be afraid to make loose, sketchy lines. Use simple shapes as guidelines to indicate the different parts of the body. Draw the circle for the head low and close to the ground plane so that the center line of the chimera's back arches up behind it. This will make the body look curved, as if she's ready to pounce. Draw horizontal and vertical lines dividing up the head to indicate the direction the chimera is looking.

2 BUILD THE BODY
Draw basic shapes to construct the bulk of the chimera's body. Mark knee and ankle joints with circles. Indicate the shoulder line with a powerful angle. The chimera's weight is resting on the front leg closest to us, so that shoulder blade will be pushed up higher than the other one. Draw two ovals to indicate the space the horns will eventually occupy.

REMEMBER YOUR REFERENCE

Look at pictures of reptiles, sheep, goats and lions for inspiration.

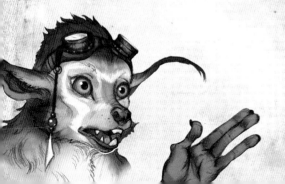

Two Heads Are Better Than One

DRAW THE CHIMERA HEADS

The head is almost always the center of interest in any drawing. Once you are satisfied with the pose and basic anatomy of your creature, start working on the head and face (or in this case, heads and faces). The snarling expression is part of what makes the chimera look so powerful!

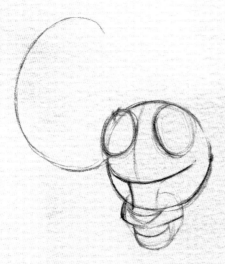

1 BLOCK IN THE FACIAL FEATURES
Use the horizontal line you drew as the eye line. Extending from the eye line down, sketch in the nose and muzzle with simple shapes. Draw a line for the mouth below and block in the area where the teeth will go.

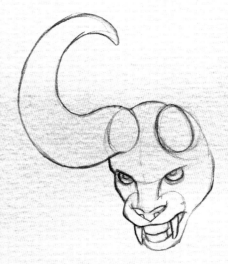

2 DRAW THE EYES AND ONE HORN
Draw the eyes. The tops of the eyes should appear flat since the head is angled downward. Fill out the form of the horn. Leave the second horn for later since it overlaps the body.

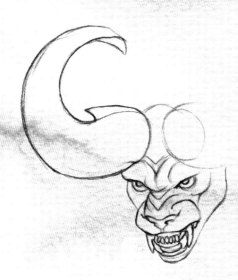

3 DRAW A SNARL AND WRINKLES
Draw a curling line up from the mouth to the top of the nose to create the effect of the lips pulled back to reveal the teeth. Draw several v-shaped lines to form the wrinkles on the nose and brow. The lower canines overlap the upper canines.

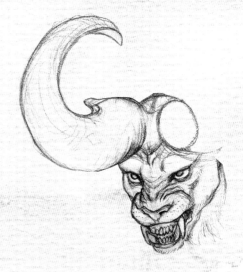

4 ADD SURFACE DETAILS
Flesh out the angry brow and nose wrinkles. To make the eyes look really mean, add a thicker line on top to indicate the overlap of the upper brow. Draw bags under the eyes for an evil-looking squint. Draw part of the underside of the horn to show that it spirals back toward the head.

DRAGON HEAD

Fill in the dragon head, er, tail.

1 FILL IN THE HEAD AND JAW
The dragon is in a three-quarter view, so we should see part of the other side of his jaw and mouth.

2 ADD FEATURE DETAILS
Fill in the brow ridge above the eye and the bony ridge along the cheekbone. Sketch in the spike on the chin and the fin along the neck.

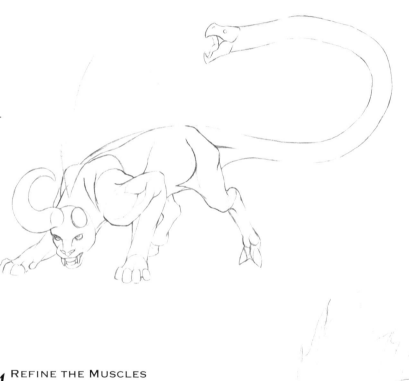

3 POWER UP WITH MUSCLES
Block in the muscles of the front leg and shoulder using interlocking bubbles. If you need to, refer to photos of lions or anatomical drawings. You can start to erase the guidelines if you no longer need them.

4 REFINE THE MUSCLES
Emphasize the strength and size of the paws by spreading out the toes. Draw some curved lines sticking out of his back along the centerline to indicate the spines on his back. Then connect the lines with sharp, triangular curves.

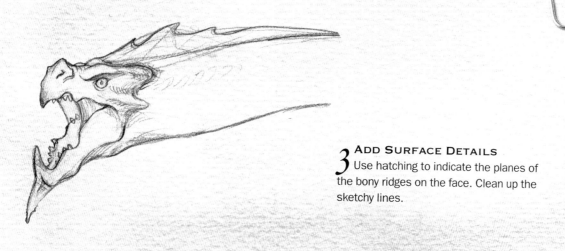

3 ADD SURFACE DETAILS

Use hatching to indicate the planes of the bony ridges on the face. Clean up the sketchy lines.

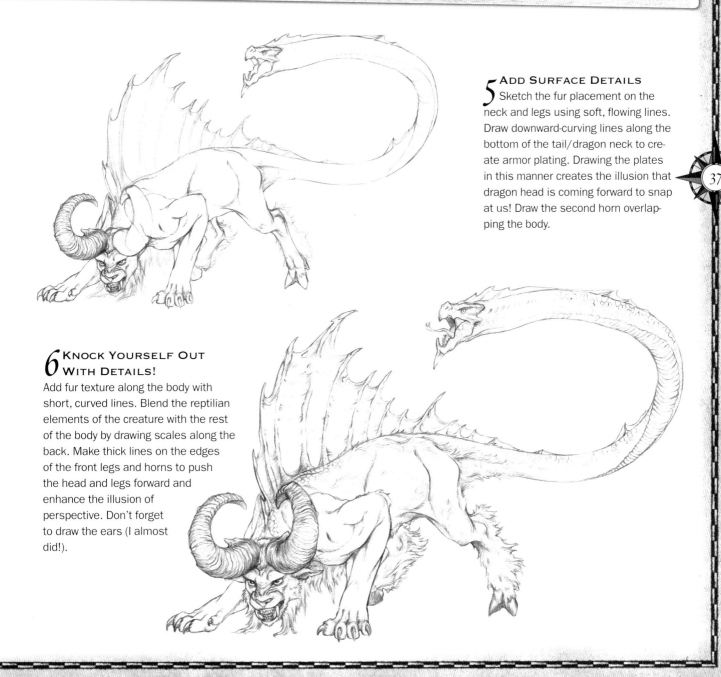

5 ADD SURFACE DETAILS

Sketch the fur placement on the neck and legs using soft, flowing lines. Draw downward-curving lines along the bottom of the tail/dragon neck to create armor plating. Drawing the plates in this manner creates the illusion that dragon head is coming forward to snap at us! Draw the second horn overlapping the body.

6 KNOCK YOURSELF OUT WITH DETAILS!

Add fur texture along the body with short, curved lines. Blend the reptilian elements of the creature with the rest of the body by drawing scales along the back. Make thick lines on the edges of the front legs and horns to push the head and legs forward and enhance the illusion of perspective. Don't forget to draw the ears (I almost did!).

Chimera
16" × 10.5" (41cm × 27cm)
Surface: 140-lb. (300gsm) cold-pressed watercolor paper
Gouache pigments: Alizarin Crimson, Burnt Sienna, Burnt Umber,
Cerulean Blue, Cobalt Blue, Lemon Yellow, Olive Green, Perma-
nent White, Permanent Yellow Deep, Raw Umber, Spectrum Red,
Ultramarine, Yellow Ochre, Zinc White

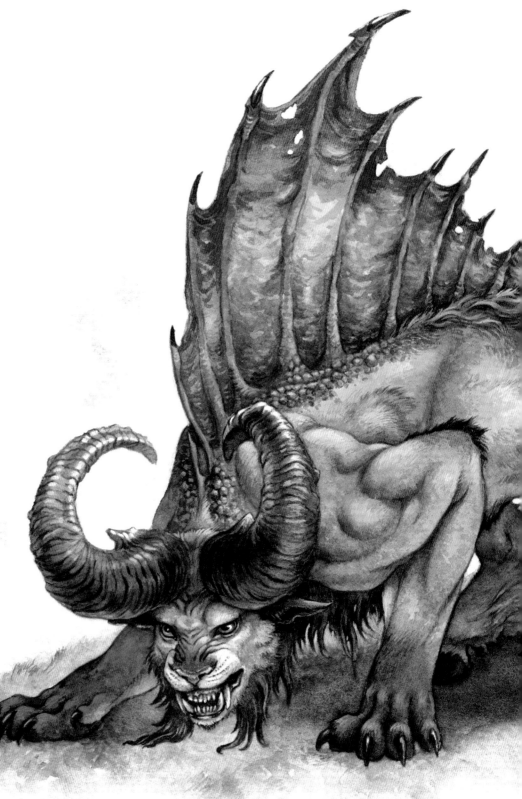

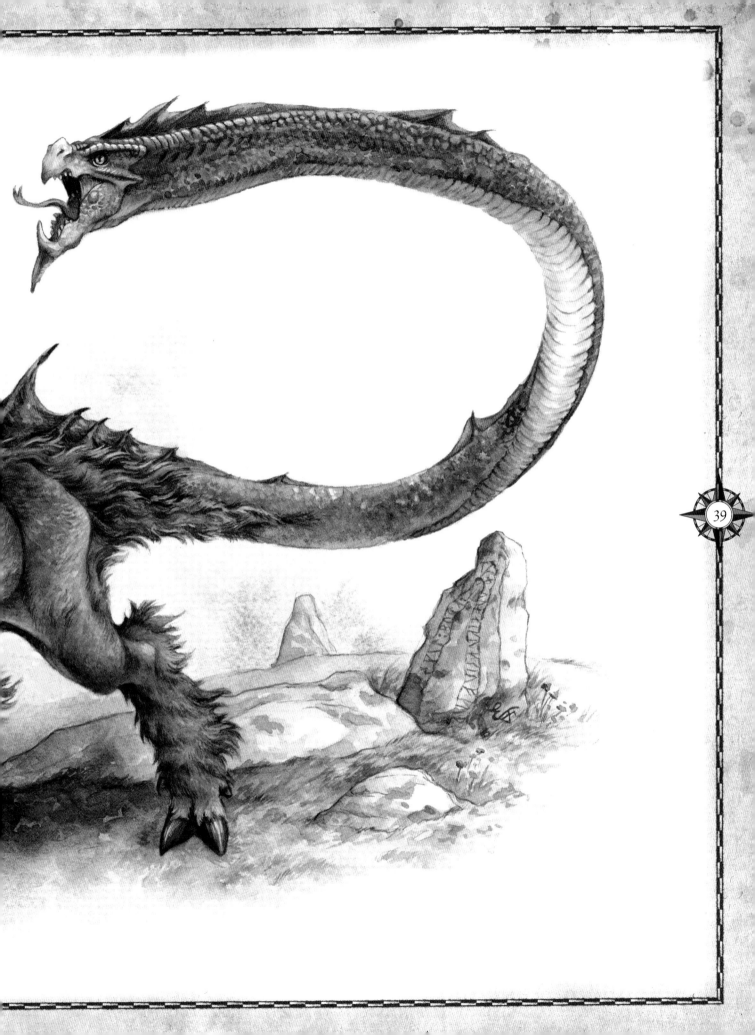

Bringing Legend to Life
DRAW A GLASS DRAGON

Since the earliest stories were told, many cultures have been fascinated by dragons. They are intelligent, cunning and powerful and come in all shapes and sizes, from slithering serpents to massive winged beasts such as the Glass Dragon—named for the crystal-like spikes on its neck and tail. Some are benevolent, some greedy and some pure evil. Dragons might challenge a hero, terrorize a village or control the weather. And whether they live deep in the forest, perch high on a mountain, or lurk beneath the sea, dragons both spark the imagination and fuel our deepest fears.

Materials

acid-free art paper

eraser

pencil

1 SKETCH THE ACTION LINE
Sketch an action line that twists and turns. This will eventually form the tail, spine and neck of the dragon. Draw a circle for the head.

2 FORM THE BODY WITH BASIC SHAPES
Sketch basic shapes to form the body. Draw curving tubes for the body, tail and neck. Draw cylinders to form the legs, using circles to mark the elbow, wrist and knee joints. Add a snout to the dragon.

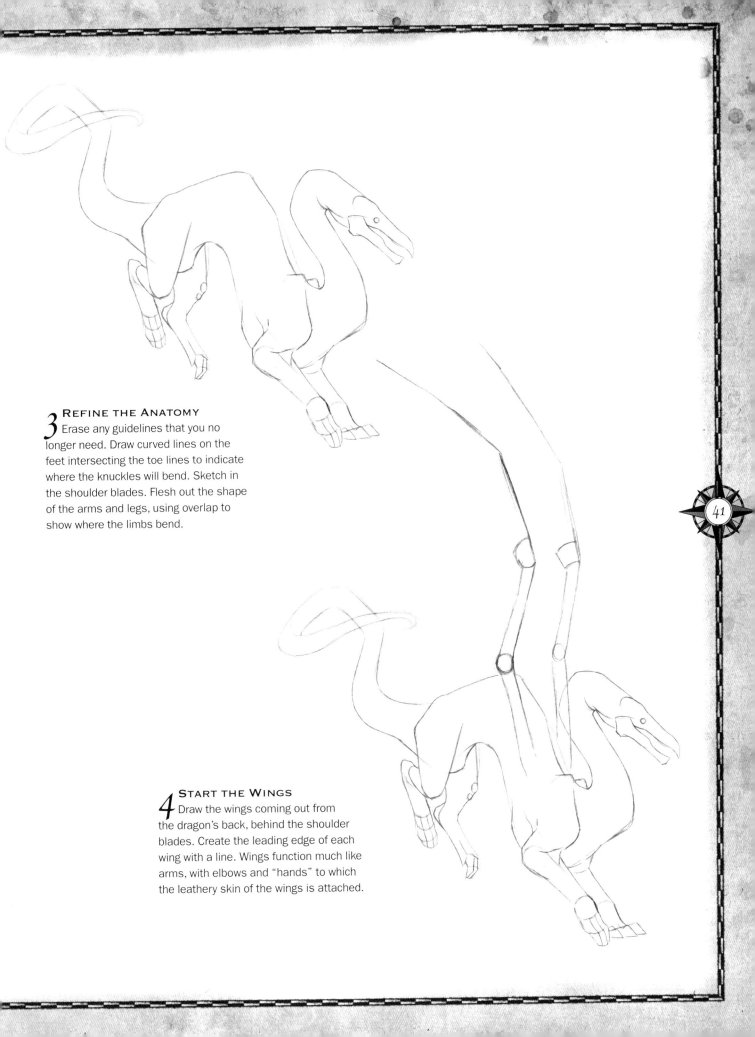

3 **REFINE THE ANATOMY**
Erase any guidelines that you no
longer need. Draw curved lines on the
feet intersecting the toe lines to indicate
where the knuckles will bend. Sketch in
the shoulder blades. Flesh out the shape
of the arms and legs, using overlap to
show where the limbs bend.

4 **START THE WINGS**
Draw the wings coming out from
the dragon's back, behind the shoulder
blades. Create the leading edge of each
wing with a line. Wings function much like
arms, with elbows and "hands" to which
the leathery skin of the wings is attached.

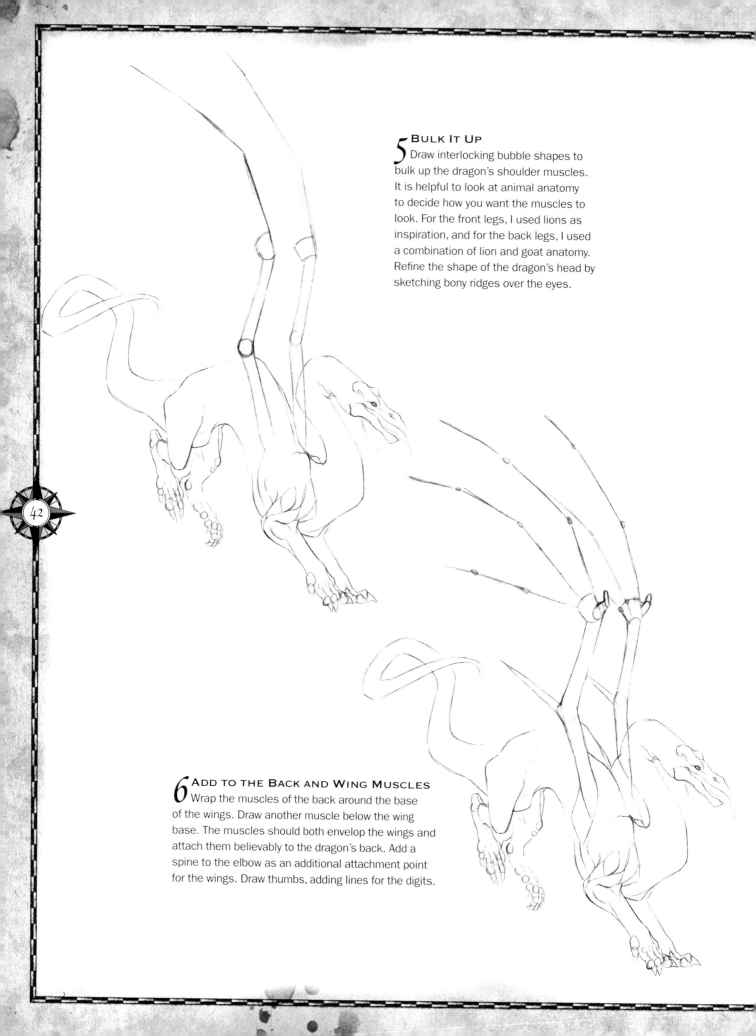

5 BULK IT UP

Draw interlocking bubble shapes to bulk up the dragon's shoulder muscles. It is helpful to look at animal anatomy to decide how you want the muscles to look. For the front legs, I used lions as inspiration, and for the back legs, I used a combination of lion and goat anatomy. Refine the shape of the dragon's head by sketching bony ridges over the eyes.

6 ADD TO THE BACK AND WING MUSCLES

Wrap the muscles of the back around the base of the wings. Draw another muscle below the wing base. The muscles should both envelop the wings and attach them believably to the dragon's back. Add a spine to the elbow as an additional attachment point for the wings. Draw thumbs, adding lines for the digits.

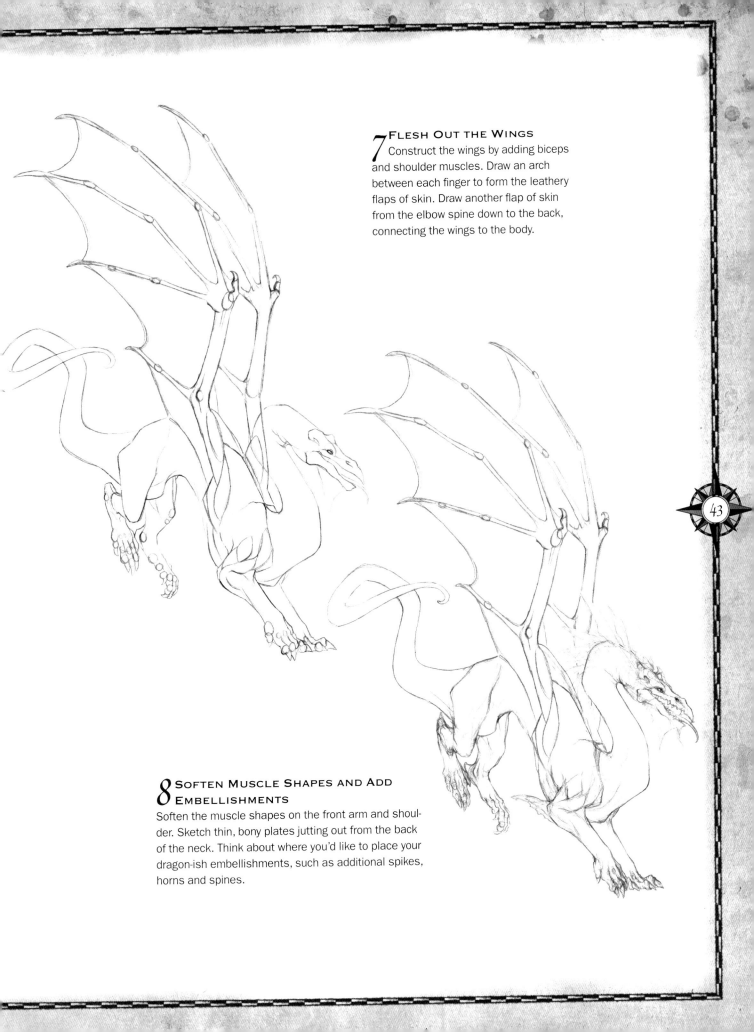

7 FLESH OUT THE WINGS

Construct the wings by adding biceps and shoulder muscles. Draw an arch between each finger to form the leathery flaps of skin. Draw another flap of skin from the elbow spine down to the back, connecting the wings to the body.

8 SOFTEN MUSCLE SHAPES AND ADD EMBELLISHMENTS

Soften the muscle shapes on the front arm and shoulder. Sketch thin, bony plates jutting out from the back of the neck. Think about where you'd like to place your dragon-ish embellishments, such as additional spikes, horns and spines.

Winging It
DRAW LEATHERY WINGS

Drawing wings of any type can be tricky. With leathery bat-like wings, the folds of skin and the way the wings bend and flap can sometimes look confusing. It's helpful to picture a bat or dragon wing as an arm. The arm bones are comparable to the bones of a human arm. The wing is made up of the hand with its fingers extended as the structure to which the leathery skin attaches. Here are some helpful tips for drawing cool looking creature wings.

Open Wings

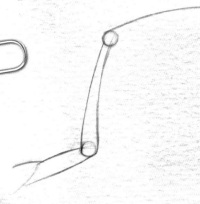
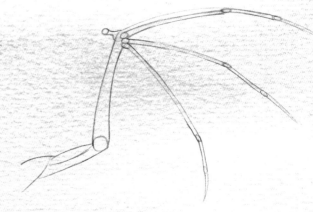

1 START WITH SIMPLE SHAPES
Sketch in simple shapes for the arm, using circles as joints. Draw a line for the top edge of the wing.

2 DRAW THE FINGERS
Draw long, thin fingers branching out from the wrist circle joint at the top of the wing. Don't forget to draw a thumb!

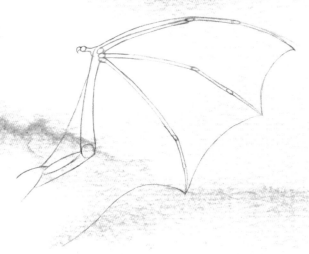
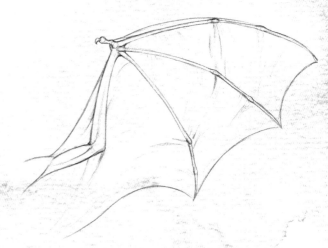

3 SKETCH THE WING EDGES
Sketch in the edges of the wings. The skin should stretch between each finger, coming to a point at each fingertip. The fingers may or may not end in claws; it's all up to you.

4 ADD TEXTURE
Indicate the texture of the leathery skin stretching between the fingers by sketching in curved lines of varying length and thickness.

Folded Wings

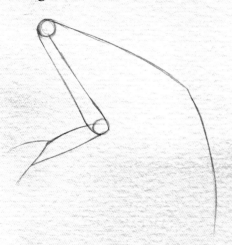

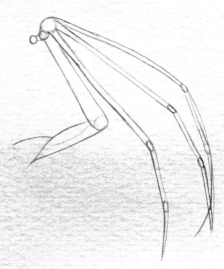

1 **LAY IN BASIC SHAPES**
Lay in the basic shape of the arm, using circles as joints. Where the wing is folded at the wrist, draw a line bending down into what will eventually become the folded shape of the wing.

2 **DRAW THE FINGERS AND KNUCKLES**
Draw long, thin fingers curving down from the wrist circle joint at the top of the wing. Indicate the knuckles by sketching a circle, making sure the fingers bend at each knuckle.

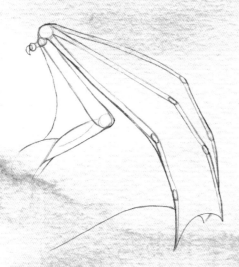

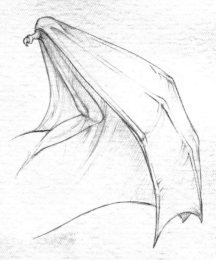

3 **CONNECT THE FINGERS**
Connect each finger with an arching shape showing the skin stretched between them. The second and third fingers overlap one another, so you won't see the skin flap there. Draw a curving line from the fingertip in the background toward your creature's body.

4 **FINISH WITH SHADING AND TEXTURE**
Finish off your drawing with shading and texture. Shading the area underneath the folded wing will help the wing to pop. Indicate the texture of the leathery skin. Since we are seeing the back of the wing, the fingers are covered by the skin and won't be as well defined as the view inside the open wing.

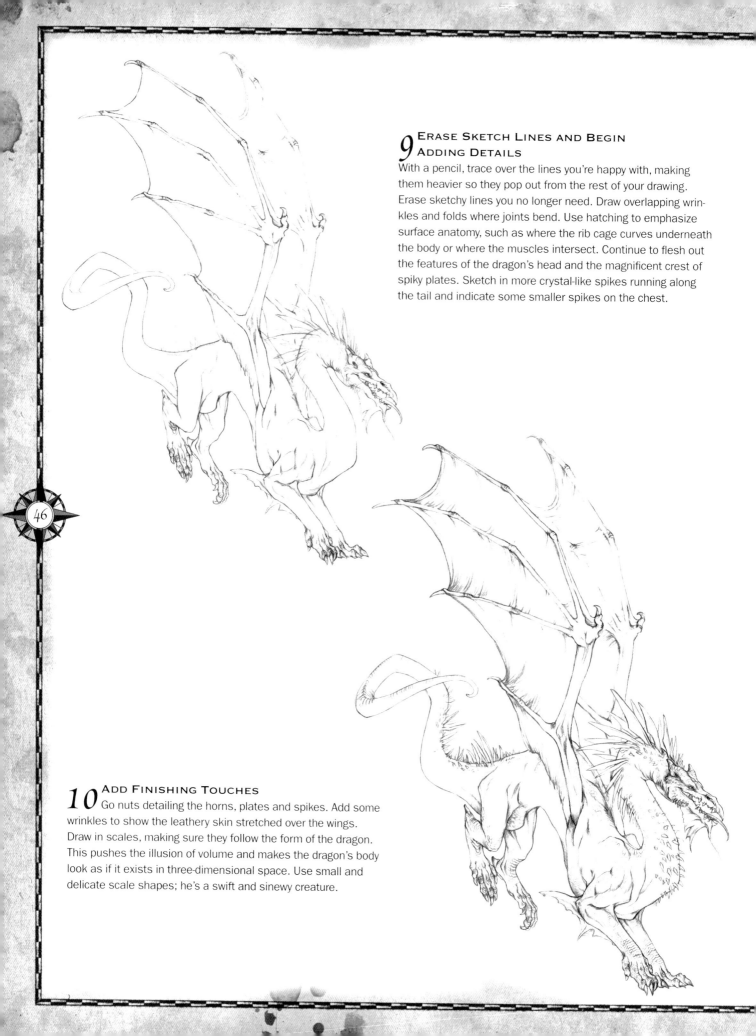

9 ERASE SKETCH LINES AND BEGIN ADDING DETAILS

With a pencil, trace over the lines you're happy with, making them heavier so they pop out from the rest of your drawing. Erase sketchy lines you no longer need. Draw overlapping wrinkles and folds where joints bend. Use hatching to emphasize surface anatomy, such as where the rib cage curves underneath the body or where the muscles intersect. Continue to flesh out the features of the dragon's head and the magnificent crest of spiky plates. Sketch in more crystal-like spikes running along the tail and indicate some smaller spikes on the chest.

10 ADD FINISHING TOUCHES

Go nuts detailing the horns, plates and spikes. Add some wrinkles to show the leathery skin stretched over the wings. Draw in scales, making sure they follow the form of the dragon. This pushes the illusion of volume and makes the dragon's body look as if it exists in three-dimensional space. Use small and delicate scale shapes; he's a swift and sinewy creature.

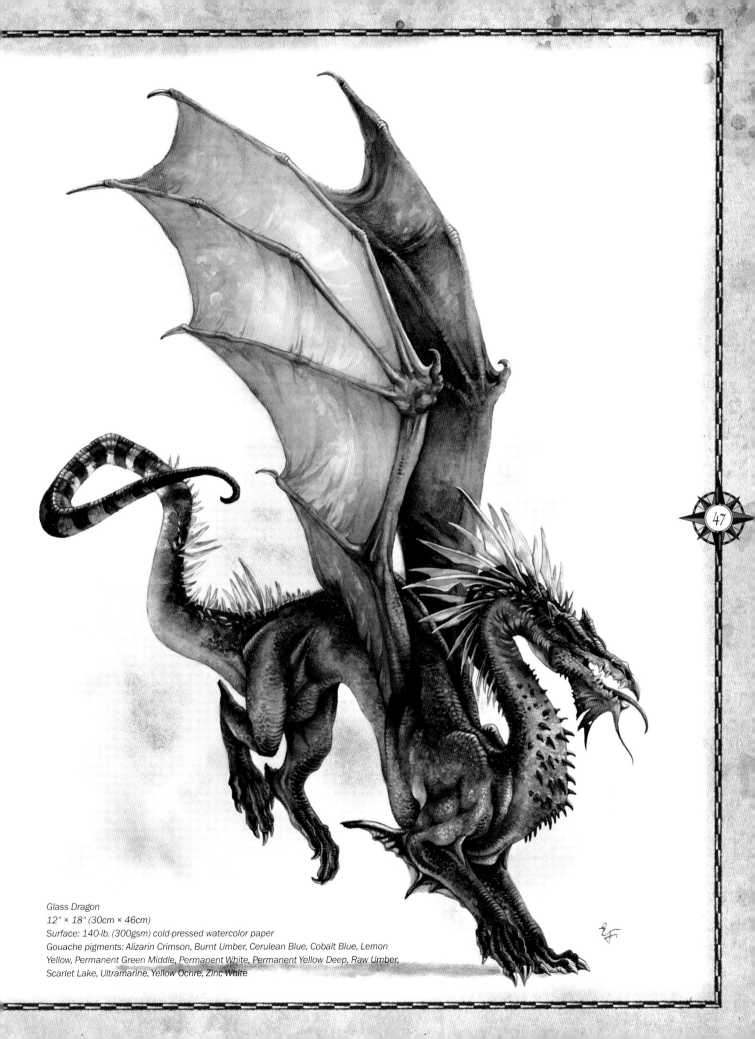

Glass Dragon
12" × 18" (30cm × 46cm)
Surface: 140-lb. (300gsm) cold-pressed watercolor paper
Gouache pigments: Alizarin Crimson, Burnt Umber, Cerulean Blue, Cobalt Blue, Lemon Yellow, Permanent Green Middle, Permanent White, Permanent Yellow Deep, Raw Umber, Scarlet Lake, Ultramarine, Yellow Ochre, Zinc White

Bringing Legend to Life
DRAW THE MINOTAUR

This powerful monster with the head of a bull, the body of a man and quite an eyebrow-raising story surrounding his origin roams the endless Labyrinth of Crete. Legend has it that each year seven girls and boys are sacrificed to feed the creature. Though he has a taste for humans, one can't help but feel a little sorry for the beast, having been thrown into the depths of the Labyrinth at birth because of his freakish appearance. Many would-be heroes have attempted to slay the Minotaur, and their efforts have ended in defeat. Perhaps things would have turned out differently if he had been sent fruits and vegetables rather than teenagers!

Materials

acid-free art paper

eraser

pencil

straightedge

1 START WITH A GESTURE DRAWING
Sketch a gesture using a powerful centerline. Draw opposing angles for the shoulders and hips, and a sharp angle where the neck meets the body to emphasize the strength of the pose. Block in the head and shoulders with circles. Don't forget a centerline to show where the head is pointing. Form the arms by drawing sticks with circles for the joints.

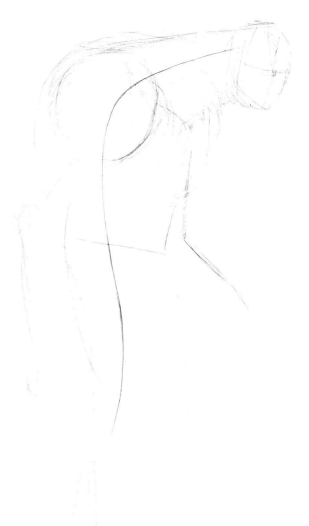

IT'S OK TO SCRIBBLE!

When beginning a drawing, it's OK to keep things loose with a big mess of lines. Use a light touch. Just keep working until you find the lines you like best. Then you can go over those with your pencil to make them darker, and erase the scribbles you don't need.

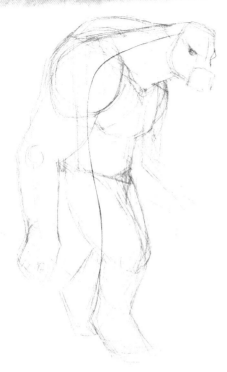

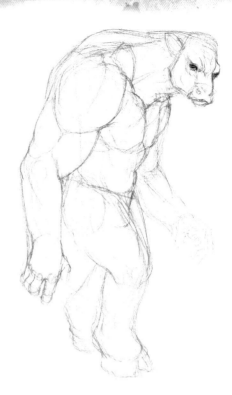

2 BLOCK IN THE BODY AND MUZZLE

Keeping in mind the location of the knees and elbows, block in the arms and legs with cylinders. Make them thick and powerful like tree trunks. Since the Minotaur will have hooves, draw his ankles a little higher than you would locate them on a human. Draw rectangular shapes to block in the chest muscles. Block in the Minotaur's muzzle using a square located low on the head.

3 PUMP HIM UP!

Flesh out the Minotaur's impressive muscles using interlocking bubble shapes. Don't make them too squishy looking; muscles, especially when flexed, should appear strong, not flabby. Draw in the facial features, keeping some reference of cows handy. Cow heads are roughly triangular in shape, tapering toward the top.

49

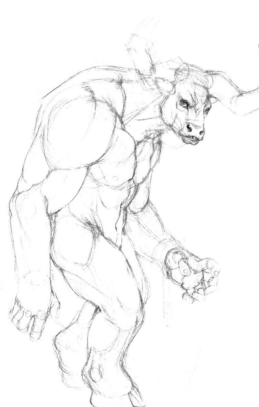

4 REFINE MUSCLES, ADD HORNS AND DETAIL THE FACE

Erase the old guidelines and darken the lines you're happy with to refine the muscle forms. Sketch in the outline of the horns. Make them any outlandish size and shape you like. Continue to detail his face, thinking about the emotion you want to convey. Perhaps he's sad and angry being stuck in the Labyrinth. Lightly sketch out the form of the weapon in his right hand.

Give 'Em a Hand

DRAW MONSTER HANDS

After the face and head, hands are generally the most important focus of a humanoid figure. The way hands are drawn can say a lot about your character, and the way he is feeling. Remember to show emotion in the hands as well as in the face.

If you are developing a humanoid creature, you can exaggerate and bend human anatomy to your own will. To create monstrous hands, draw big thick fingers, massive knuckles, popping tendons, bursting veins and leathery folds in the skin. Claws or cracked fingernails on a big guy like this Minotaur are an extra bonus detail. Adding or subtracting the amount of fingers is another way to make your creature's hands look otherworldly.

Closed Hand

1 START WITH SIMPLE SHAPES
Block in simple shapes dividing the hand into roughly three segments: the back of the hand, the fingers and the thumb. As you work, keep in mind that he is holding a weapon tightly.

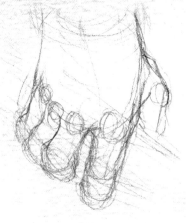

2 DRAW THE KNUCKLES
Draw circles to show where the knuckles will be. For this guy, they should be big and meaty.

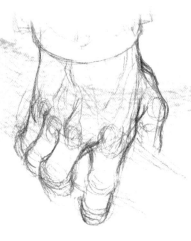

3 ADD DETAILS
Flesh out the hand with some details. Draw veins and craggy folds in the knuckles to add personality.

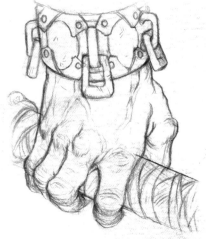

4 CLEAN UP AND ADD FINAL DETAILS
Clean up the construction lines and add finishing touches to finalize your drawing.

Open Hand

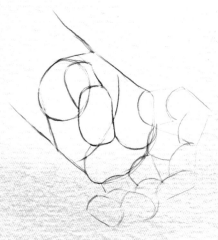

1 SKETCH THE BASIC FORM AND POSE
Draw boxy shapes to form the palm. Sketch in the general placement and pose of the fingers.

2 CONSTRUCT THE FINGERS AND THUMB
Construct the fingers and thumb with simple cylinders. Stacking the cylinders on top of each other from the bottom up will foreshorten them, creating depth.

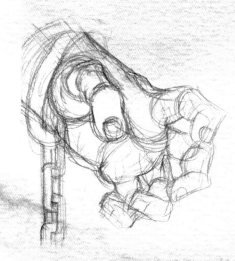

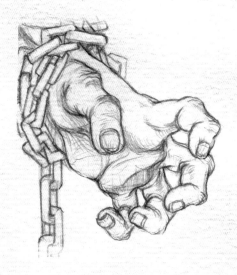

3 FLESH OUT THE HANDS
Make the palm of the hand look softer and fleshier than the fingers, which should look strong and sturdy. Add fingernails. Not only are these interesting details to draw, but they can help indicate the position of each finger in space.

4 FINISH WITH SHADING
Finish your details. Use shading or hatching to enhance the form and volume of the hand. This looks like a very powerful hand!

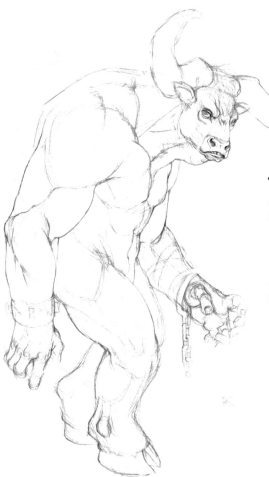

5 ADD DETAIL TO THE HEAD AND HANDS

Foreshorten the horns so that the one closest to us overlaps itself as it curves back into space. Draw V-shaped frown lines between his eyes. Continue detailing the head and face. Add a thick flap of loose skin hanging from the neck. Block in his wrist guard and the chain around his arm.

6 CONTINUE ADDING DETAIL

Use hatching to help define the forms of the face. Use a heavy line to indicate thick eyelids. Add any other fun details you like, such as battle scars or chips out of his horns. Draw some chunky shapes to block in hair hanging over his horns and forehead. Draw veins pulsating in his arms to make him look even stronger.

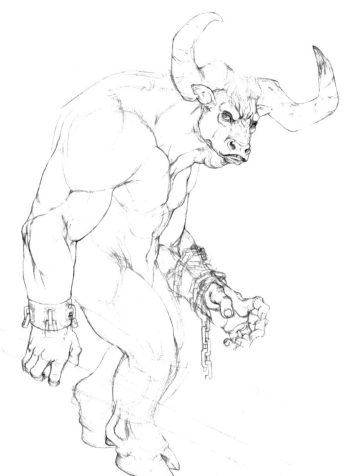

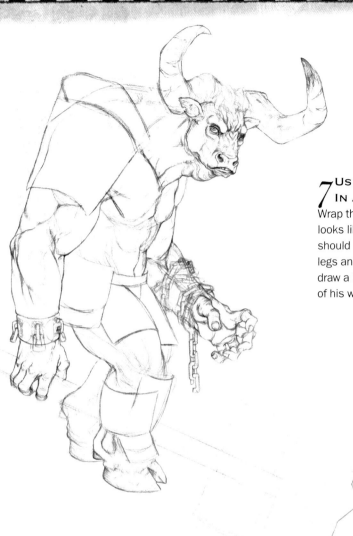

7 USE BASIC SHAPES TO BLOCK IN ARMOR

Wrap the armor around his form so it looks like he's really wearing it. Straps should look like they encircle the arms, legs and chest. Use a straightedge to draw a long, skinny cylinder for the handle of his war hammer.

8 REFINE THE ARMOR

Sketch massive overlapping plates on his shoulder armor. Slightly curve the rectangular plates making up the thigh armor to fit the form of the legs. Draw more square shapes to create the armor plates on the shin guards. It's OK to draw through the war hammer handle as you design the shin guards; erase the extra lines later. Turn the rectangular end of the war hammer into a cylinder by drawing arcing lines wrapping around the top and bottom. We are looking at the hammer from overhead, so the lines should curve downward.

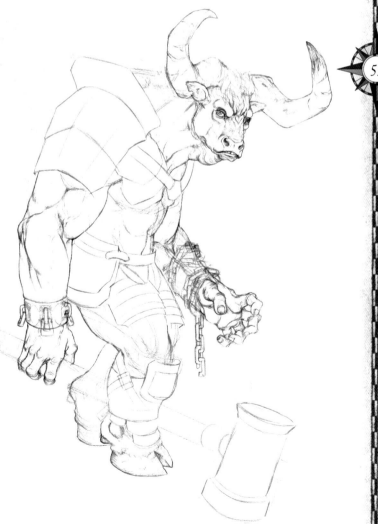

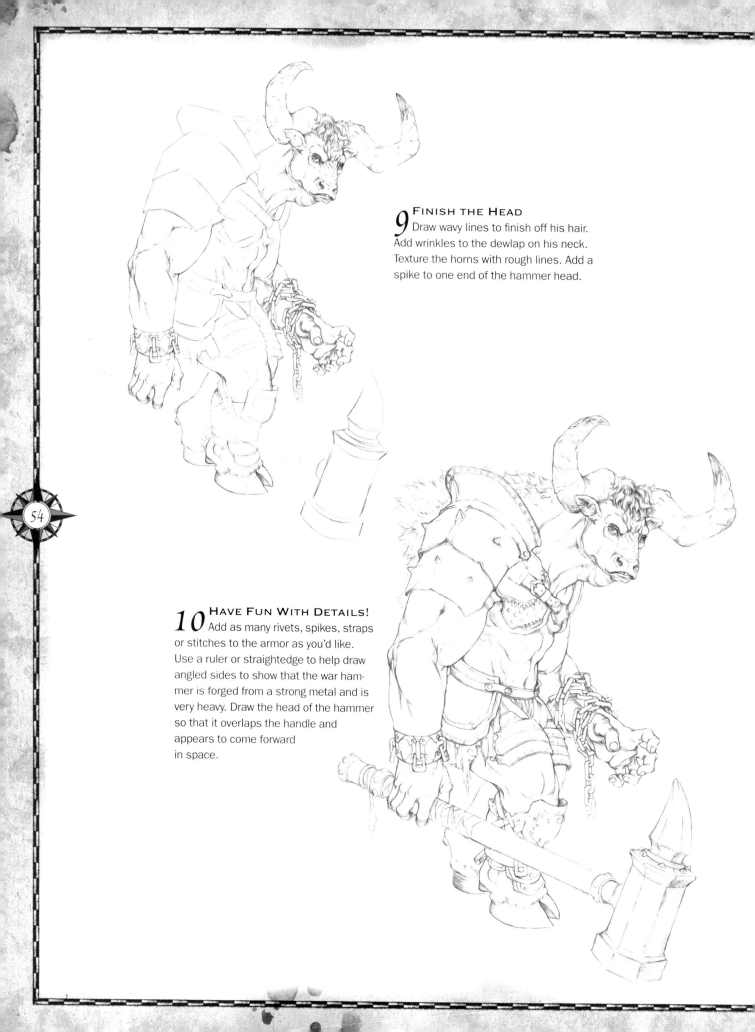

9 FINISH THE HEAD

Draw wavy lines to finish off his hair. Add wrinkles to the dewlap on his neck. Texture the horns with rough lines. Add a spike to one end of the hammer head.

10 HAVE FUN WITH DETAILS!

Add as many rivets, spikes, straps or stitches to the armor as you'd like. Use a ruler or straightedge to help draw angled sides to show that the war hammer is forged from a strong metal and is very heavy. Draw the head of the hammer so that it overlaps the handle and appears to come forward in space.

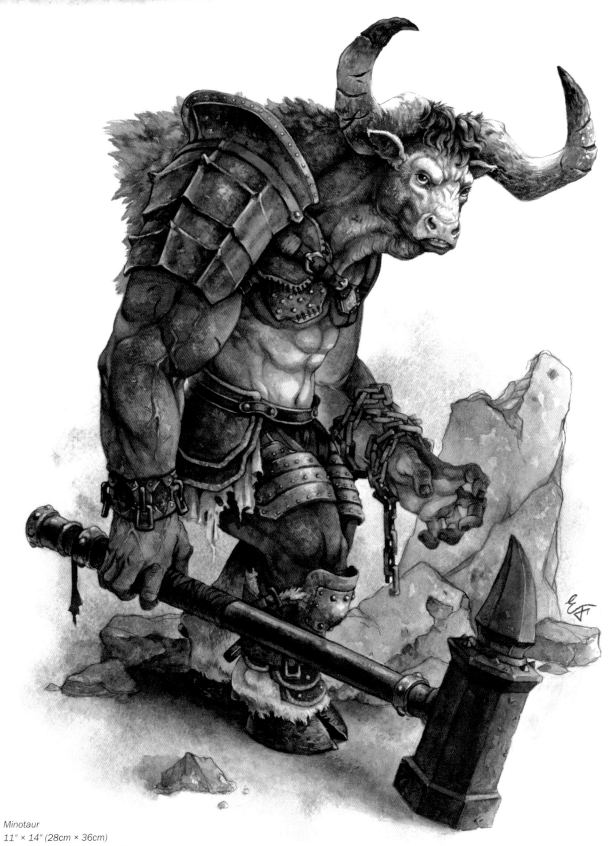

Minotaur
11" × 14" (28cm × 36cm)
Surface: 140-lb. (300gsm) cold-pressed watercolor paper
Gouache pigments: Alizarin Crimson, Burnt Sienna, Burnt Umber, Cerulean
Blue, Cobalt Blue, Ivory Black, Lemon Yellow, Olive Green, Permanent White,
Permanent Yellow Deep, Raw Umber, Scarlet Lake, Spectrum Red, Ultramarine,
Yellow Ochre, Zinc White

Bringing Legend to Life
DRAW THE HYDRA

This slithering abomination lurks in gloomy swampland. Any venomous serpent can be pretty scary, but how about a huge one with multiple heads? The hydra sports nine deadly heads, each with nasty big pointy teeth. If you try to destroy her by cutting off any of the heads, two new ones will grow in its place! According to legend, Hercules discovered this the hard way when he was sent to destroy the Hydra as one of the labors he had to complete for King Eurystheus. (What I want to know is, how can she make her mind up with all those heads?)

Materials

acid-free art paper

eraser

pencil

1 SKETCH A GESTURE DRAWING
When drawing what is basically a nine-headed snake, you want to have some swaying, slithering action going on. That's where a flowing gesture comes in. Start at the central head of the hydra and loosely draw a long S-curve for the center line, looping and twisting around to form the tail. Draw similar S-curves for the next two heads. Use broad sweeping lines and try to keep your pencil on the paper almost continuously. Block in the head shapes with rectangles, and the arms with sticks and circles.

2 BLOCK IN the BODY WITH BASIC SHAPES
Indicate the placement of fins on the head and back with simple triangle shapes. Draw a centerline along the hydra's back to show where the spine would be and add another centerline on each neck to indicate where it is twisting in space. Draw ovals to form the meaty part of the jaws, and a line blocking in each mouth. Use curvy lines on the side of each neck to indicate placement of the smaller hydra heads.

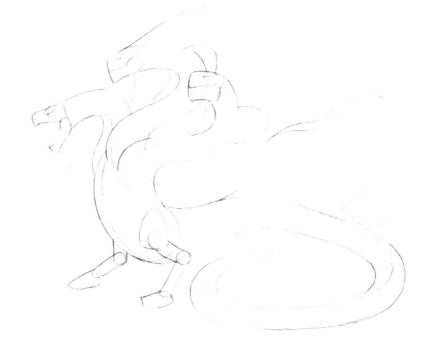

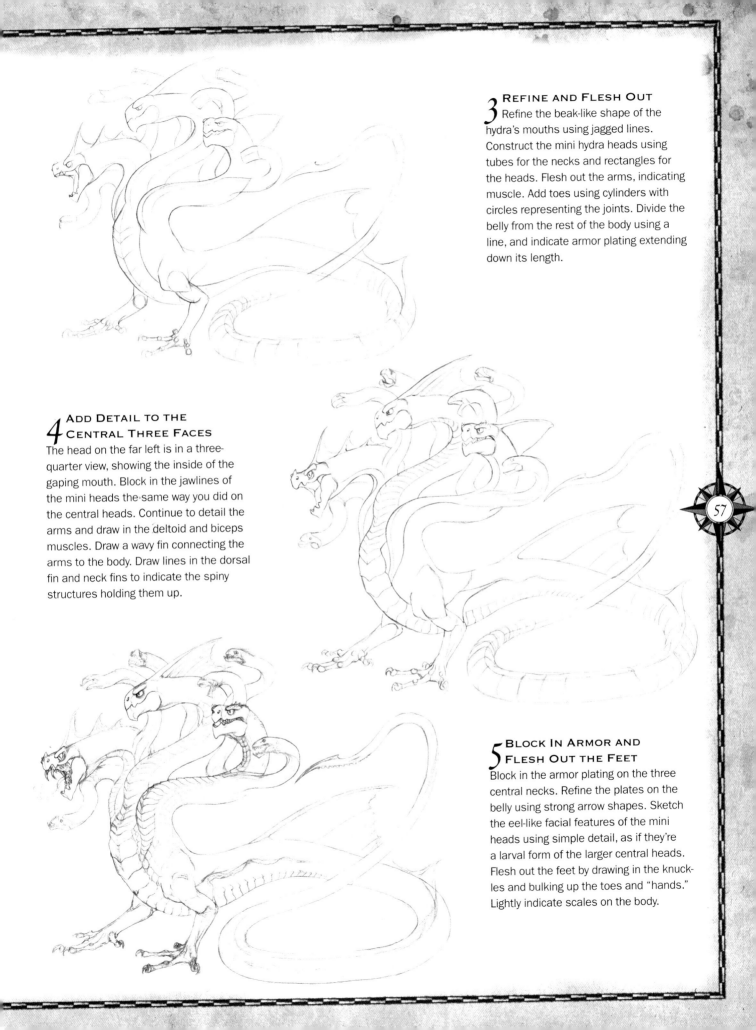

3 REFINE AND FLESH OUT

Refine the beak-like shape of the hydra's mouths using jagged lines. Construct the mini hydra heads using tubes for the necks and rectangles for the heads. Flesh out the arms, indicating muscle. Add toes using cylinders with circles representing the joints. Divide the belly from the rest of the body using a line, and indicate armor plating extending down its length.

4 ADD DETAIL TO THE CENTRAL THREE FACES

The head on the far left is in a three-quarter view, showing the inside of the gaping mouth. Block in the jawlines of the mini heads the same way you did on the central heads. Continue to detail the arms and draw in the deltoid and biceps muscles. Draw a wavy fin connecting the arms to the body. Draw lines in the dorsal fin and neck fins to indicate the spiny structures holding them up.

5 BLOCK IN ARMOR AND FLESH OUT THE FEET

Block in the armor plating on the three central necks. Refine the plates on the belly using strong arrow shapes. Sketch the eel-like facial features of the mini heads using simple detail, as if they're a larval form of the larger central heads. Flesh out the feet by drawing in the knuckles and bulking up the toes and "hands." Lightly indicate scales on the body.

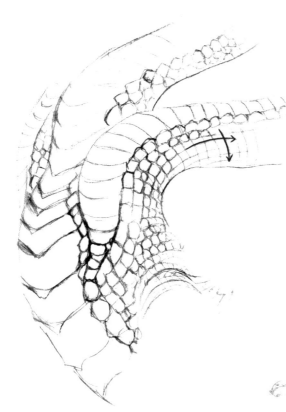

6 SKETCH IN SCALES

Block in where the scales will go with curves that follow the form of the limb or tail. Draw curving lines that intersect them, creating a sort of checkerboard pattern. Refine the shape of each scale so they form an interlocking pattern. Scales will be bigger where there is more surface area to cover, or where the creature needs more protection. They will be smaller in places where things need to bend, like knees, shoulders or elbows.

7 EMBELLISH WITH DETAILS

Add battle damage, stretchy skin between the toes, spikes—you name it. Draw a tongue flicking out of the mouth of the far left head, complete with venomous spittle. Draw as many or as few scales as you like, just leave a few blank spots for the viewer's eye to rest on.

FORMS IN SPAAAAAACE!

Lightly sketching a series of curving lines or circles around body features can be helpful in constructing the forms and figuring out where they exist in space. Depending which way your lines curve, shapes can look like they're coming toward the viewer or receding back into space. This is handy when foreshortening an arm or leg or drawing something from a difficult angle.

Hydra
11" × 14" (28cm × 36cm)
Surface: 140-lb. (300gsm) cold-pressed watercolor paper
Gouache pigments: Alizarin Crimson, Burnt Sienna, Burnt Umber, Cerulean
Blue, Cobalt Blue, Lemon Yellow, Olive Green, Permanent Yellow Deep, Prussian
Blue, Raw Umber, Spectrum Red, Ultramarine, Yellow Ochre, Zinc White

59

Bringing Legend to Life
DRAW A SPHINX

The sphinx embodies beauty, intelligence and strength. The regal qualities of a lion, a human visage and feathered wings combine to shape this magnificent creature. The form of the sphinx has been used in centuries-old art to represent the power of pharaohs and queens. A sphinx may appear as male or female, depending on the culture of origin of the tales that feature the creature. Legend has it that the sphinx is famous for tormenting unlucky travelers by asking them to answer nearly unsolvable riddles. Those who can solve her puzzles may continue on their journey; those who can't meet their doom.

Materials

acid-free art paper

eraser

pencil

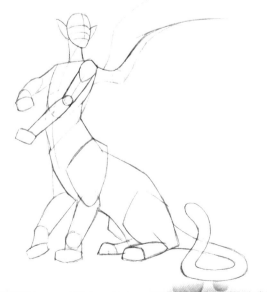

1 START WITH SWEEPING GESTURE LINES
The most important gesture line is the centerline showing the action of the pose. Block in a couple diagonal lines to indicate the angle of the shoulders and hips. Draw an S-curve, which will eventually form the shape of the sphinx's back.

2 BLOCK IN BASIC SHAPES
At this stage it helps to think of the human and lion parts of the sphinx as separate sections. Draw a cylinder shape to block in the human torso. Lightly sketch a triangle to show where the lion's hindquarters will be. This helps ground the figure and reminds you that the bulk of the sphinx's weight is resting on the hindquarters. Sketch simple lines to show placement of the arms, front legs and wings. Draw the centerline and the eye, nose and mouth lines on the head for placement of the facial features.

3 BLOCK IN THE LIMBS AND WINGS
Draw cylinders for the arms and legs, using circles to mark the joints. Use the same technique on the wings. Keep track of your centerline down the torso. It will help you keep the body in the correct three-quarter perspective. The spine creates powerful angles as it extends elegantly from neck to the tail, adding a regal air to the pose.

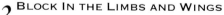

Let's Face It

DRAW A SPHINX FACE

Most of the creature facial features in this guide are of non-human animals. In the case of the sphinx, we're looking at a stern yet elegant human face. It's often a good idea to work on the face of a character or creature early in a drawing, because it's such an important focal point.

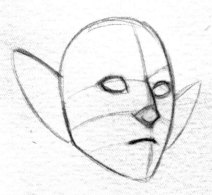

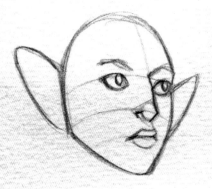

1 DRAW GUIDELINES AND BLOCK IN FEATURES

After drawing a centerline and horizontal lines dividing the face into thirds for the eyes, nose and mouth, it's time to add the features. As a general rule, eyes are about one eye-width apart when a face is looking forward. This face is in a three-quarter view, so we will see more of the eye closer to us, and less of the eye further away as it is covered partially by the nose and curves back into perspective along with the rest of the face. Generally, human-sized ears fit between the eye and nose lines. That is not the case with the larger cat-like ears on this drawing.

2 DEVELOP THE FACIAL FEATURES

Draw in the irises of the eyes, the nostrils, and the upper and lower lips. Draw slightly downturned eyebrows to make her look as though she's in deep concentration. Eyes and eyebrows are the most effective features for conveying emotion.

3 ADD DEFINING DETAILS

Sketch in more defining characteristics to give your face, well, more character. Drawing lips in three-quarter perspective can be tricky. Curve them back into space with the rest of the head so that we see the corner of the mouth on the side of the face pointing toward us. Study yourself in a mirror to see how facial features look at different angles.

4 DRAW HAIR AND ADD FINAL DETAILS

Sketch in some cheekbones and block in long locks of hair. Give her a strong chin and a slightly angular jaw. Draw the folds of the ears overlapping to give them more dimension. Finish drawing the face with any other details you'd like.

4 REFINE THE ANATOMY

Blend the hips of the human torso into what will be the neck and shoulders of the lion. Block in the shape of the breasts and wings. Block in bubble shapes for the toes of the powerful paws. Jot down lines in her hands to indicate the bow and arrow she will be wielding.

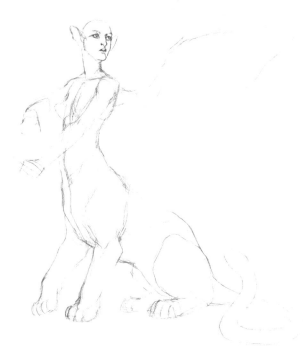

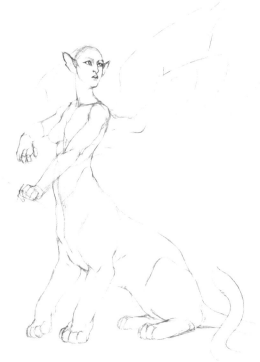

5 FOCUS ON THE HUMAN ASPECT

Draw the deltoid, biceps and triceps muscles of the arms. Her right forearm is facing us, and is slightly foreshortened as she prepares to nock an arrow. Sketch in the fingers on each hand using cylinders and circles to mark the knuckles. The hand gripping the bow should look like a powerful fist, while the hand nocking the arrow should look more dextrous and relaxed. Divide the wings into three sections for the placement of feathers later on.

6 CLEAN UP THE LINES

Trace over the lines you're happy with, making them heavier to refine the contours of the upper body. Erase any sketchy construction lines you no longer need.

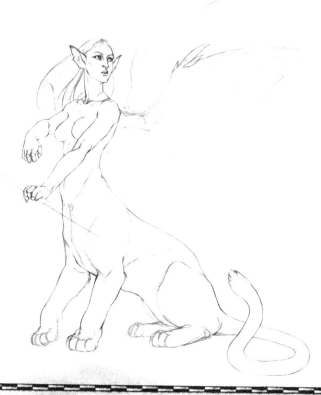

7 FINISH THE LION HALF OF THE BODY

Sketch interlocking bubble shapes to define the lion's foreleg and shoulder muscles. The shoulder blade will protrude from the back slightly as the weight of the body rests on the front leg. Block in a shirt for your sphinx. Lightly sketch lines for the primary feathers along the outer layer of the wings.

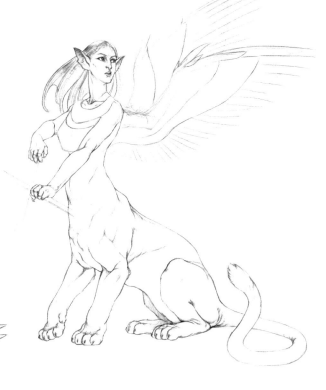

8 DEVELOP THE WINGS

Draw the primary feathers arching out from the center of the wings, using the lines from the previous step as a guide. Sketch similar lines on the second and third layers of each wing, overlapping the primary feathers. Shade in the chest and stomach of the lion to indicate a light source and further push the illusion that the sphinx is a character in three-dimensional space.

9 FINISH THE WINGS

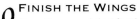

Draw the remaining feathers, making them gradually smaller as you move inward from the primaries. Exaggerate some aspects of the wings, like unusually long or strangely shaped feathers to give the sphinx an otherworldly, godess-like look. Draw curved lines for the feathers and her flowing hair to tie together separate design elements and make your design cohesive.

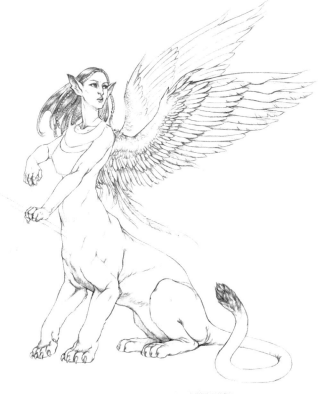

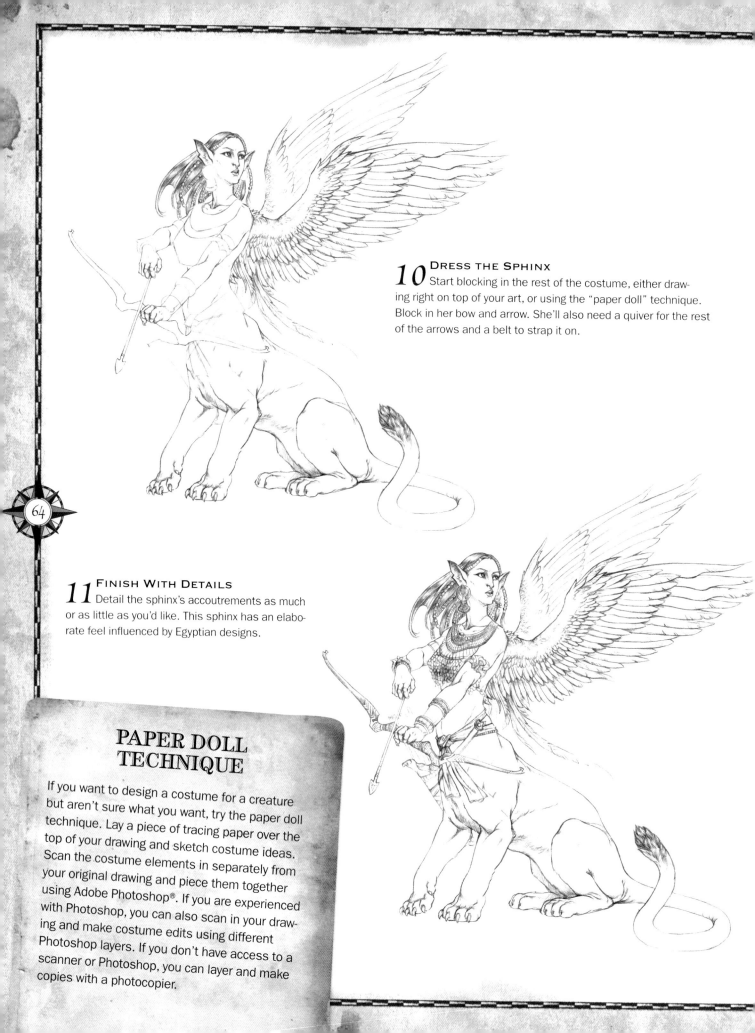

10 DRESS THE SPHINX
Start blocking in the rest of the costume, either drawing right on top of your art, or using the "paper doll" technique. Block in her bow and arrow. She'll also need a quiver for the rest of the arrows and a belt to strap it on.

11 FINISH WITH DETAILS
Detail the sphinx's accoutrements as much or as little as you'd like. This sphinx has an elaborate feel influenced by Egyptian designs.

PAPER DOLL TECHNIQUE

If you want to design a costume for a creature but aren't sure what you want, try the paper doll technique. Lay a piece of tracing paper over the top of your drawing and sketch costume ideas. Scan the costume elements in separately from your original drawing and piece them together using Adobe Photoshop®. If you are experienced with Photoshop, you can also scan in your drawing and make costume edits using different Photoshop layers. If you don't have access to a scanner or Photoshop, you can layer and make copies with a photocopier.

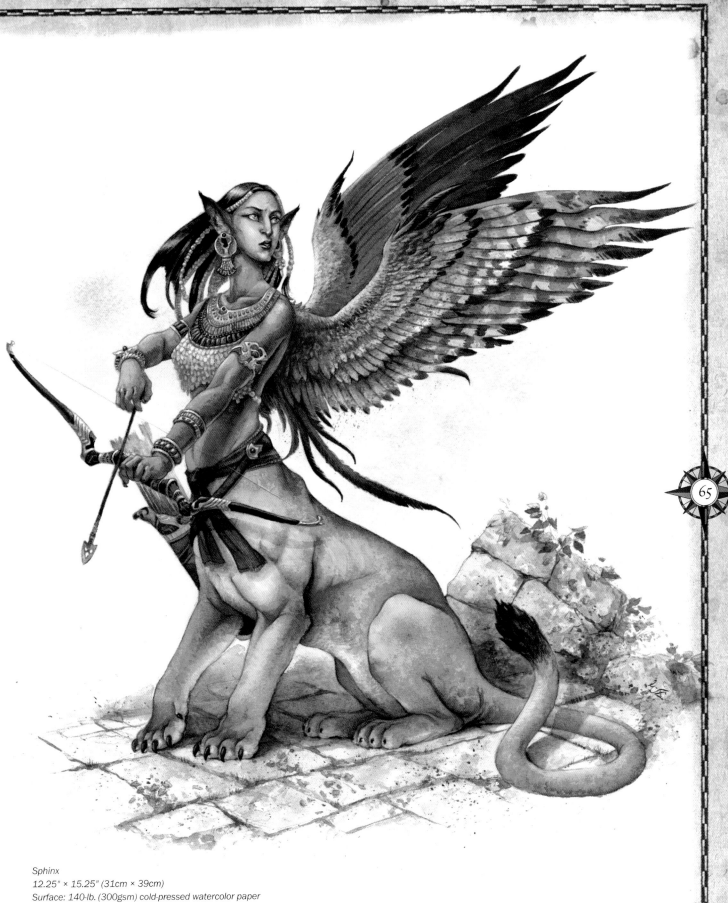

Sphinx
12.25" × 15.25" (31cm × 39cm)
Surface: 140-lb. (300gsm) cold-pressed watercolor paper
Gouache pigments: Alizarin Crimson, Burnt Sienna, Burnt Umber, Cerulean Blue, Cobalt Blue, Ivory Black, Lemon Yellow, Permanent Green Middle, Permanent White, Permanent Yellow Deep, Raw Umber, Scarlet Lake, Spectrum Red, Ultramarine, Yellow Ochre, Zinc White

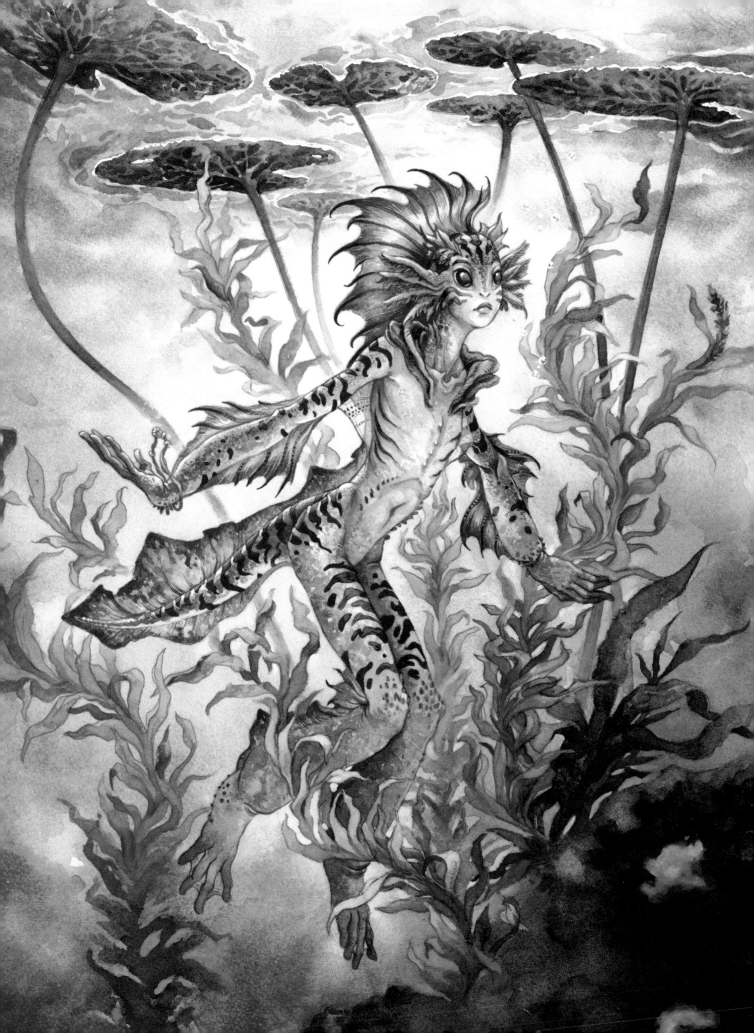

CHAPTER FOUR

Creatures of the Water

For those of us who make our homes on land, the water seems mysterious and unknown. What lurks in the depths of the ocean or the murkiness of the swamp? A great number of species live in the water. Some creatures live so far beneath the surface, no one can record their image. Others are so rare, they only exist in whispers of legend. And there are many that are yet to be discovered. It can be a little creepy, wondering what lies beneath, but gather your courage and let's explore this watery realm together. After we've taken a look at some of the critters I've uncovered, perhaps you can explore some of your own.

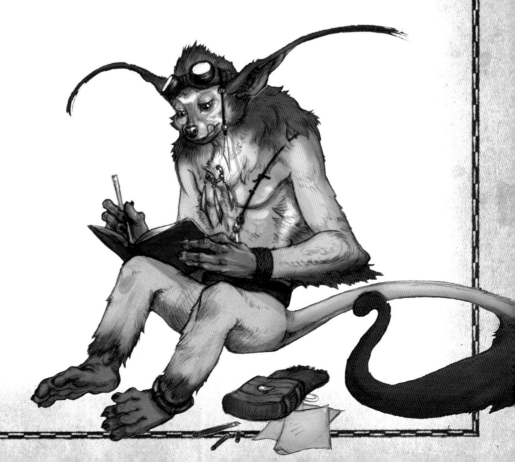

Discovering the Depths
DRAW A PAINTED MARSH NYMPH

Making their home in marshes and swamps, these timid and delicate beings are rarely observed due to their shy nature. Marsh nymphs are amphibious creatures that give birth to live young. As youths, they spend all of their time in the water, but as they mature, they are able to venture onto land and breathe air, though they rarely do so. Because of this, they retain their gills throughout life. They feed exclusively on plant material. Not much is known about their social behavior.

Materials

acid-free art paper

eraser

pencil

1 SKETCH A GESTURE DRAWING
Begin with the action line. Draw a circle for the head. Draw straight lines to indicate the angle of the shoulders and hips. Connect them with loose, angular strokes to suggest the pose of the body.

2 DIVIDE THE HEAD AND BLOCK IN THE LIMBS
Draw a centerline and eye line to divide the head and indicate the direction she is facing. Block in the mass of the legs, and sketch in some lines to show the position of the arms.

3 SKETCH BASIC SHAPES TO FORM THE BODY
Make sure the curve of her back retains the loose feeling of the gesture drawing as you work. Divide the body into sections that also serve as starting points to block in the anatomy. Indicate the rib cage, waist and hips. Draw a horizontal line curving around the rib cage to remind yourself that the surface details you add later should follow this curve as you work.

4 FLESH OUT THE ANATOMICAL FEATURES

Give a more natural shape to the body. This creature's body is thin and elongated, so her torso, neck and limbs should be long and elegant. Taper the arms and legs toward the elbow and knee joints, and make the forearm and shins slightly thicker, like a frog's. Lightly sketch in her nostrils and lips.

5 BLOCK IN FINGERS AND FINS

Sketch in long, graceful fingers on each hand. Draw circles to indicate the knuckles. Position her left hand to give the impression that she is floating or treading water. (It's perfectly fine to change or alter parts of your drawing at any stage if they aren't working for you.) Lightly sketch in some lines wrapping around her chest to show where the ribs might fall. This will help you to locate where to draw the gills later on. Block in some angular shapes for her fins.

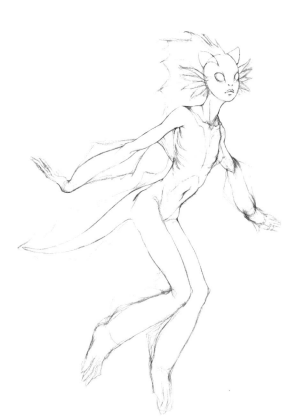

6 CREATE AN OTHERWORLDLY LOOK

Small stylistic changes to the form of the body can make a humanoid creature look more unique. Exaggerate the size of the irises and the shape of the lips to make them more fish- or frog-like. Make the wrists and ankles reflect a similar "froggy" look, somewhat rotund and chubby. Extend this motif down to the feet when you sketch in the toes. Repeating design details throughout the body gives your creature design unity.

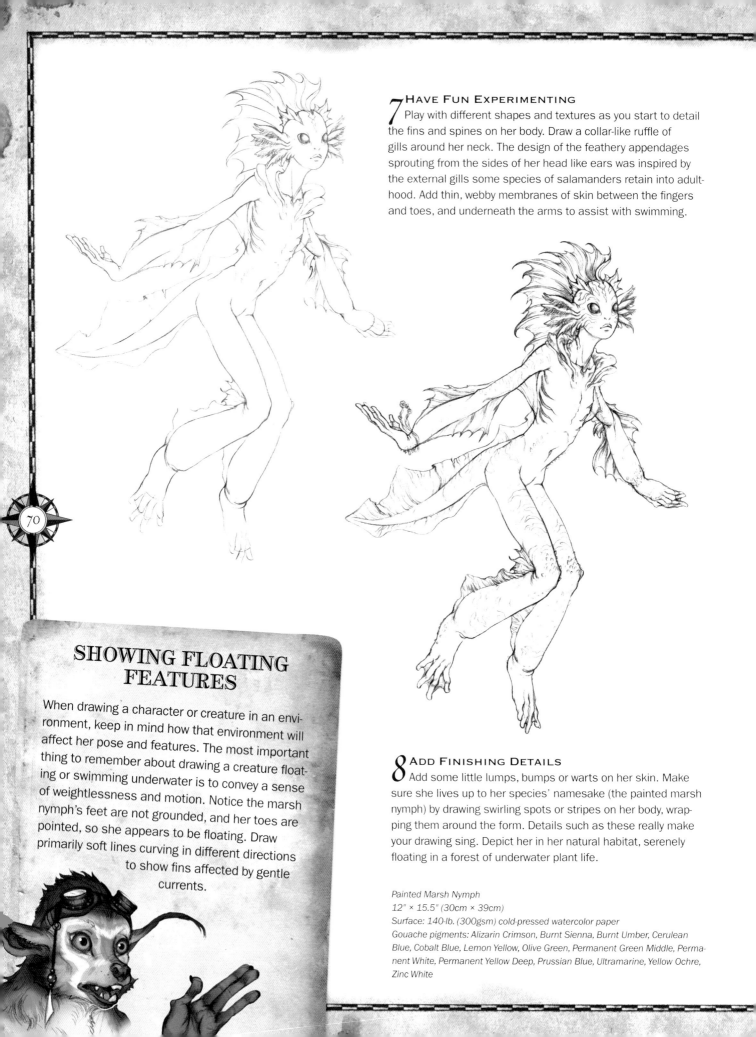

7 HAVE FUN EXPERIMENTING

Play with different shapes and textures as you start to detail the fins and spines on her body. Draw a collar-like ruffle of gills around her neck. The design of the feathery appendages sprouting from the sides of her head like ears was inspired by the external gills some species of salamanders retain into adulthood. Add thin, webby membranes of skin between the fingers and toes, and underneath the arms to assist with swimming.

SHOWING FLOATING FEATURES

When drawing a character or creature in an environment, keep in mind how that environment will affect her pose and features. The most important thing to remember about drawing a creature floating or swimming underwater is to convey a sense of weightlessness and motion. Notice the marsh nymph's feet are not grounded, and her toes are pointed, so she appears to be floating. Draw primarily soft lines curving in different directions to show fins affected by gentle currents.

8 ADD FINISHING DETAILS

Add some little lumps, bumps or warts on her skin. Make sure she lives up to her species' namesake (the painted marsh nymph) by drawing swirling spots or stripes on her body, wrapping them around the form. Details such as these really make your drawing sing. Depict her in her natural habitat, serenely floating in a forest of underwater plant life.

Painted Marsh Nymph
12" × 15.5" (30cm × 39cm)
Surface: 140-lb. (300gsm) cold-pressed watercolor paper
Gouache pigments: Alizarin Crimson, Burnt Sienna, Burnt Umber, Cerulean Blue, Cobalt Blue, Lemon Yellow, Olive Green, Permanent Green Middle, Permanent White, Permanent Yellow Deep, Prussian Blue, Ultramarine, Yellow Ochre, Zinc White

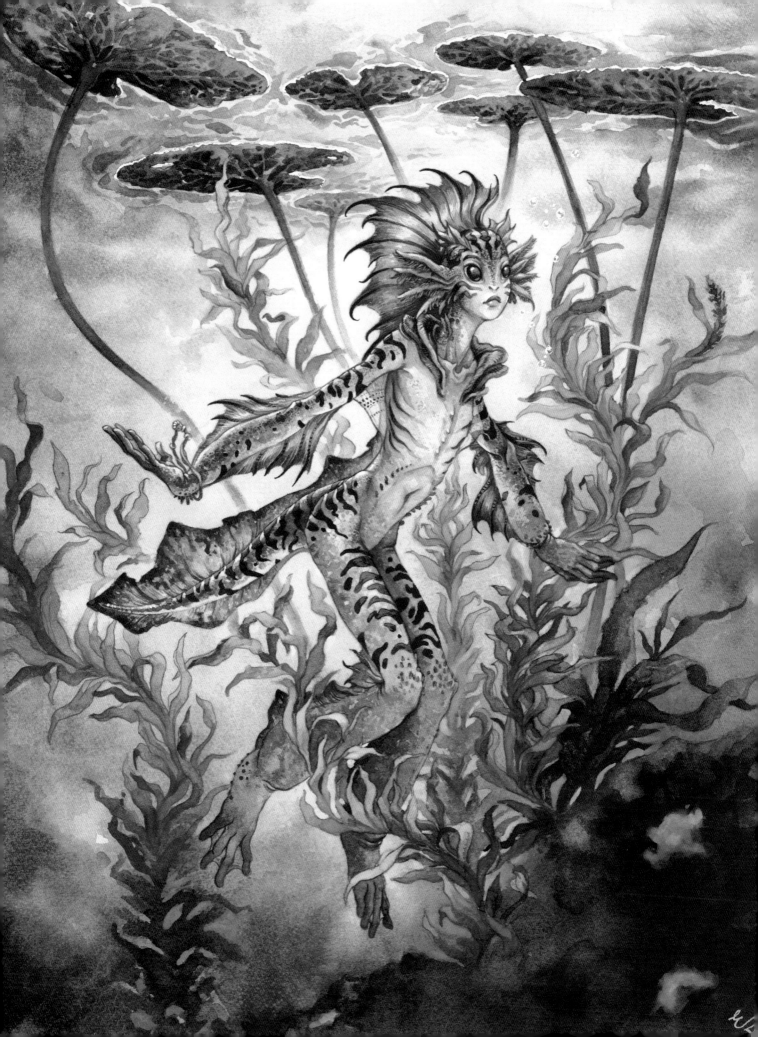

Discovering the Depths
DRAW A SEA SERPENT

A creature that has inspired legend and struck fear into the hearts of seafarers everywhere, this massive predator lives in the open ocean. Despite its name, the sea serpent is more closely related to fish than reptiles. It hunts for its prey in a large territory, from the ocean's depths to the surface. The serpent feeds mostly on other large predators including whales, sharks and occasionally (gulp) boatloads of people.

Some sailors have reported a member of this species approaching 750 feet (229 meters) long! A flattened, rudder-like tail propels its smooth, muscular body through the water. Equipped with heat sensing organs near its mouth for deep water attacks and a bioluminescent lure on its chin to attract prey, the sea serpent is a deadly and effective predator. It is a solitary creature, only coming into contact with others of its kind to mate. Because the ecosystem cannot support many animals of this size, few of these humongous creatures exist. They have no predators aside from intrepid hunters on ships.

Materials

acid-free art paper

eraser

pencil

1 DRAW THE ACTION LINE
Start with a dot that will represent the placement of the head and draw a long, curvy line. Draw loosely from your wrist to give your line a boost of energy. This line will become one side of the serpent's body.

2 SKETCH YOUR GESTURE DRAWING
Using the dot as a reference point, sketch in the serpent's head with simple shapes. Give your serpent a gaping jaw. Draw another spiraling line alongside the line you made in the previous step to complete the serpent's body. It's okay to draw through the overlapping shapes to connect your lines properly. Make the neck area thicker and gradually taper your serpent's body as you get toward the tail to show that the serpent is very long and the tail is much farther away from the viewer than the head.

Something's Fishy
DRAW FINS

Creatures that live under the sea are among the most widely varied and amazing animals on the planet, ranging from tiny to huge, from astonishingly beautiful to scary and dangerous. Fish fins come in an amazing array of sizes, shapes and colors. Any frills or fins you can imagine, no matter how outlandish, would be appropriate for your underwater creatures. Fins can be very colorful, exhibit complex patterns or be almost completely transparent. Decide if you would like your creature's fins to be delicate, soft or menacing. Here are just a few examples of fin shapes you might like to try.

Pointy Fin

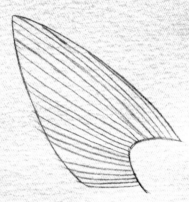

1 START WITH THE BASIC SHAPE
Draw a rounded triangle shape. This will form the part of the pectoral fin that connects to the body. Draw another triangle sprouting out from that shape.

2 ADD LINES
Draw lines radiating out from the inside of the fin to the tip.

3 REFINE THE EDGES
Connect the lines you drew in the previous step with a varying shape so the fin doesn't look so mechanical. Depending on the type of fin you want to portray, you could connect your lines with pointy or rounded shapes. Here, the edge of the fin is soft and rounded.

Round Fin

1 START WITH THE BASIC SHAPE
Draw a semicircle. Draw a fan shape coming out from the semicircle.

2 ADD LINES
Draw lines radiating from the inside of the fin to the outside edge. If you like, double up the lines to make thicker spines so that the fin looks a bit more substantial.

3 REFINE THE EDGE
Refine the edge of the fin by drawing a scalloped shape.

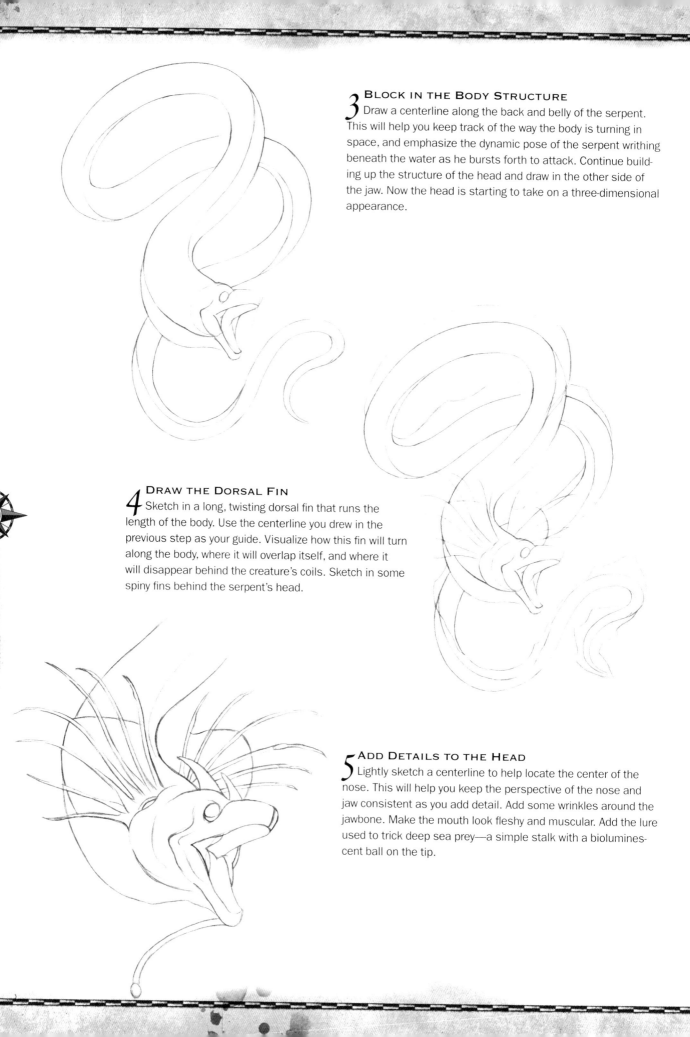

3 BLOCK IN THE BODY STRUCTURE

Draw a centerline along the back and belly of the serpent. This will help you keep track of the way the body is turning in space, and emphasize the dynamic pose of the serpent writhing beneath the water as he bursts forth to attack. Continue building up the structure of the head and draw in the other side of the jaw. Now the head is starting to take on a three-dimensional appearance.

4 DRAW THE DORSAL FIN

Sketch in a long, twisting dorsal fin that runs the length of the body. Use the centerline you drew in the previous step as your guide. Visualize how this fin will turn along the body, where it will overlap itself, and where it will disappear behind the creature's coils. Sketch in some spiny fins behind the serpent's head.

5 ADD DETAILS TO THE HEAD

Lightly sketch a centerline to help locate the center of the nose. This will help you keep the perspective of the nose and jaw consistent as you add detail. Add some wrinkles around the jawbone. Make the mouth look fleshy and muscular. Add the lure used to trick deep sea prey—a simple stalk with a bioluminescent ball on the tip.

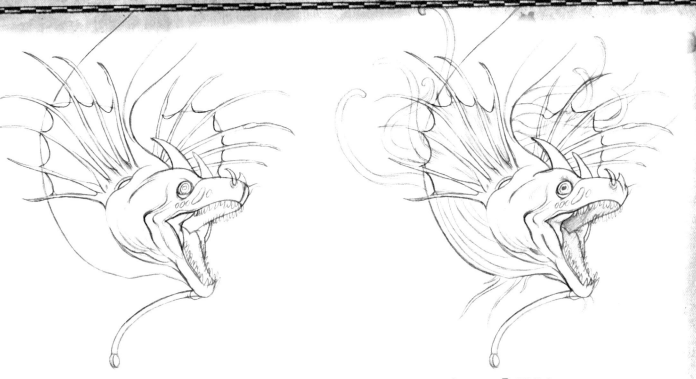

6 ADD TEETH AND HORNS AND REFINE THE FINS

Add several rows of sharp teeth to the fearsome maw of the serpent. Using the centerline you sketched earlier, add some fleshy horns to the tip of the nose. To refine the fins, draw curving lines connecting the spines to create a more interesting shape, as if fabric is loosely stretched between each spine.

7 CONTINUE ADDING DETAILS

Draw lines to form the grooves on the throat pouch that help the serpent's throat expand to engulf and swallow large prey. Sketch in the fleshy tentacles behind the fins. Finish adding spines, horns, barnacles—whatever other details you would like to add. Shade in the mouth to push the three-dimensionality of the face and add that in-your-face ferociousness.

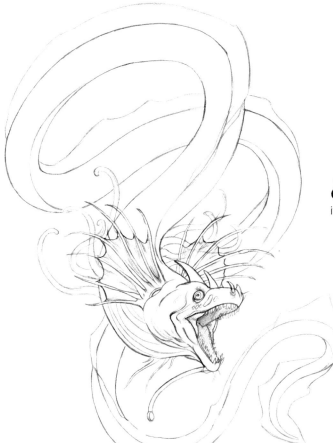

8 CHECK YOUR PROGRESS

Here is the nearly completed head as it appears on the body of the serpent.

9 FINISH WITH TEXTURE AND SHADING

Enrich your drawing with texture and shading. Draw fleshy, overlapping wrinkles where the body curves around itself. Add a speckled camouflage that breaks up the shape of the serpent underwater so that he can stealthily approach his prey from underneath the waves.

ATMOSPHERIC PERSPECTIVE

Varying the line weight is especially effective at pushing the atmospheric perspective in this drawing. Go over your lines on the face and fins to pop the head out from the rest of the body. Use a lighter touch on the coils of the serpent and the tail in the background to push them back into space so that they appear further away. Draw less texture and detail the farther away the body gets to give the impression it is receding into deeper water.

Sea Serpent
11" × 14" (28cm × 36cm)
Surface: 140-lb. (300gsm) cold-pressed watercolor paper
Gouache pigments: Alizarin Crimson, Burnt Umber, Cerulean Blue, Cobalt Blue, Lemon Yellow, Olive Green, Permanent Green Middle, Permanent Yellow Deep, Prussian Blue, Scarlet Lake, Spectrum Red, Ultramarine, Zinc White

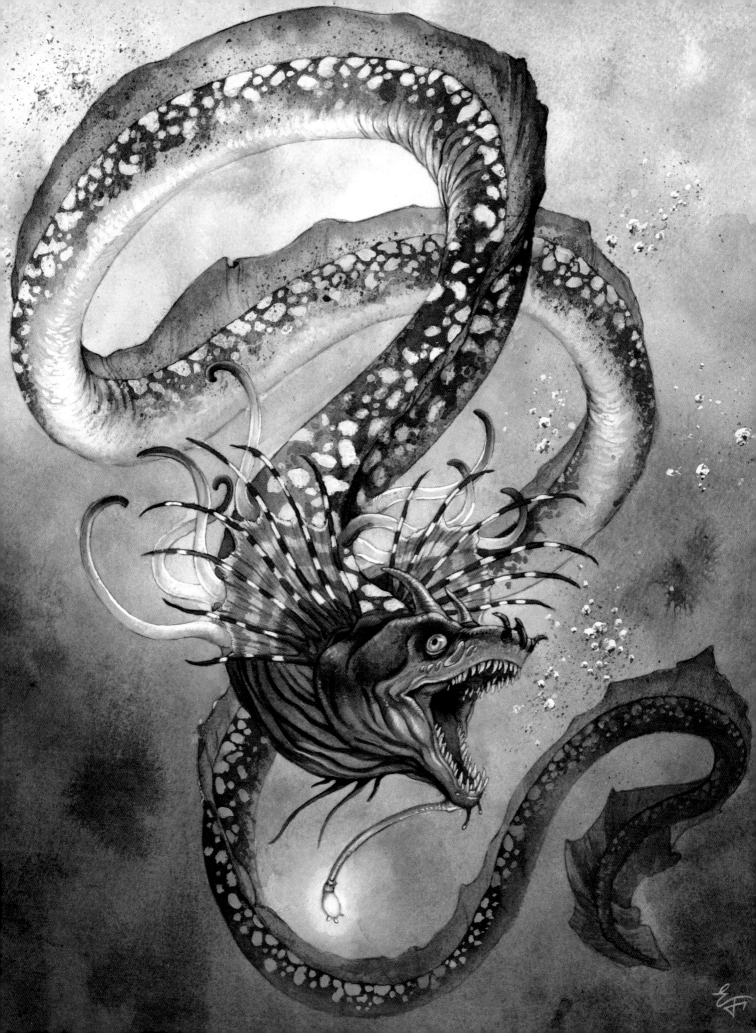

Discovering the Depths
DRAW A LIVING ISLAND

This rare colossal beast has been mistaken for islands by explorers as well as the organisms that colonize them. This massive being is so large that it can support its own little ecosystem! The living island makes its home in large freshwater lakes. It can remain motionless in a hibernating state for more than a century, and its lifespan can last many centuries. Thick limbs anchor it to the ground during its resting period, and new limbs slowly grow, working their way down to burrow into the ground. These creatures rarely see each other and are specially equipped with the ability to produce their own fertilized eggs, so that they may reproduce without having to find a mate.

When they do pick up and move, other creatures move with them whether they want to relocate or not! Living islands help distribute many species throughout the land, increasing biodiversity. (If only they moved more often, I could make my home here and do all my exploring from my own backyard!)

Materials

acid-free art paper

eraser

pencil

1 SKETCH THE BASIC SHAPE
Draw a rectangular shape for the head and a long oval shape that tapers at the end to form the tail.

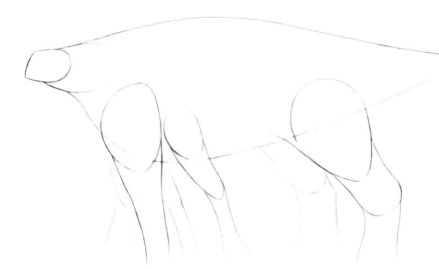

2 BLOCK IN LIMBS
Draw a series of cylinders and ovals to create the limbs.

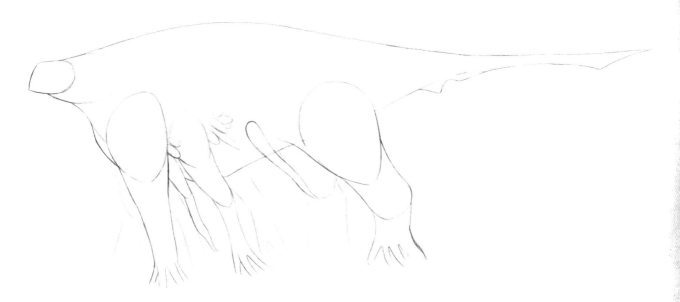

3 ADD TOES AND NEW LIMBS

Sketch long, root-like toes at the bottom of each leg. Draw some shorter, thinner, tentacle-like limbs branching off from the body. Add oval-shaped buds of new limbs forming behind the first and second legs.

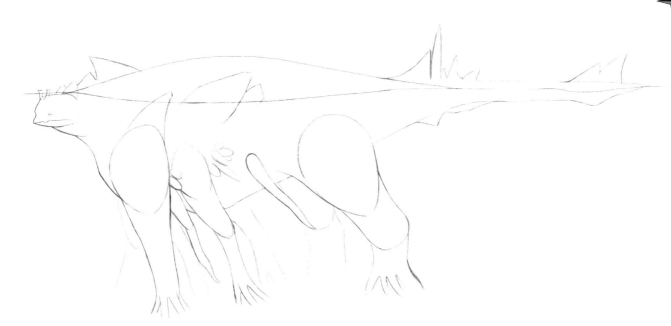

4 DRAW THE WATER LINE AND BLOCK IN UPPER-BODY FEATURES

Draw in the water line around the top of the creature's back. Block in the details of the face including closed eyes, a line for the mouth, and long nostrils on stalks reaching up out of the water. Block in the rock-like bony protrusions coming off of the island's back and tail.

DRAW TREES AND ROCKS

Every living island has a different appearance. Various sizes and shapes of trees and plants will grow on its back, depending on the region it's slumbering in. Rocky structures on its body may grow large or erode. Unique animals might colonize the creature's body. Draw whatever features you like to make your living island your own. Here are some quick tips for drawing basic rocks and trees to detail your creature with.

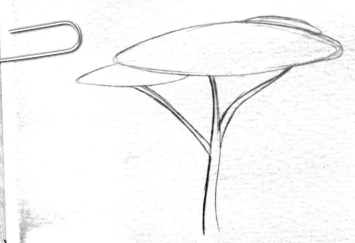

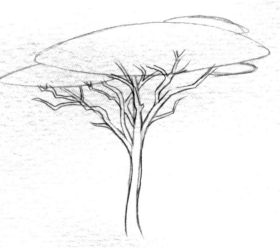

1 SKETCH THE TRUNK AND BLOCK IN THE CANOPY
Sketch a simple trunk splitting off in a couple directions. Draw long, flat ovals to block in the shapes of the canopy.

2 SPLIT THE TRUNK AND ADD BRANCHES
Split each part of the trunk into progressively smaller and smaller branches. Make the branches skinnier as you move up the trunk, with those farthest at the top of the tree looking very twig-like. Make sure the branches twist and turn. Very few trees have branches that look straight.

3 SKETCH THE CANOPY AND FINISH WITH SHADING
Sketch in the canopy of the tree using loose, scribbly shapes. Don't attempt to draw individual leaves, especially since we are seeing this tree at a distance. Treat the tree as a shape with a top and bottom plane. Show the form of clumps of foliage by shading the underside, and leaving the top light where the sunlight would illuminate it. Add birds if you desire.

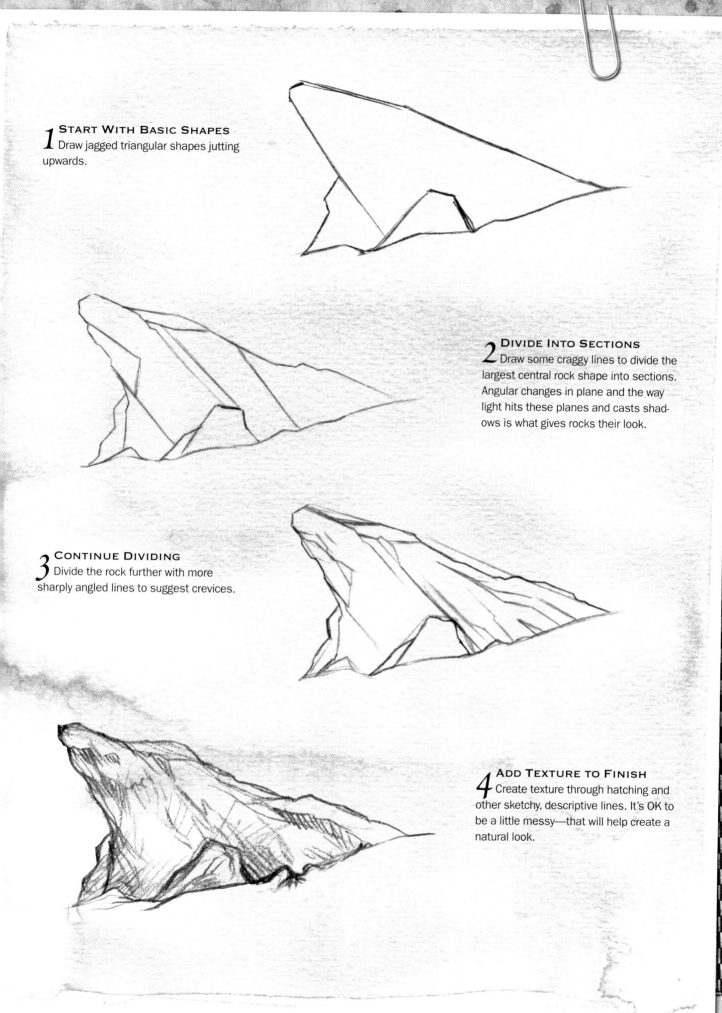

1 START WITH BASIC SHAPES
Draw jagged triangular shapes jutting upwards.

2 DIVIDE INTO SECTIONS
Draw some craggy lines to divide the largest central rock shape into sections. Angular changes in plane and the way light hits these planes and casts shadows is what gives rocks their look.

3 CONTINUE DIVIDING
Divide the rock further with more sharply angled lines to suggest crevices.

4 ADD TEXTURE TO FINISH
Create texture through hatching and other sketchy, descriptive lines. It's OK to be a little messy—that will help create a natural look.

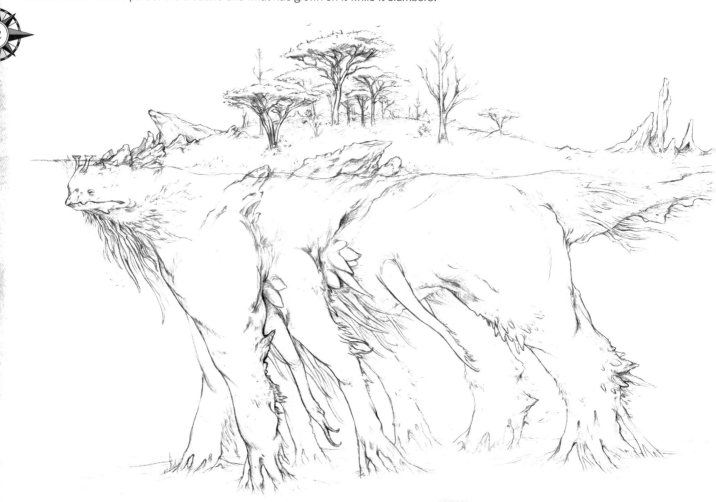

5 REFINE THE BODY

Make sure the anatomy, while strange and plant-like, looks like it can function to allow the creature to walk when it finally does decide to move. Make your lines soft and organic. Add details that look like a cross between animal and plant parts. It should be difficult to tell what is part of the creature and what has grown on it while it slumbers.

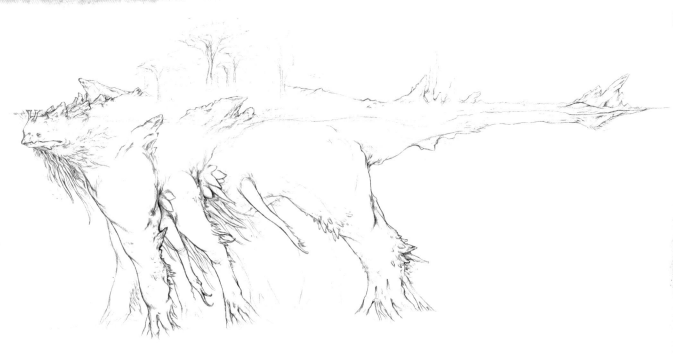

6 CONTINUE REFINING DETAILS

Trace over and darken the pencil lines you like, bringing them forward and popping them out from the background. Go wild adding any details you like on the creature's back and its underwater underside. Your drawing of this creature can be all your own, sporting any forms you can imagine: rocky horns, bumps, plant-like growths, colonies of coral. The details are up to you.

7 ADD TEXTURE AND FINAL DETAILS

Use varying line weight to help bring overlapping features forward and make parts closer to us stand out from those in the background. Lightly shade in the limbs farthest away, but keep the outlines soft so they appear to recede in space. Make sure he looks like he's rooted to the sandy lake bottom by his tree-like toes. Finish off this mini-ecosystem by adding any other touches you like.

IT'S ALL RELATIVE: SHOWING SCALE

The best way to show scale is to position a familiar object next to your fantasy creature. The size of that object relative to the size of the creature instantly creates a sense of scale. One of the best markers to help show scale is a human figure, since we are all so familiar with the size of an average person.

Size and shape variety can also show scale. Creating overlapping layers of sizes and shapes shows how they relate in proportion to one another. Drawing forms leading from big to small, thick to thin, less detailed to more detailed can also emphasize scale.

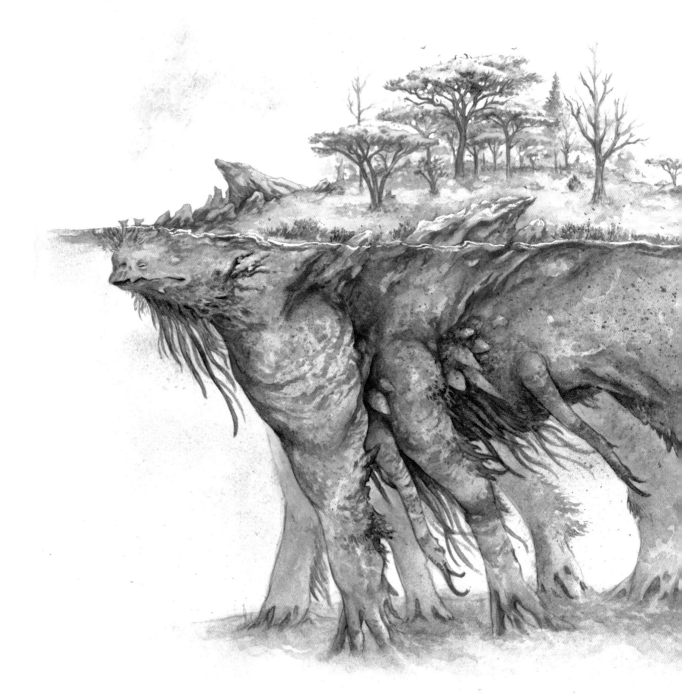

Living Island
18.5" × 12" (47cm × 30cm)
Surface: 140-lb. (300gsm) cold-pressed watercolor paper
*Gouache pigments: Alizarin Crimson, Burnt Sienna, Burnt Umber, Cerulean
Blue, Cobalt Blue, Lemon Yellow, Olive Green, Permanent Green Middle,
Permanent Yellow Deep, Raw Umber, Ultramarine, Yellow Ochre*

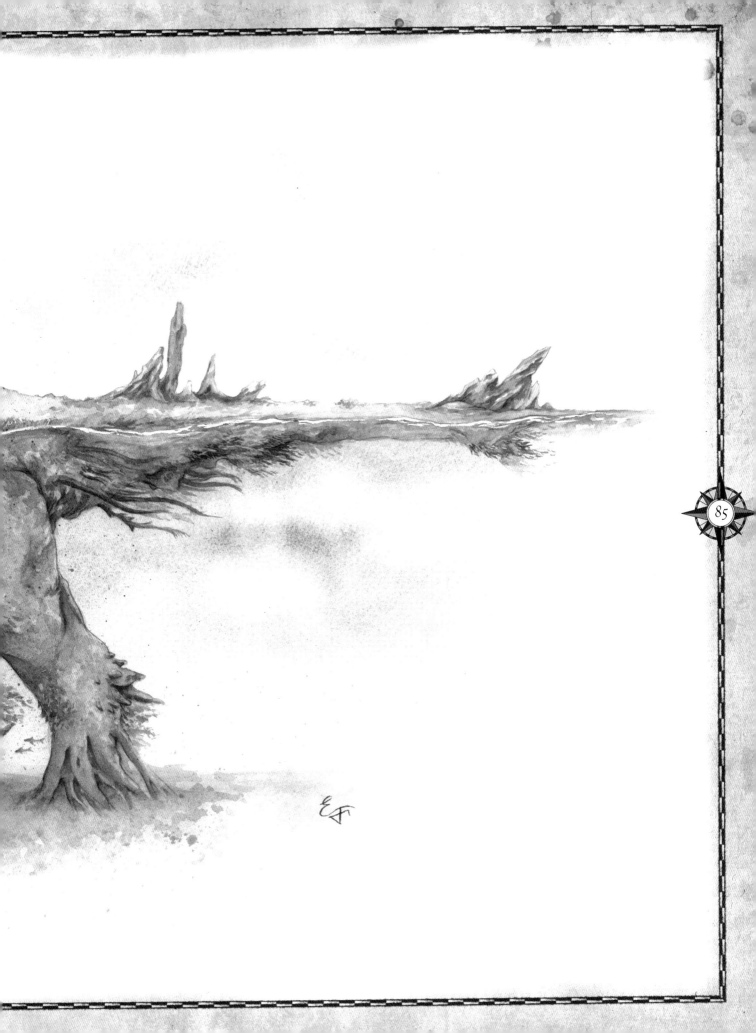

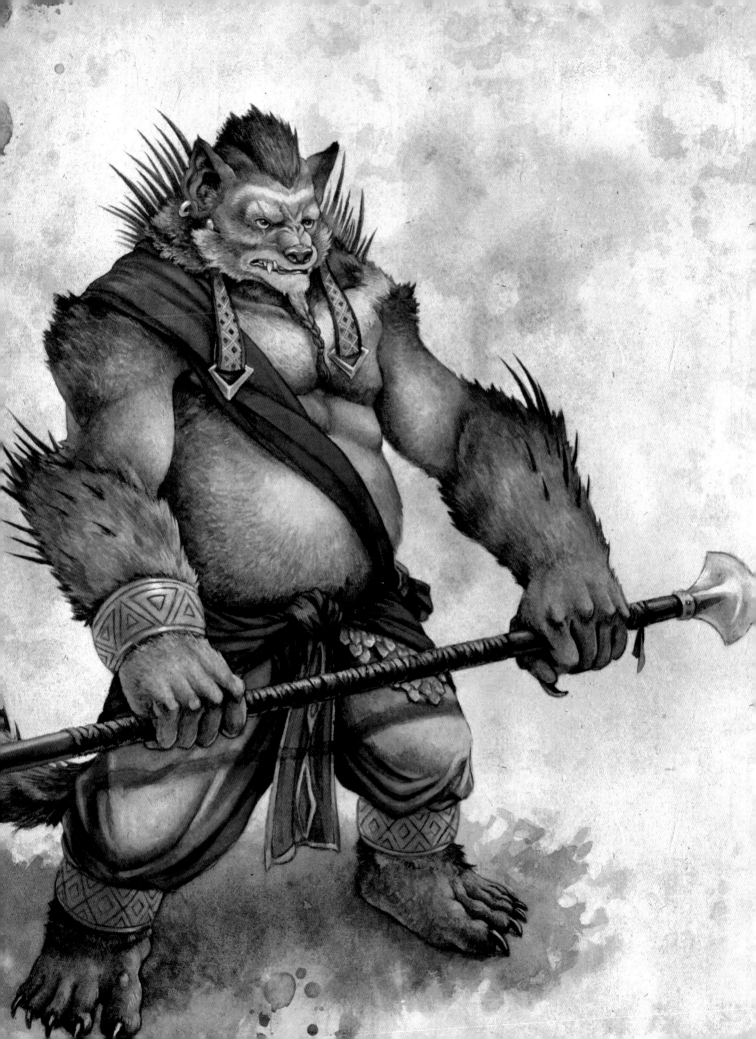

CHAPTER FIVE
Creatures of the Land

Creatures that live, graze and hunt on land are often those we are most familiar with. From reptiles to birds to mammals, many beasts make their homes here. The landscape offers a wide range of climates and habitats to explore. Herds of magnificent Ibak gallop across vast plains of tall grasses. The majesty of lush forests teem with creatures great and small. Dragons bask, content in the forbidding heat of the desert. You'll find much to explore and much to learn from here. Put on your running shoes in case we come upon some tough customers. I never said all these creatures were friendly!

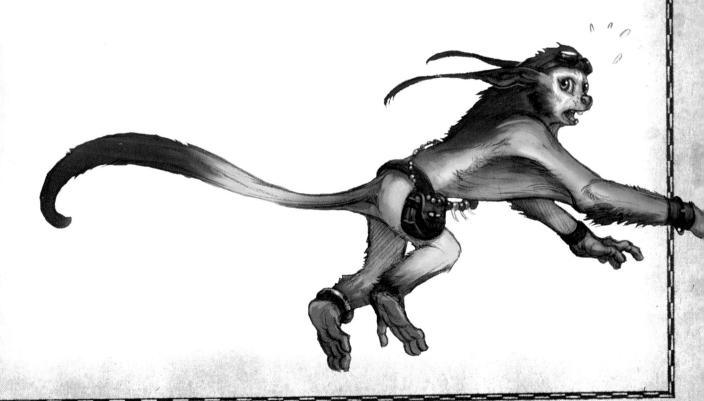

DRAW A VENOM-SPITTING SAND DRAGON

This dragon lives in rocky and sandy desert areas. Its broad body shape and the spines on its back help it to soak up the sun and conserve heat. The hump on its back is made of fat, like a camel's, and helps it survive during long stretches without food or water. The large front feet and claws are excellent for digging into the earth. Broad scales and spikes on the legs help to deflect sand and dirt, and the smaller hind legs and flat tail help move debris behind the dragon as it burrows. Spikes on the throat and spines on the head are used for display, and the throat can inflate as an impressive defense mechanism. Glands inside the throat produce the toxic venom the dragon spits at its enemies or uses to immobilize prey.

Materials

acid-free art paper

eraser

pencil

1 START WITH AN ACTION LINE
Draw a bold line of action. Make your lines as relaxed as possible while roughing out the dragon's form. Sketch a teardrop shape for the dragon's body. Make a box for the head and connect it to the body.

2 BLOCK IN THE FORM
Block in the dragon's form using basic shapes. Draw an oval for the dragon's midsection. Use oval and cylinder shapes to form the legs and tail. Space the legs widely apart to give the dragon a low center of gravity and to support his bulk.

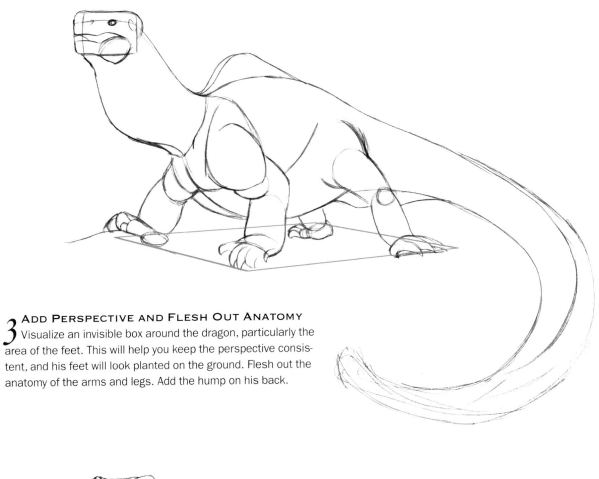

3 ADD PERSPECTIVE AND FLESH OUT ANATOMY

Visualize an invisible box around the dragon, particularly the area of the feet. This will help you keep the perspective consistent, and his feet will look planted on the ground. Flesh out the anatomy of the arms and legs. Add the hump on his back.

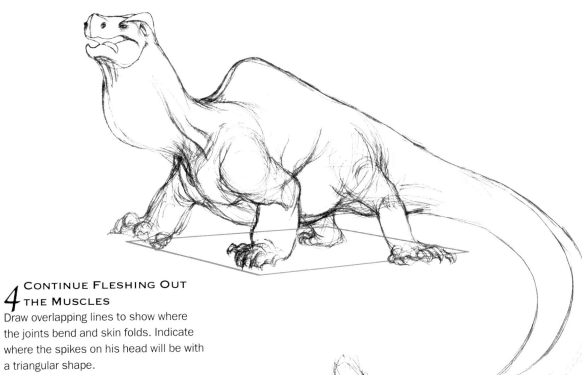

4 CONTINUE FLESHING OUT THE MUSCLES

Draw overlapping lines to show where the joints bend and skin folds. Indicate where the spikes on his head will be with a triangular shape.

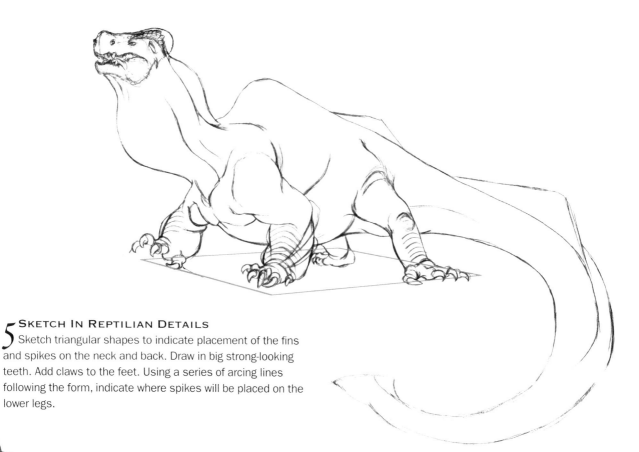

5 SKETCH IN REPTILIAN DETAILS

Sketch triangular shapes to indicate placement of the fins and spikes on the neck and back. Draw in big strong-looking teeth. Add claws to the feet. Using a series of arcing lines following the form, indicate where spikes will be placed on the lower legs.

A TRUSTY TOME

If you plan to make a habit of drawing creatures, it's very helpful to have an animal anatomy reference book to refer to. My favorite is *Cyclopedia Anatomicae* by György Fehér and András Szunyoghy. This book not only shows skeletal and muscle anatomy for humans and many animals species, but it also shows comparisons between the anatomy of those animal species and humans.

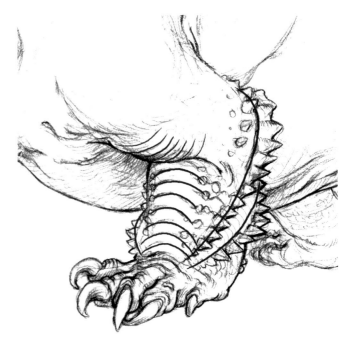

6 ADD SPIKES AND ARMOR PLATING

Draw in spikes along the edge of the leg and elbow, using the lines you sketched previously as a guide. Draw armor plating on the front of the foreleg the same way. These details help give the leg volume and make it look thick and powerful.

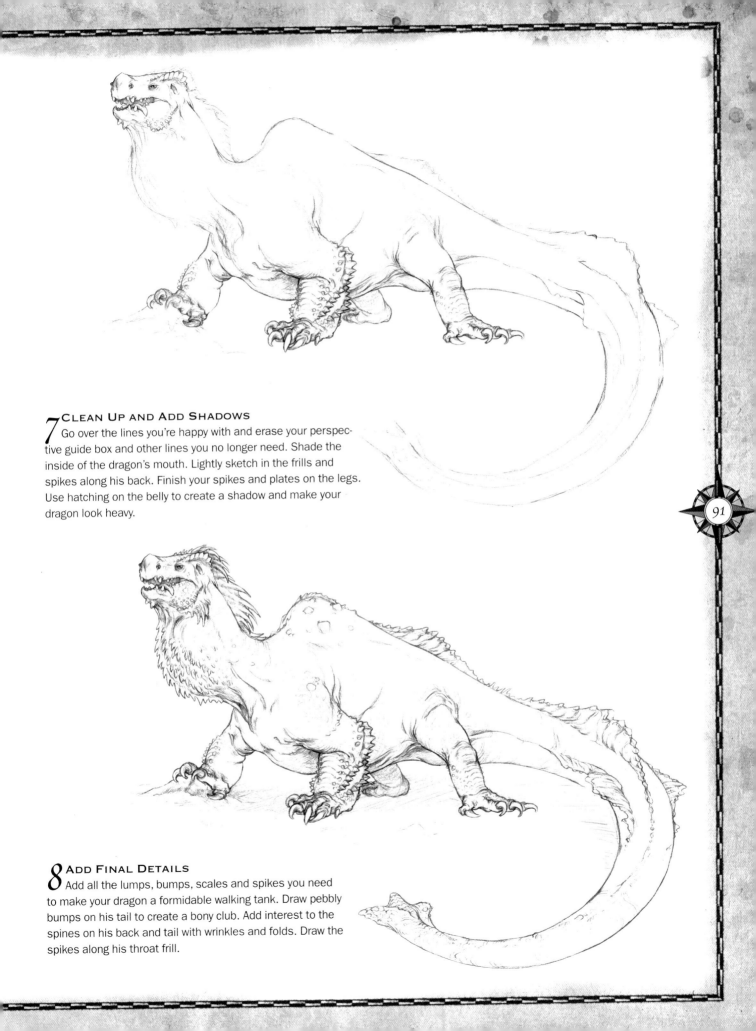

7 CLEAN UP AND ADD SHADOWS

Go over the lines you're happy with and erase your perspective guide box and other lines you no longer need. Shade the inside of the dragon's mouth. Lightly sketch in the frills and spikes along his back. Finish your spikes and plates on the legs. Use hatching on the belly to create a shadow and make your dragon look heavy.

8 ADD FINAL DETAILS

Add all the lumps, bumps, scales and spikes you need to make your dragon a formidable walking tank. Draw pebbly bumps on his tail to create a bony club. Add interest to the spines on his back and tail with wrinkles and folds. Draw the spikes along his throat frill.

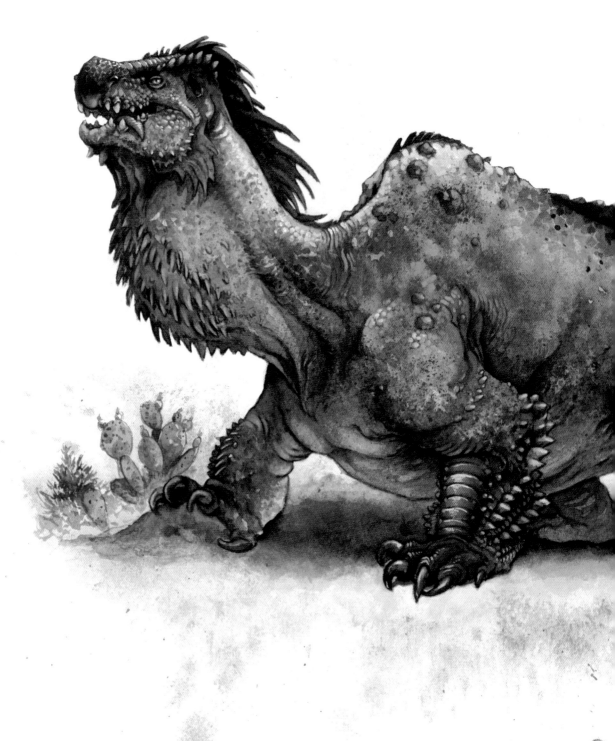

Venom-Spitting Sand Dragon
16.25" × 12" (41cm × 30cm)
Surface: 140-lb. (300gsm) cold-pressed watercolor paper
Gouache pigments: Alizarin Crimson, Burnt Sienna, Burnt Umber, Cerulean Blue, Cobalt Blue, Lemon Yellow, Olive Green, Permanent Yellow Deep, Raw Umber, Scarlet Lake, Spectrum Red, Ultramarine, Yellow Ochre, Zinc White

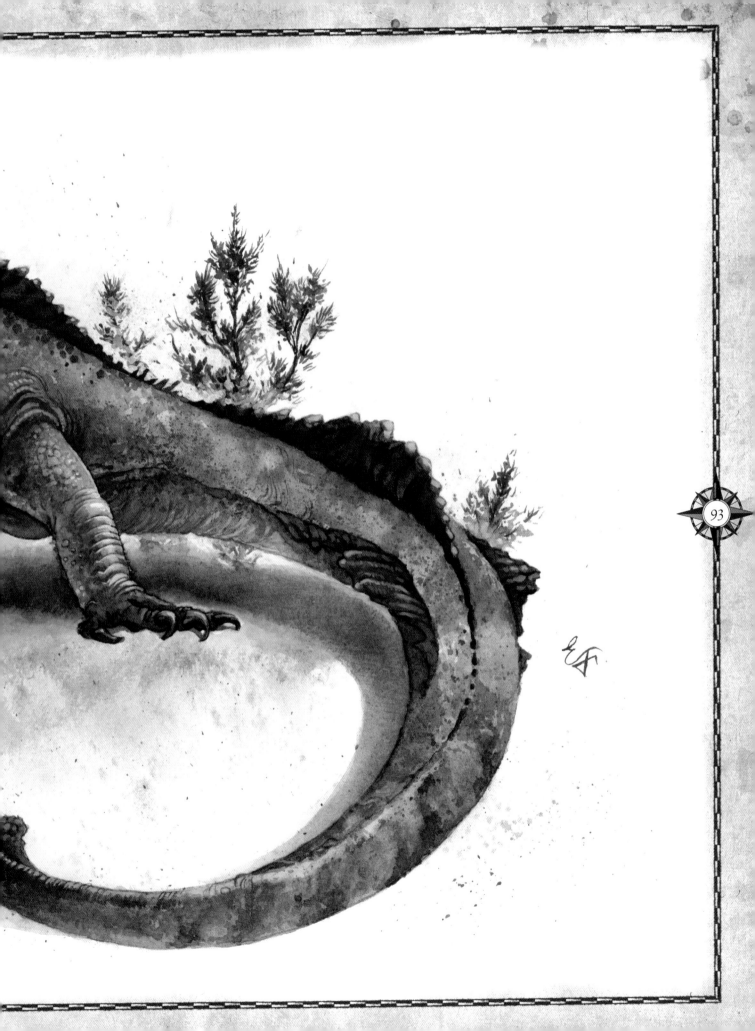

Exploring Uncharted Territory
DRAW A FOREST BEHEMOTH

True to its name, the forest behemoth is a colossal herbivore that makes its home in forests with equally gargantuan trees. These bulky creatures stretch their long necks up into the canopy to feed on leafy branches and twigs. Strong teeth and a tough hide allow them to chew even the toughest and thorniest branches. Food is stored in the crop and regurgitated for rumination and for calves that cannot reach the treetops to feed. Behemoths live in small family groups dominated by females. Because they must eat a lot of food to support their massive size, they migrate from food source to food source. Both males and females possess bony plates on top of the nose and head which males clash together at mating season to win the favor of females. Behemoths have no predators and are threatened only by the destruction of their habitat.

Materials

acid-free art paper

eraser

pencil

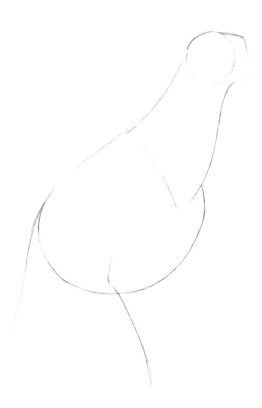

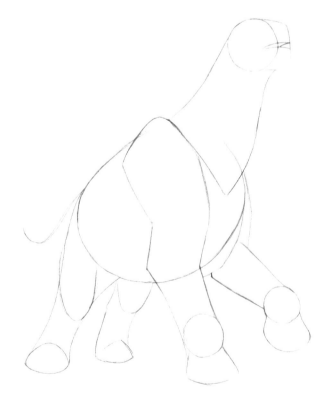

1 SKETCH A GESTURE DRAWING
Begin your drawing with a circle for the head and a sweeping line down to the ground plane. This will become the behemoth's spine. Block in the heavy mass of the body with an oval shape.

2 BLOCK IN FORMS WITH BASIC SHAPES
Sketch in the behemoth's limbs using basic shapes. Keep the forms bulky and thick. Draw through to keep track of where everything fits together.

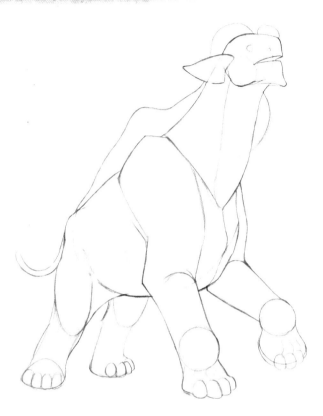

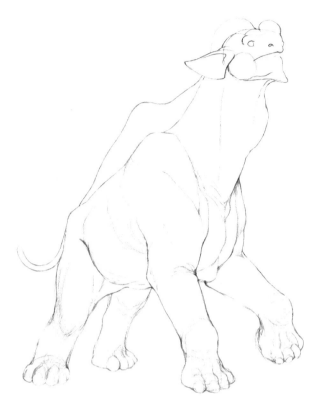

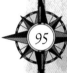

3 BLOCK IN FACIAL FEATURES AND GIVE SHAPES DIMENSION

Block in the facial features and add detail to the basic forms. Indicate a centerline for the chest, which helps show the roundness of the body. Overlap your shapes to help add three-dimensional form to your behemoth.

4 DEFINE MUSCLE ANATOMY AND REFINE SHAPES

Sketch in the muscle anatomy of the upper arms and shoulders. Refine the shapes of your lines throughout the drawing so your behemoth takes on a more natural appearance. Sketch in wrinkles and skin folds, especially around joints, to give the appearance of loose, leathery skin.

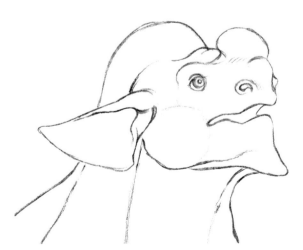

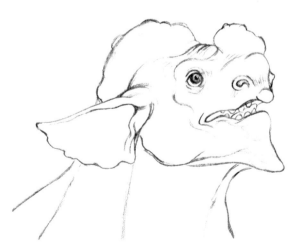

5 FOCUS ON THE FACE

Now that the facial features are in place, begin drawing in the details. Refine the shape of the mouth, including the fleshy tip of the upper lip. Draw an iris and pupil to add life to the eyes.

6 CONTINUE WITH DETAILS

Continue to detail your behemoth's face by drawing wrinkles around the ear and jawline. Draw in the bony areas of the cheekbone, eye sockets and chin. Refine the shapes of the bony growths on the head and nose.

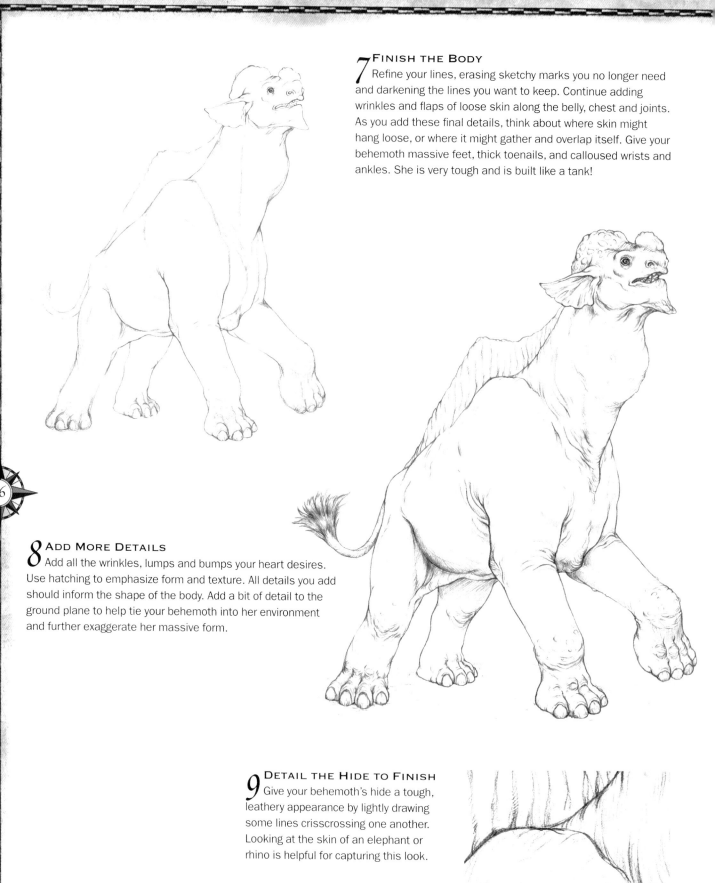

7 FINISH THE BODY

Refine your lines, erasing sketchy marks you no longer need and darkening the lines you want to keep. Continue adding wrinkles and flaps of loose skin along the belly, chest and joints. As you add these final details, think about where skin might hang loose, or where it might gather and overlap itself. Give your behemoth massive feet, thick toenails, and calloused wrists and ankles. She is very tough and is built like a tank!

8 ADD MORE DETAILS

Add all the wrinkles, lumps and bumps your heart desires. Use hatching to emphasize form and texture. All details you add should inform the shape of the body. Add a bit of detail to the ground plane to help tie your behemoth into her environment and further exaggerate her massive form.

9 DETAIL THE HIDE TO FINISH

Give your behemoth's hide a tough, leathery appearance by lightly drawing some lines crisscrossing one another. Looking at the skin of an elephant or rhino is helpful for capturing this look.

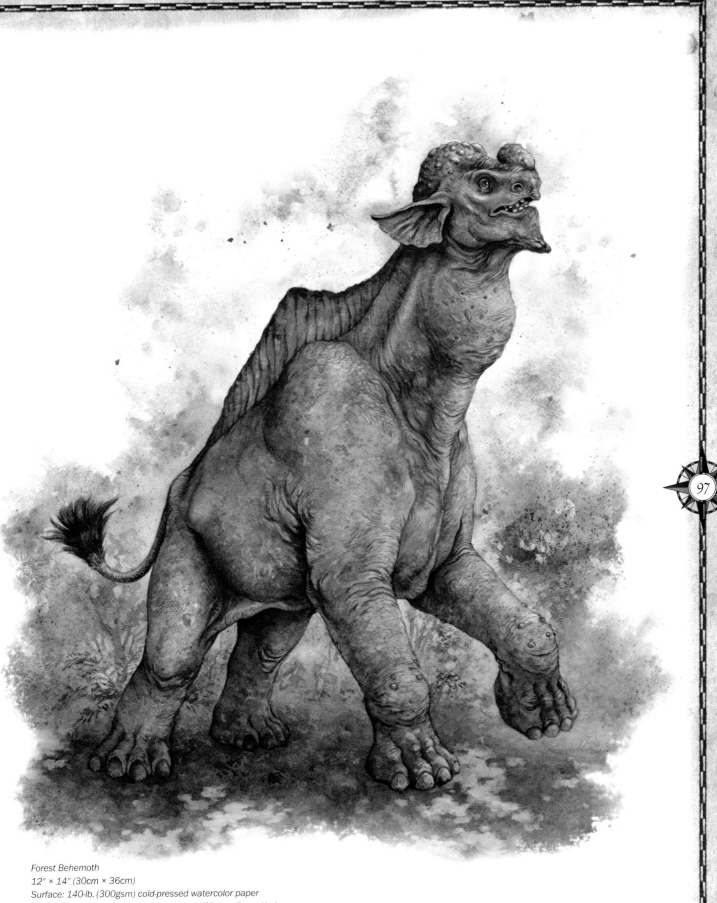

Forest Behemoth
12" × 14" (30cm × 36cm)
Surface: 140-lb. (300gsm) cold-pressed watercolor paper
Gouache pigments: Alizarin Crimson, Burnt Sienna, Burnt Umber,
Cerulean Blue, Cobalt Blue, Lemon Yellow, Olive Green, Permanent Green
Middle, Prussian Blue, Raw Umber, Spectrum Red, Ultramarine, Yellow Ochre,
Zinc White

Exploring Uncharted Territory
DRAW A CROWNED IBAK

This elegant creature lives on vast, grassy plains, where it grazes in herds. Named for the large curving horns gracing the top of its head, the Crowned Ibak can run at high speeds, and its broad chest and large sternum add extra lung capacity allowing it the stamina to run long distances. Flexible toe pads provide a large surface area adapted to running on both soft and hard ground. Both male and female Ibak have a crown of horns, but the male sports a pair of fleshy wattles on his chin. Due to its intelligence, speed and gentle disposition, the Ibak has been domesticated by people for riding for hundreds of years.

Materials

acid-free art paper

eraser

pencil

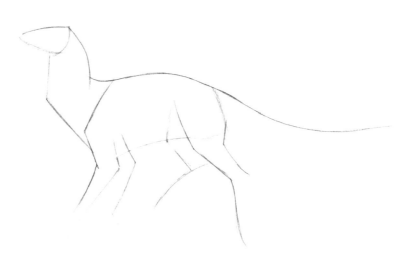

1 SKETCH A GESTURE DRAWING
Start with a triangle shape for the head. Draw a curved line for the back of the neck, leading into a long, flowing line that doubles as the spine and the action line representing the flow of the pose. Block in some bold, angular lines for the legs. This will be a trotting pose.

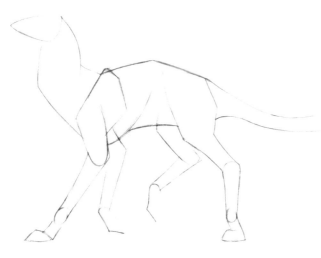

2 BLOCK IN THE BODY
Emphasize strong angles in the shape and position of the legs to add interest and action to the pose. Pay special attention to focal points of surface anatomy such as the shoulder blade, knee and ankle joints. Indicating these will help you to add details while keeping track of the underlying anatomy. Draw the legs to be long and slender to emphasize this creature's speed and elegance.

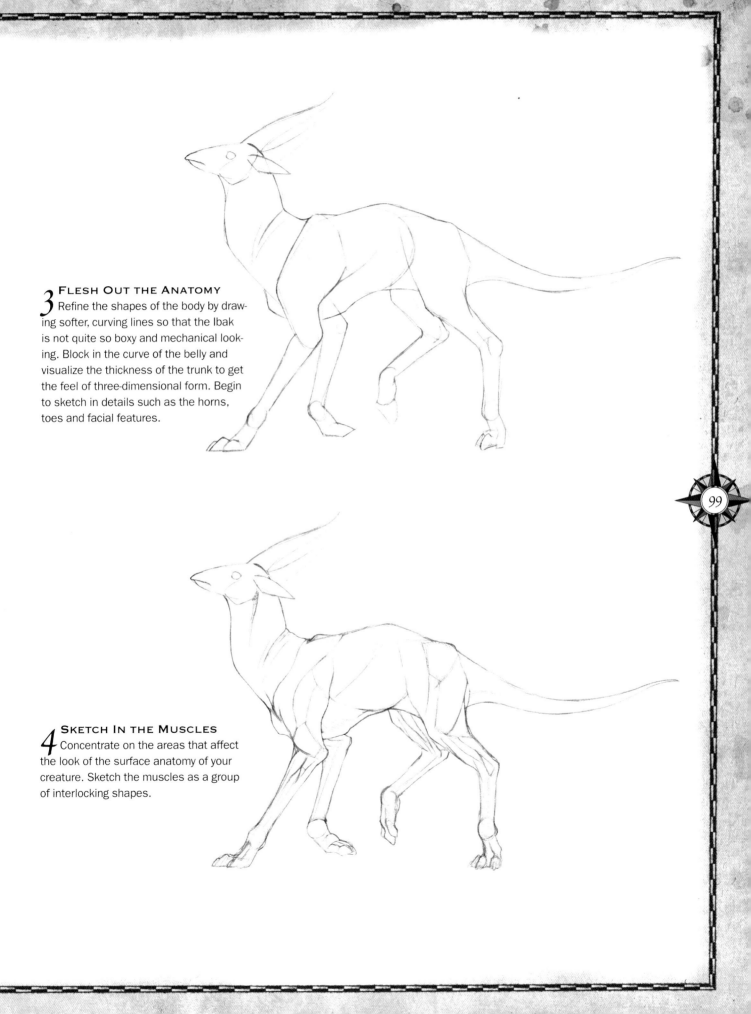

3 FLESH OUT THE ANATOMY

Refine the shapes of the body by drawing softer, curving lines so that the Ibak is not quite so boxy and mechanical looking. Block in the curve of the belly and visualize the thickness of the trunk to get the feel of three-dimensional form. Begin to sketch in details such as the horns, toes and facial features.

4 SKETCH IN THE MUSCLES

Concentrate on the areas that affect the look of the surface anatomy of your creature. Sketch the muscles as a group of interlocking shapes.

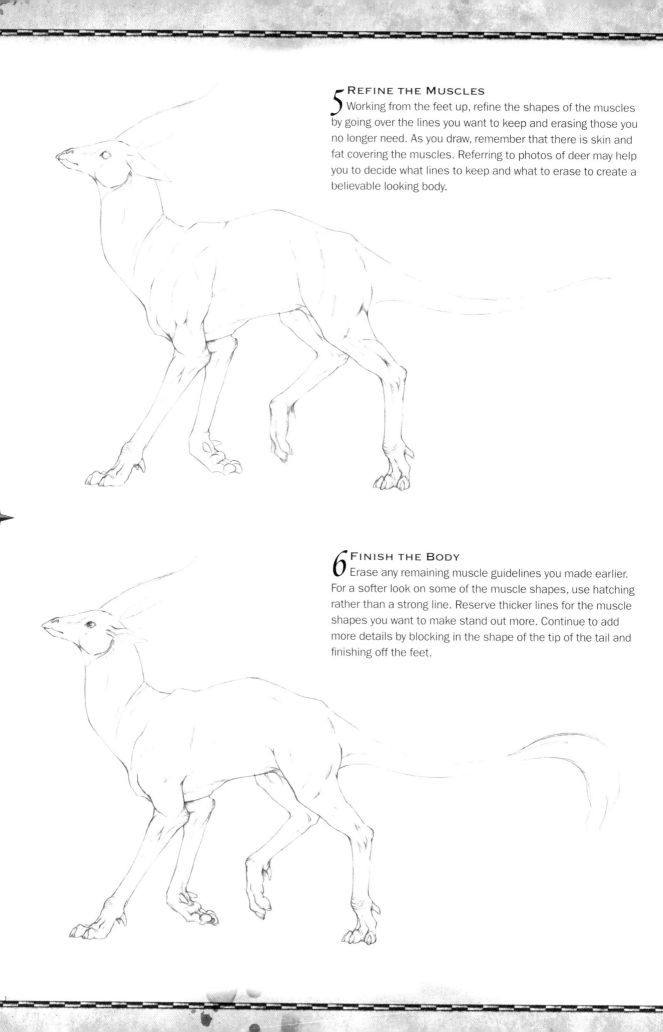

5 REFINE THE MUSCLES
Working from the feet up, refine the shapes of the muscles by going over the lines you want to keep and erasing those you no longer need. As you draw, remember that there is skin and fat covering the muscles. Referring to photos of deer may help you to decide what lines to keep and what to erase to create a believable looking body.

6 FINISH THE BODY
Erase any remaining muscle guidelines you made earlier. For a softer look on some of the muscle shapes, use hatching rather than a strong line. Reserve thicker lines for the muscle shapes you want to make stand out more. Continue to add more details by blocking in the shape of the tip of the tail and finishing off the feet.

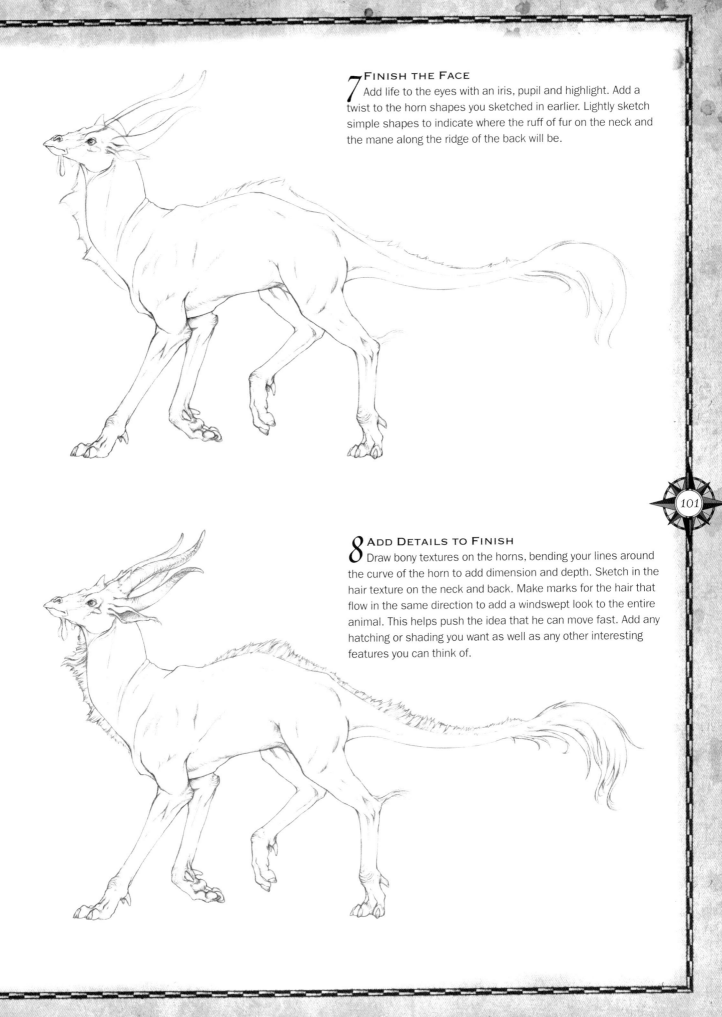

7 FINISH THE FACE

Add life to the eyes with an iris, pupil and highlight. Add a twist to the horn shapes you sketched in earlier. Lightly sketch simple shapes to indicate where the ruff of fur on the neck and the mane along the ridge of the back will be.

8 ADD DETAILS TO FINISH

Draw bony textures on the horns, bending your lines around the curve of the horn to add dimension and depth. Sketch in the hair texture on the neck and back. Make marks for the hair that flow in the same direction to add a windswept look to the entire animal. This helps push the idea that he can move fast. Add any hatching or shading you want as well as any other interesting features you can think of.

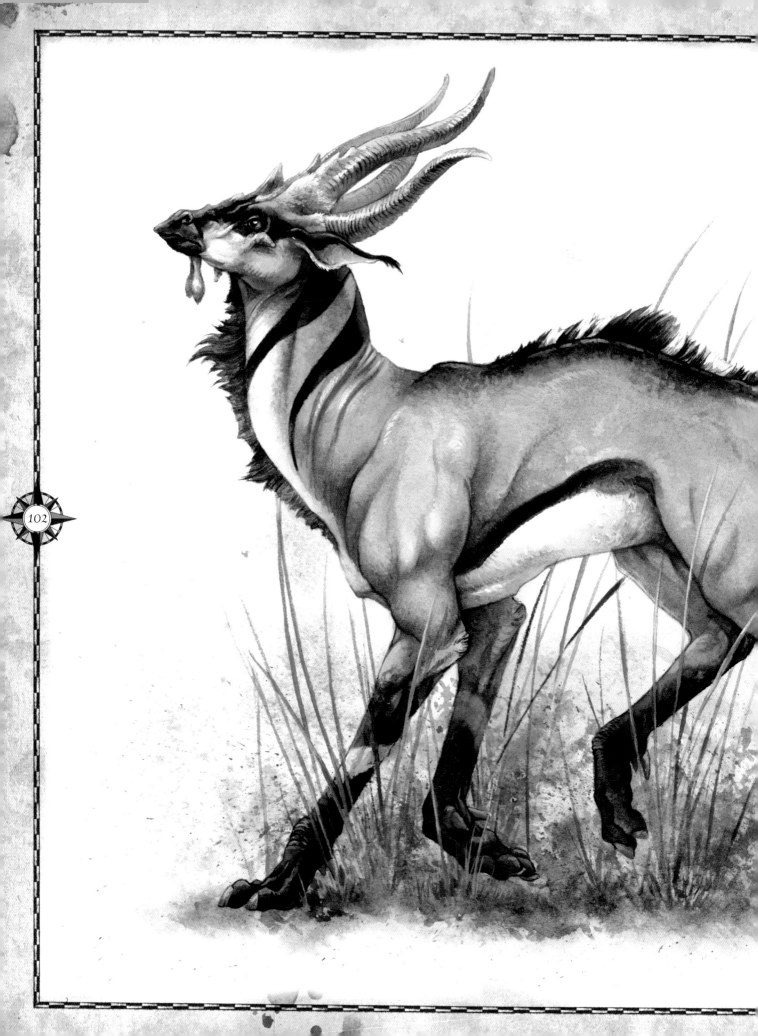

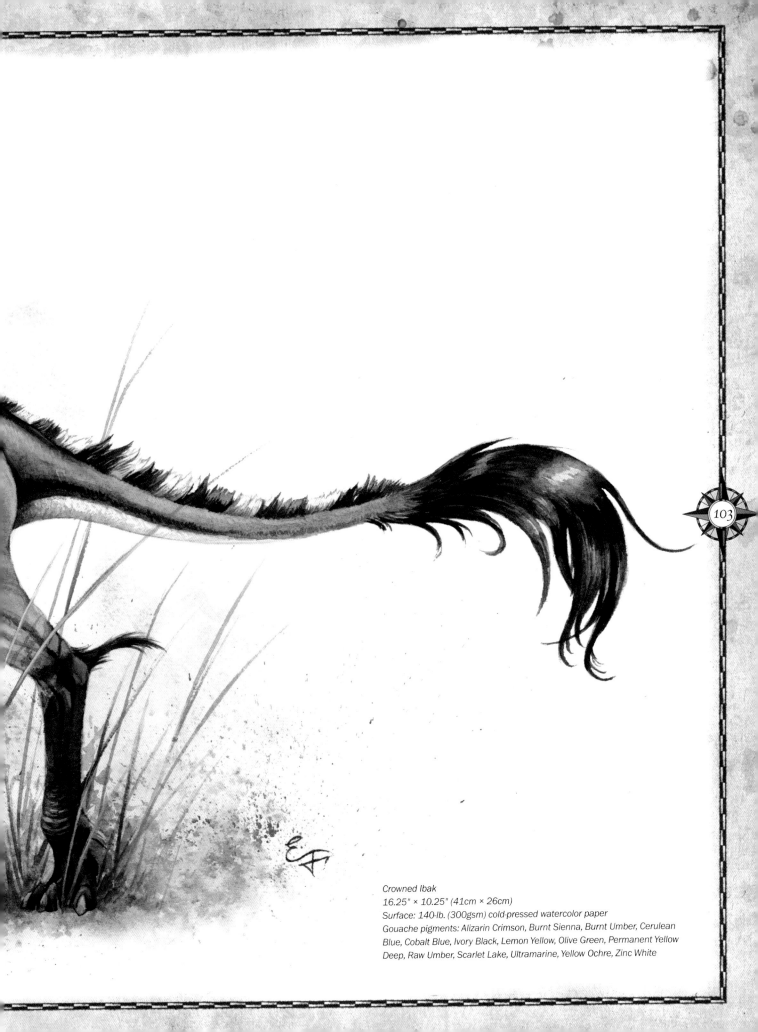

Crowned Ibak
16.25" × 10.25" (41cm × 26cm)
Surface: 140-lb. (300gsm) cold-pressed watercolor paper
Gouache pigments: Alizarin Crimson, Burnt Sienna, Burnt Umber, Cerulean Blue, Cobalt Blue, Ivory Black, Lemon Yellow, Olive Green, Permanent Yellow Deep, Raw Umber, Scarlet Lake, Ultramarine, Yellow Ochre, Zinc White

Costumes and Accessories

When designing a creature and a rider, the two should go together hand in hand. Costume details on a rider can be echoed throughout the accoutrements on the creature. Repeating shapes and design motifs are good ways to achieve a matching set.

Function First!

A saddle should make sense when fitted on the animal. Think about where on the creature the rider sits, and how she would be positioned. Keep in mind the size of the rider compared to the size of the creature, and design a seat that will reflect that.

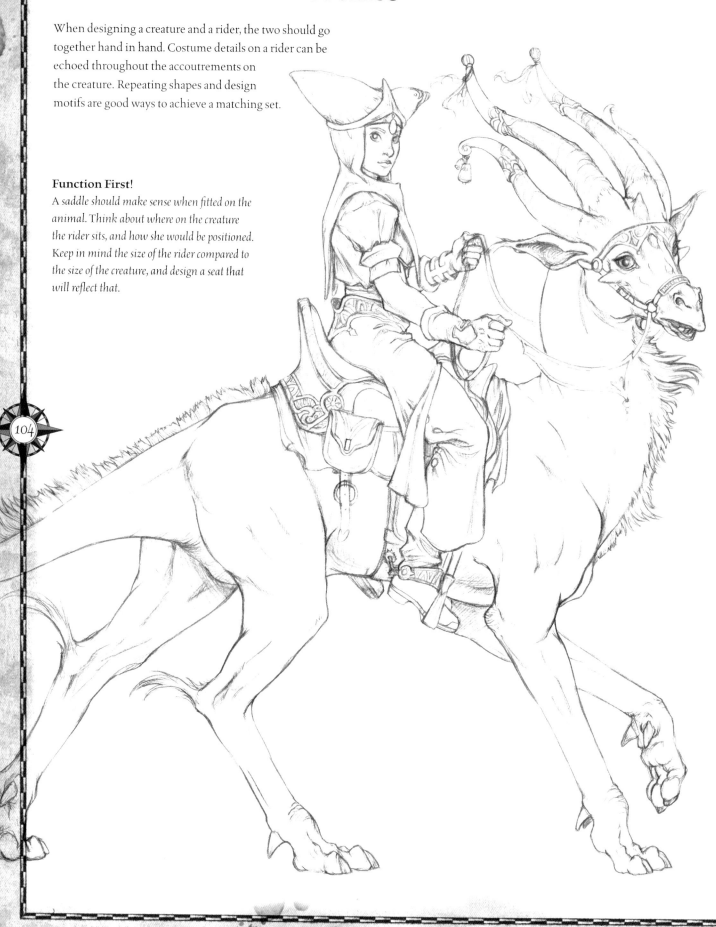

Drapery

Drapery is one of the trickiest things to draw, and takes lots of practice to get all of the folds and wrinkles right. The best way to learn is to draw from photo reference or life studies. In time, you will start to see patterns surrounding the way fabric falls over a body.

Think about the type of material you're drawing. Different types of fabric will drape and fold differently. Thicker or stiffer fabrics tend to form larger folds, while thinner fabrics will form a number of smaller, tightly spaced wrinkles. Keep in mind the way the clothing is worn. Is it tight and form-fitting or loose and billowy?

Consider How the Rider Communicates With Her Companion

Can they communicate solely through voice commands and body language, or is a bit, reins or other equipment required? Think about other useful items a rider might carry on her journey.

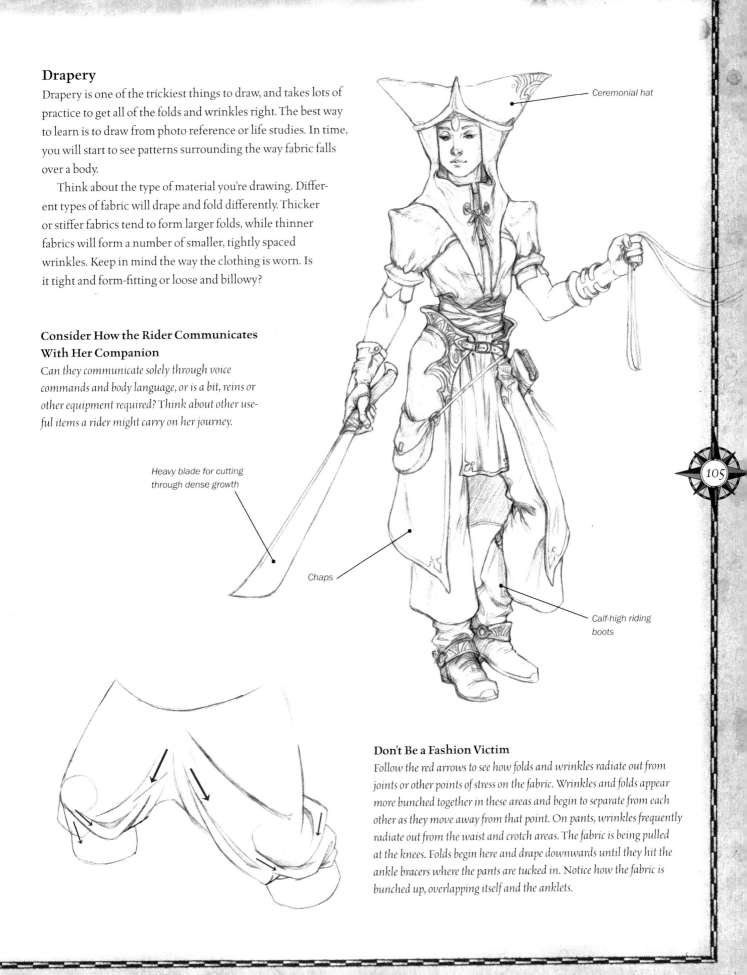

Ceremonial hat

Heavy blade for cutting through dense growth

Chaps

Calf-high riding boots

Don't Be a Fashion Victim

Follow the red arrows to see how folds and wrinkles radiate out from joints or other points of stress on the fabric. Wrinkles and folds appear more bunched together in these areas and begin to separate from each other as they move away from that point. On pants, wrinkles frequently radiate out from the waist and crotch areas. The fabric is being pulled at the knees. Folds begin here and drape downwards until they hit the ankle bracers where the pants are tucked in. Notice how the fabric is bunched up, overlapping itself and the anklets.

Weapons

One important element to fantasy costumes is frequently the weapon. Practically everyone in fantasy is on some kind of epic quest, right? Well, they need something to fight with and to protect themselves along the way, especially if they aren't as formidable a creature as a dragon.

Just remember that not all characters can lift something that looks more like a giant slab of iron than a sword. Make sure the type and size of weapon you bestow upon your creature or character fits not only his or her physique, but also their fighting style and personality.

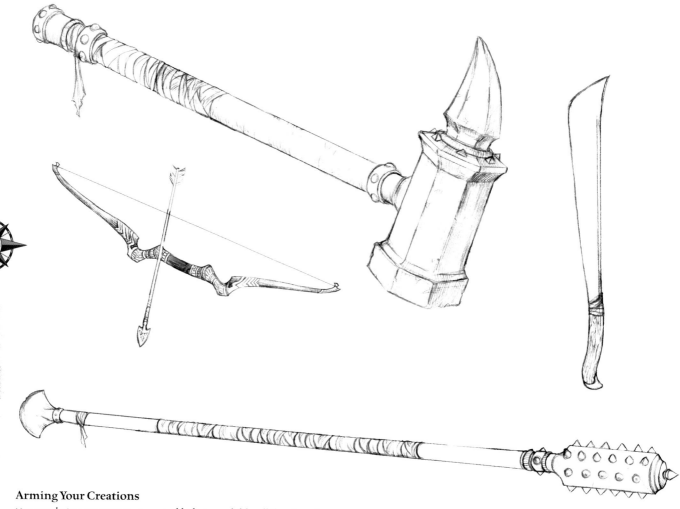

Arming Your Creations

You can design any weapon imaginable, but, much like all the other elements we've discussed, it's often more believable if your design originates from a weapon used in the real world. Look at the shape, structure or purpose of historical weapons, and use that as inspiration. Then use your imagination to exaggerate size, come up with new shapes, or elaborate decoration to create your own unique weaponry.

Accessorize Away!
DRAW A SADDLE

There are many types of riding saddles. This saddle is very similar to a western style saddle. Look at saddles used on different animals and from cultures around the world to see how the shape and structure differs from saddle to saddle.

Materials

acid-free art paper

eraser

pencil

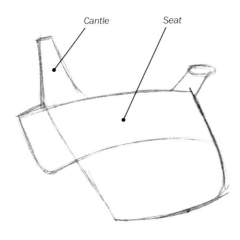

Cantle *Seat*

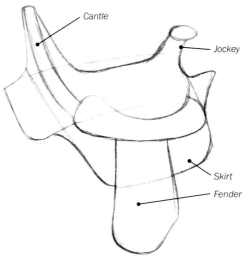

Cantle

Jockey

Skirt

Fender

1 **BLOCK IN THE SADDLE**
Use basic shapes overlapping one another. Draw a rectangular shape in the middle to form the seat. Draw a triangular shape in back to form the cantle.

2 **ADD THE SKIRT AND FENDER**
Refine and round off the simple shapes you drew. Sketch in the skirt and fender which the rider's leg rests against while the foot is in the stirrup. Draw in the edge of the cantle and bring it down to connect to the jockey.

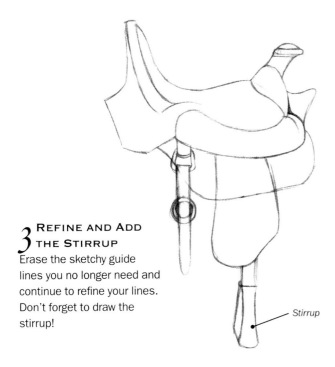

Stirrup

3 **REFINE AND ADD THE STIRRUP**
Erase the sketchy guide lines you no longer need and continue to refine your lines. Don't forget to draw the stirrup!

4 **ADD DETAILS**
Add details such as colorful patterns embossed into the leather. Echoing your designs in the costume of the rider or other equipment for your creature is a plus.

Exploring Uncharted Territory
DRAW A MARMOKEN WARRIOR

These powerful beings live in higher elevations of mountainous and forested regions. The Marmoken live in close-knit family clans forming a complex society that emphasizes creativity through art and storytelling, with favorite subjects being epic tales of hunting and courageous quests. Their strong, stocky build and thick fur make them adept at surviving the tough wilderness surrounding their home. Their natural features, which include powerful claws and teeth and sharp quills, make them fearsome opponents. While they would be efficient enough fighters without them, the Marmoken warriors prefer to manufacture their own finely crafted weapons for battle. They choose to live peacefully but can be fearsome when attacked or provoked.

Materials

acid-free art paper

eraser

pencil

straightedge

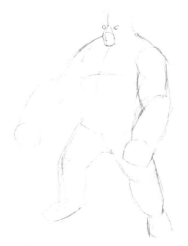

1 SKETCH A GESTURE DRAWING
Draw an oval shape for the head, marked with the centerline and the eye line for placing the features. Sketch in the curving action line where the center of the body will be. The most important part of this step is infusing the feeling of power in the gesture by keeping your shapes big and bold.

2 BUILD UP THE FORM
Continue to build up the form of the Marmoken using big, rounded shapes. It's OK to keep everything sketchy at this stage. Form the muzzle on his face, keeping in mind where the centerline of the head is.

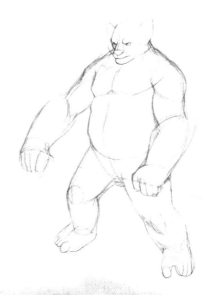

3 FLESH OUT MUSCLES AND BLOCK IN FACIAL FEATURES
Use interlocking bubble shapes to form the muscles, but make them look strong rather than squishy. Begin to detail the hands and feet. Use circle shapes to indicate the form of the knuckles and draw lines to divide each mass into fingers and toes. Draw a straight line between his hands to indicate the weapon he will be holding. Block in the features of his face over the top of the muzzle form you drew in the previous step.

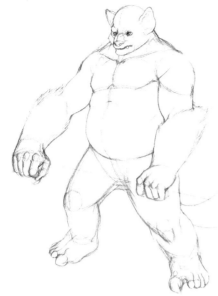

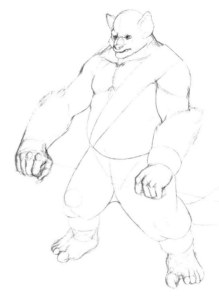

4 GIVE HIM A SNARL AND A TAIL

Sketch in V-shaped wrinkles to form a furrowed brow and crumpled nose. Pull back his lip to reveal some sharp teeth underneath. Bulk up the fingers and toes to emphasize their size and strength. Block in a tail. Erase any sketch lines you no longer need.

5 ADD CLOTHES

Lightly sketch in the basic shapes of the clothing over the body. Give him baggy pants that hang loosely about the legs. Keep the circles representing the knee joints visible, as they will help you detail the clothing later. Sketch in the shape of the sash, taking care to show that it's curving around his upper body.

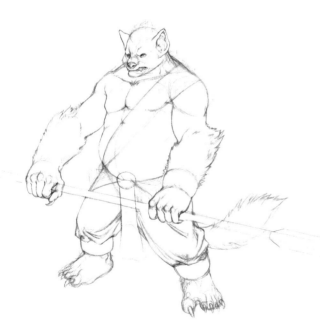

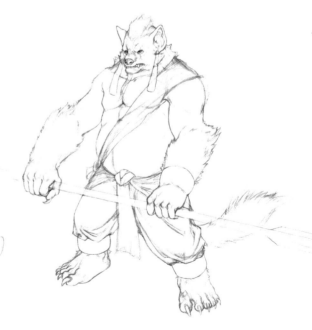

6 BEGIN ADDING DETAIL

Block in the shapes of the fur on the head, arms, tail and back. Draw the forms in groups of pointy tufts. Add more detail to his face, making your lines follow the structure of the brow ridge and muzzle. Emphasize his fierce expression. Layer additional garments of clothing over the others you have already drawn. As you sketch in the folds of the pants, pay attention to the points where the folds generate at the waist and knees, and the way the pants bunch up where they are tucked in at the ankle bracers.

7 CONTINUE ADDING DETAIL TO THE CLOTHING

Refine the folds and wrinkles on the pants, sash and fabric tied around the waist. Make the folds on the sash crossing the chest converge at the point where the sash is tied along the side of the body. Draw more folds and wrinkles closely together where there is stress on a garment from being pulled or bunched. Draw gentle ripples in loosely hanging fabric, such as the cloth sash hanging from his waist. Draw cylinders to block in his weapon.

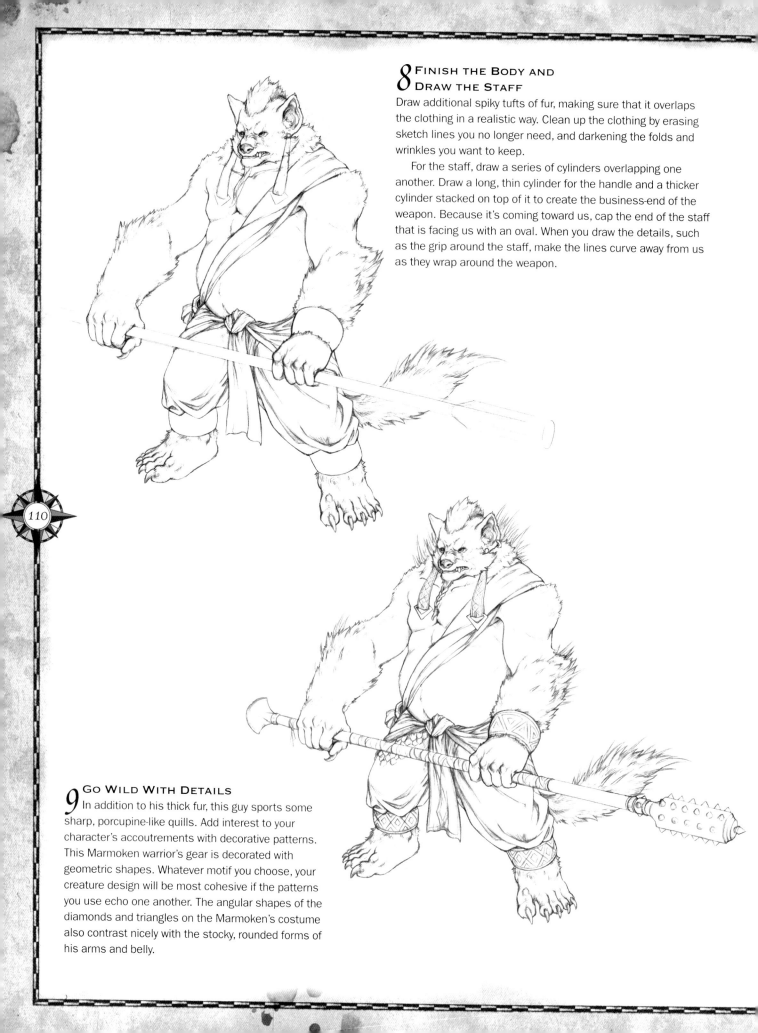

8 FINISH THE BODY AND DRAW THE STAFF

Draw additional spiky tufts of fur, making sure that it overlaps the clothing in a realistic way. Clean up the clothing by erasing sketch lines you no longer need, and darkening the folds and wrinkles you want to keep.

For the staff, draw a series of cylinders overlapping one another. Draw a long, thin cylinder for the handle and a thicker cylinder stacked on top of it to create the business-end of the weapon. Because it's coming toward us, cap the end of the staff that is facing us with an oval. When you draw the details, such as the grip around the staff, make the lines curve away from us as they wrap around the weapon.

9 GO WILD WITH DETAILS

In addition to his thick fur, this guy sports some sharp, porcupine-like quills. Add interest to your character's accoutrements with decorative patterns. This Marmoken warrior's gear is decorated with geometric shapes. Whatever motif you choose, your creature design will be most cohesive if the patterns you use echo one another. The angular shapes of the diamonds and triangles on the Marmoken's costume also contrast nicely with the stocky, rounded forms of his arms and belly.

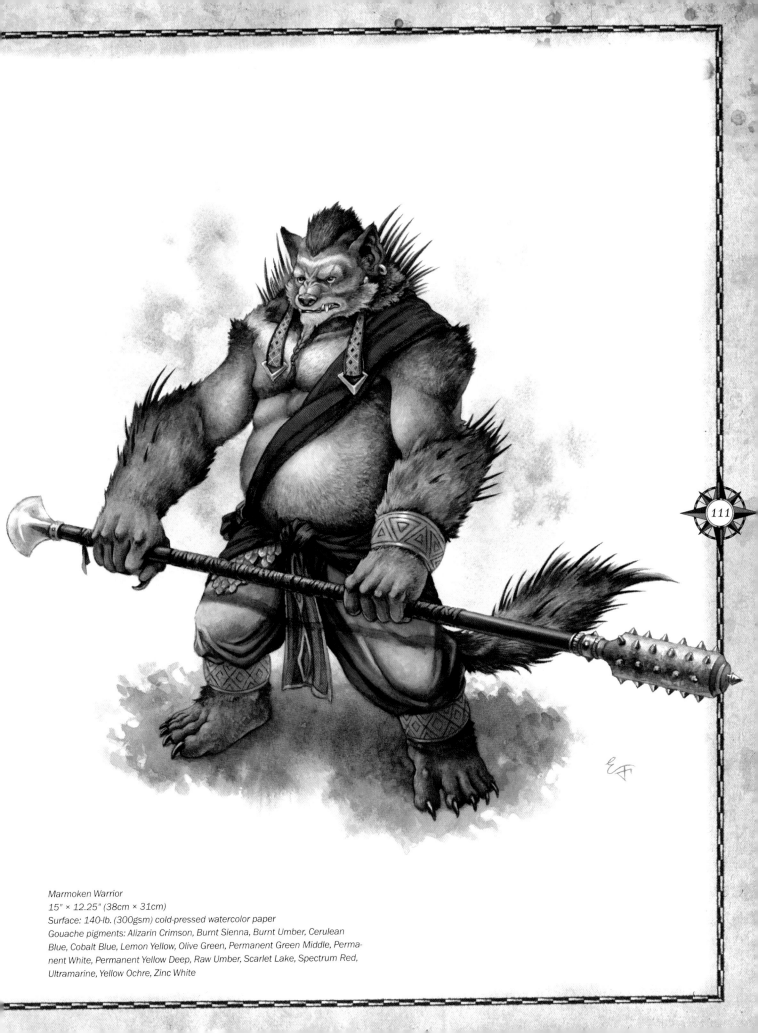

Marmoken Warrior
15" × 12.25" (38cm × 31cm)
Surface: 140-lb. (300gsm) cold-pressed watercolor paper
Gouache pigments: Alizarin Crimson, Burnt Sienna, Burnt Umber, Cerulean
Blue, Cobalt Blue, Lemon Yellow, Olive Green, Permanent Green Middle, Perma-
nent White, Permanent Yellow Deep, Raw Umber, Scarlet Lake, Spectrum Red,
Ultramarine, Yellow Ochre, Zinc White

Chapter Six
Creatures of the Sky

How inspirational to gaze up at the sky and imagine gliding high amongst the clouds! If you're a bird, this might be an everyday occurrence. Although we can't fly like the birds, we are often drawn to the sky where our imagination can soar. Be it a dragon gliding through the icy air of a mountain range, or a rambunctious pancake glider jumping from tree to tree, they are all free to float upon the air. Some of these critters can be tough to capture because they're always on the move (and your neck sure can get sore looking up constantly), but the time spent doing it is worth it. Grab your pencil and some climbing gear or binoculars and let's get to it!

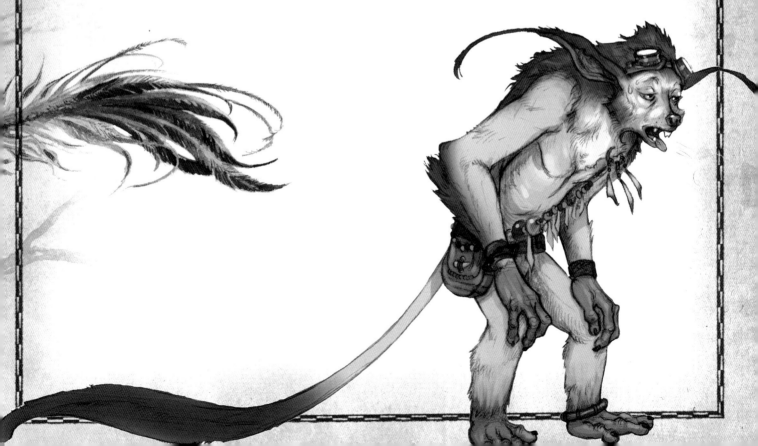

Take to the Skies
DRAW A PANCAKE GLIDER

This rambunctious and social rodent makes its home in tall tropical forests. It can glide through the canopy from treetop to treetop with the aid of several special adaptations. An amazing super-articulated flexible skeleton, along with stretchy muscular skin flaps, helps stretch and flatten the body into a pancake shape (hence the name) to provide these critters a large surface area with which to ride the air. Gliders also have a furless air pouch on the chest that they can inflate with air to extend a glide. Male pancake gliders have brightly colored pouches, which help them attract a mate. Female gliders give birth to one to three babies per year. The babies hitch a ride on her back until they learn how to climb and glide on their own. These gliders spend most of their lives in the trees and usually nest in tree hollows where they can avoid predators.

Materials

acid-free art paper

eraser

pencil

Jumping Glider

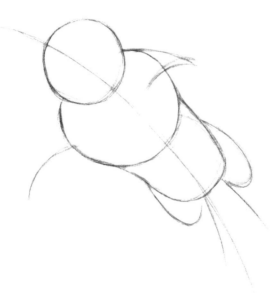
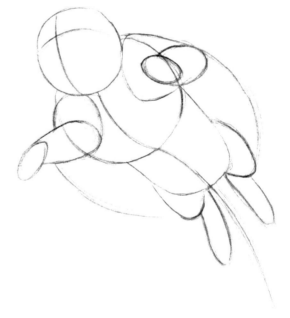

1 SKETCH A GESTURE DRAWING
Start your pancake glider with a sweeping action line that shows the direction of his leap. Draw stacked circular shapes overlapping one another from the head downward to show that the head is closest to us and the rest of the body is pushed back into space. Sketch some simple lines to show the pose and placement of the front and hind legs.

2 ADD THE CENTERLINE AND BLOCK IN LIMBS
Draw a line down the center of the body to indicate the centerline. Draw intersecting horizontal and vertical guidelines on the head for the placement of the facial features. Using more simple, rounded shapes, block in the arms, paws and legs. Keep round and circular in mind as you draw to keep within the circle-shaped design motif of the critter. Indicate the edges of the gliding membrane.

Simplified Anatomy
SHAPE UP!

Using simple shapes can be helpful when coming up with a design motif for a creature. As you can see from these examples, using various shapes for a starting point can lead to different looks. Even though the features of the face are almost identical, changing the shape of the head creates several design options.

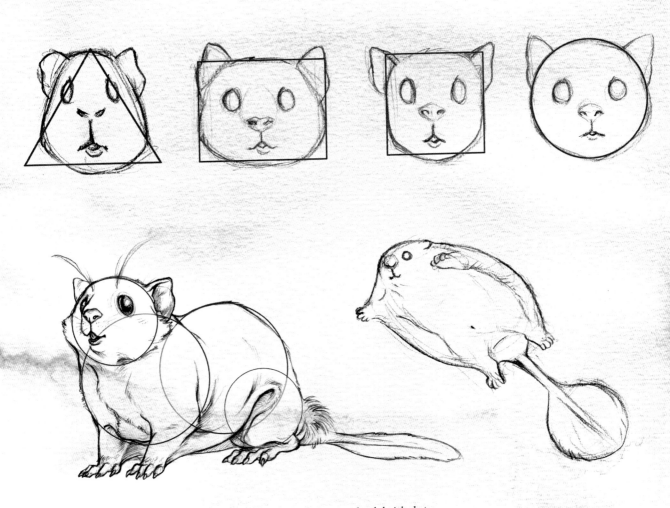

The same shape concept can be applied to the body of your creature. The pancake glider's body is constructed mainly of circles and when in flight, the body is literally circle shaped.

3 DRAW THE FACE AND FLESH OUT THE BODY

Block in the eyes, muzzle and ears. Flesh out the anatomy of the body, including blocking in the air pouch on the chest. Draw in the paws, toes and tail.

4 CONTINUE DEVELOPING THE FACE AND REFINE THE PAWS

Draw the nose and mouth over the muzzle shape you drew. Erase the eye line if it's no longer needed. Refine the glider's paws further by drawing soft fingertips and toes. Indicate where the flying membrane attaches to the wrists and haunches. Add tufts of hair along the cheeks to make this little guy super cute!

5 FINISH WITH DETAILS

Give him nostrils and little incisor teeth peeking out from his lips. Add the antennae-like "eyebrows" and whiskers, so he can find his way in the dark. Draw sharp toenails for him to grip tree trunks and branches with. Using short, quick pencil strokes, texture his body with fur. You're finished!

Flying Glider

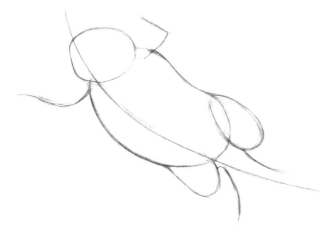

1 SKETCH A GESTURE DRAWING
Draw an action line showing the sweep of the pancake glider's spine. Draw an oval for the head and hind legs and a jelly bean shape for the body. Remember: rounded and circular!

2 DRAW THE CENTERLINE AND BLOCK IN THE ANATOMY
Draw the centerline of the head to show a three-quarter view. Indicate the placement of the eyes, nose and mouth with horizontal lines encircling the head. From this perspective, his eyes and nose will appear to be along the same horizontal eye line. Flesh out the arms, legs and tail with simple shapes. Connect the wrists and knees with a curved line for the gliding membrane.

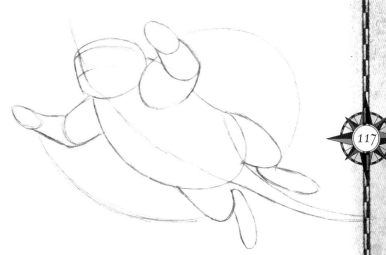

3 ADD FACIAL FEATURES AND FLESH OUT THE ANATOMY
Draw the eye and nose along the eye line at the top of the head. Draw the mouth along the horizontal guideline below that. Block in the fingers and toes and the anatomy of the belly. Keep everything soft and rounded. The chest pouch in this pose should look like it has expanded from the previous jumping pose demo, as though it's beginning to inflate with air. Draw a circle for the tail. Compare how it looks here with the previous pose. It has flattened out to help extend the pancake glider's air time.

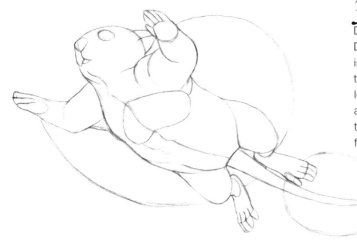

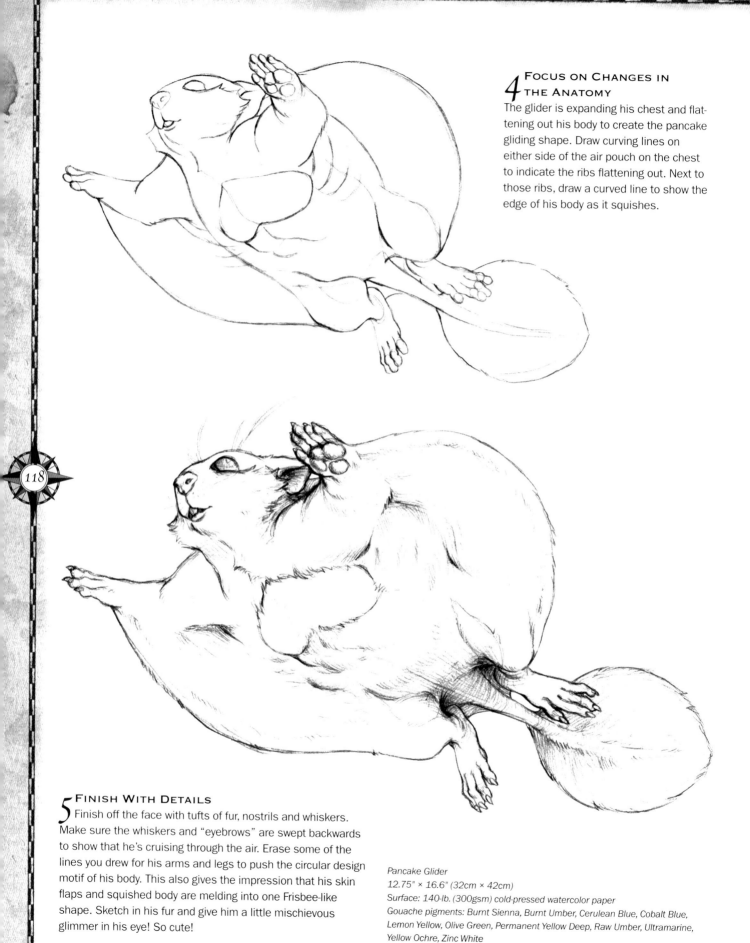

4 FOCUS ON CHANGES IN THE ANATOMY

The glider is expanding his chest and flattening out his body to create the pancake gliding shape. Draw curving lines on either side of the air pouch on the chest to indicate the ribs flattening out. Next to those ribs, draw a curved line to show the edge of his body as it squishes.

5 FINISH WITH DETAILS

Finish off the face with tufts of fur, nostrils and whiskers. Make sure the whiskers and "eyebrows" are swept backwards to show that he's cruising through the air. Erase some of the lines you drew for his arms and legs to push the circular design motif of his body. This also gives the impression that his skin flaps and squished body are melding into one Frisbee-like shape. Sketch in his fur and give him a little mischievous glimmer in his eye! So cute!

Pancake Glider
12.75" × 16.6" (32cm × 42cm)
Surface: 140-lb. (300gsm) cold-pressed watercolor paper
Gouache pigments: Burnt Sienna, Burnt Umber, Cerulean Blue, Cobalt Blue, Lemon Yellow, Olive Green, Permanent Yellow Deep, Raw Umber, Ultramarine, Yellow Ochre, Zinc White

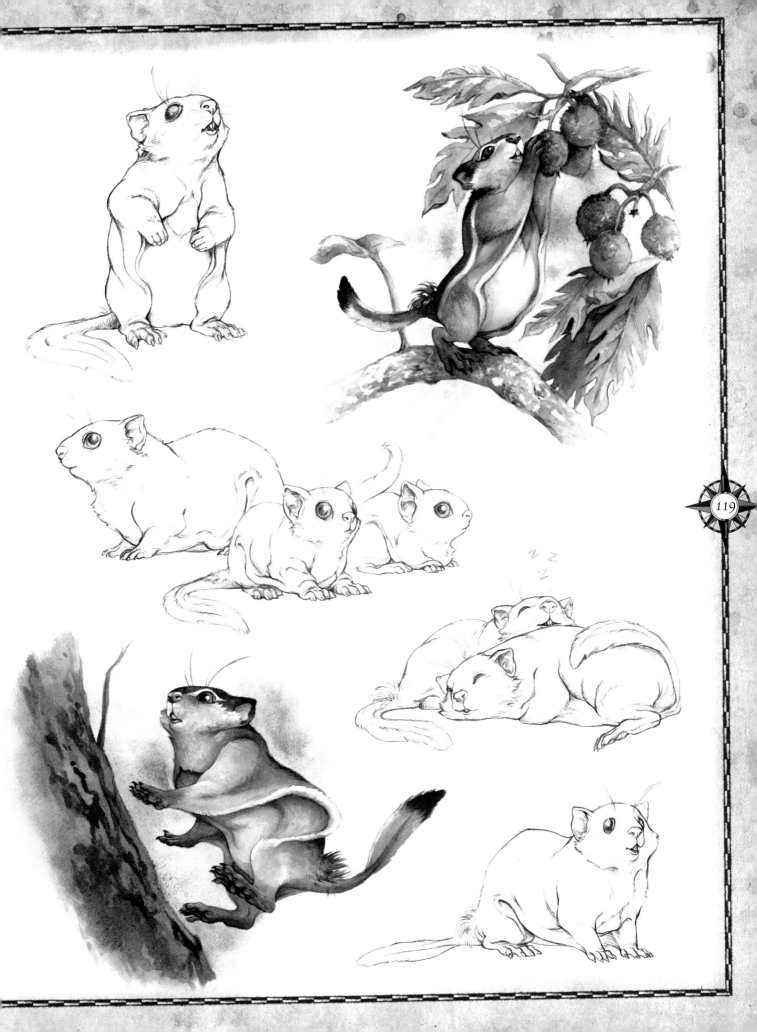

DRAW A HOOK-LEGGED BODEO

A large bird with brilliant plumage, the hook-legged bodeo is named for the special pair of hook-like appendages extending from behind its legs. These birds live in lush rainforests and are adept at acrobatic feats of climbing. Their preferred diet of fruits and nuts is located high in the forest canopy on delicate tree branches that are difficult for these heavy birds to perch on. With the assistance of their hooked limbs, they anchor themselves to stronger tree branches where they can safely stretch their long necks to grab their grub. A powerful beak allows them to crack open the shells of the toughest nuts and fruit. While they're expert climbers, they are clumsy fliers. Male hook-legged bodeos display colorful sacs on their necks, which they inflate during mating season to attract females. Both sexes are brightly colored and sport large bony crests on their heads.

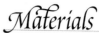

Materials

acid-free art paper

eraser

pencil

1 SKETCH A GESTURE DRAWING
Start with a circle for the head and quickly sketch in a basic gesture, laying out the curve of the body and the placement of the wings.

2 FORM THE BODY
Expand on your gesture lines by drawing simple shapes to form the body. Draw circles to mark the joints in the wings and legs.

3 BLOCK IN WING AND LEG MUSCLES
Think of the wing as an arm, and sketch bubbles to form the deltoid, biceps and forearm muscles. Sketch in the hook-like "legs" and block in some thick branches for your bird to latch onto. It's important to indicate where the branches will be early in the drawing, so that his interaction with them looks believable.

Winging It
DRAW FEATHERED WINGS

Drawing feathered wings and wings in various stages of flight can be challenging. With all those layers of feathers, it can be tough to discern the shape of the wing underneath.

Picture the wing as an arm without feathers. Many of the bones in a wing are the same as in a human's arm. Look in a mirror and pose your own arm in the same positions you want to draw a wing.

Folded Wing

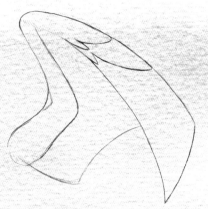

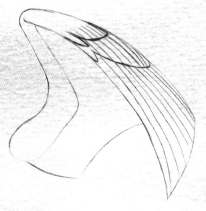

1 LAY IN THE BASIC SHAPE
Sketch a basic arm, drawing a curving triangle where the hand would fold at the wrist. Draw the wing tip folding over itself. (Imagine the corner of a piece of paper folded down.)

2 DIVIDE THE WINGS INTO SECTIONS
Sketch in sections for the feather layers. Make sure they overlap one another.

3 INDICATE FEATHER PLACEMENT
Draw long, curving lines through the folded wing shape to indicate where the feathers will be.

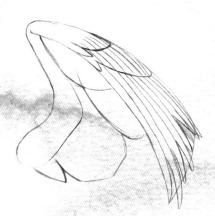

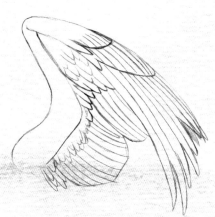

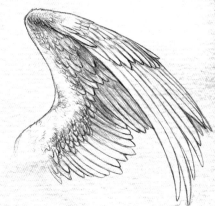

4 DIVIDE THE LAYERS AND ADD FEATHER TIPS
Block in shapes to divide up the feather layers on the inside of the wing. Sketch rounded tips for the primary flight feathers.

5 ERASE THE GUIDELINES AND ADD INNER-WING FEATHERS
Erase the guidelines you drew for the primary feathers. Block in the feathers on the inner wing.

6 FINISH WITH TEXTURE AND SHADING
Finish each feather with a rounded point at the tip. Use small, tight U-shaped pencil strokes to create the texture of the smallest feathers. Shade the inside of the wing to reinforce the look of the wing folding over itself.

Extended Wing

1 **SKETCH THE BASIC SHAPE**
Sketch the bird's arm. Lightly sketch a curving line around it to block in the shape of the open wing.

2 **CONTINUE BLOCKING IN BASIC SHAPES AND LAYERS**
Block in progressively smaller shapes that echo the form of the outer wing. These will become the overlapping layers of feathers.

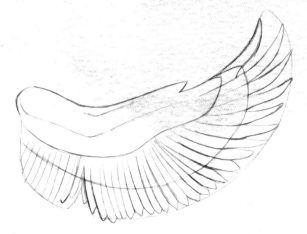
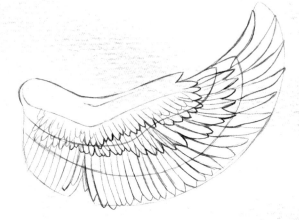

3 **INDICATE FEATHER PLACEMENT**
Block in the primary feathers by drawing curved lines that radiate from the arm. Taper the feathers at the tips, but avoid making them look very sharp and pointy unless you are drawing a creature with a more aggressive design.

4 **SKETCH THE INNER FEATHERS**
Sketch in the shorter inner feathers. Stagger the feather shapes where they overlap so that the wing looks natural.

5 **FINISH WITH DETAILS**
Add detail with increasingly smaller feathers as you move from the wing tips inward. Erase the guidelines.

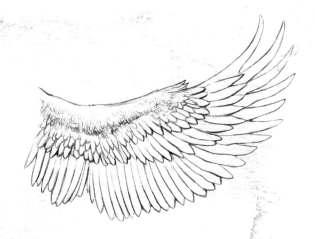

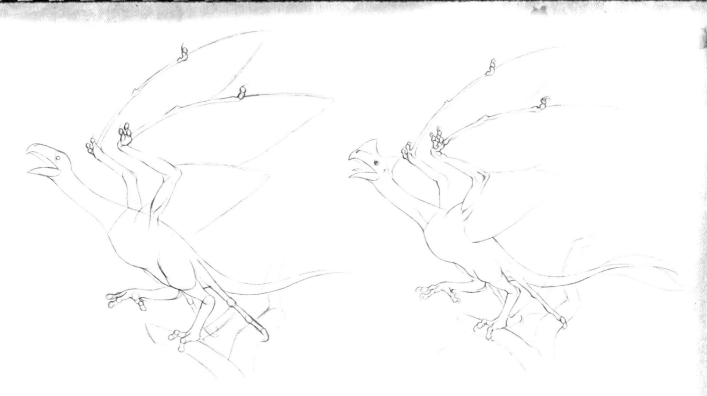

4 FLESH OUT THE WINGS AND LEGS
Sketch in his wing claws and toes, using circles to mark where the knobby joints will be. Block in the overall shape of the wings.

5 CONCENTRATE ON THE CLAWS AND FEET
Flesh out the "fingers" and toes and add strong claws for climbing. Erase any guidelines that you no longer need.

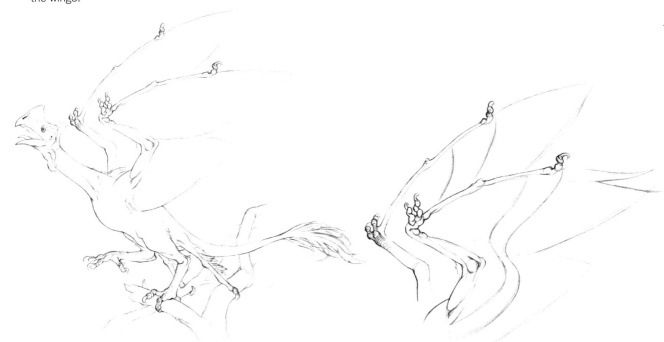

6 ADD TEXTURE AND DETAILS
Embellish his face and neck with more detail. The air pouch on his neck should hang loosely, like a turkey's wattle, while it's not inflated for display. Continue to add detail to the tail feathers. Texture his legs with bumpy scales.

7 FOCUS ON THE WINGS
Concentrate on the wings for the next few steps. Sketch in S-shaped curves to break the wings up into several chunks for the layers of feathers.

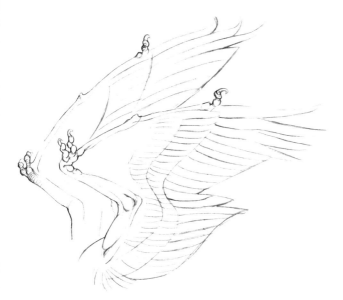

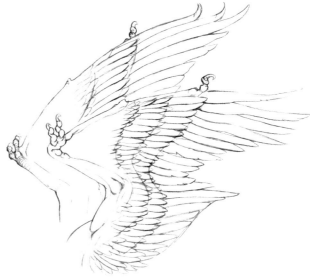

8 ADD FEATHERS
Sketch a series of lines radiating from the center of the wing to divide each section with feathers. Start to refine the edges of the primary flight feathers. They should taper gracefully toward the tips.

9 STAGGER THE FEATHERS AND ROUND OFF THE TIPS
Using the lines you laid in previously, round off the tips of each feather. Stagger them as they overlap so they look realistic. Vary the shape and size of the feathers.

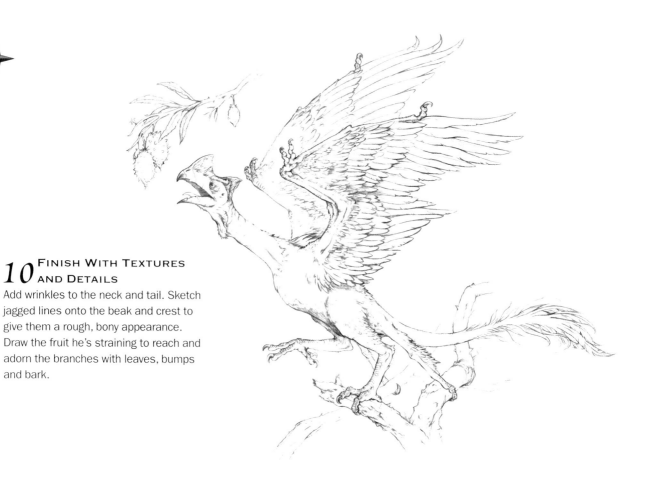

10 FINISH WITH TEXTURES AND DETAILS
Add wrinkles to the neck and tail. Sketch jagged lines onto the beak and crest to give them a rough, bony appearance. Draw the fruit he's straining to reach and adorn the branches with leaves, bumps and bark.

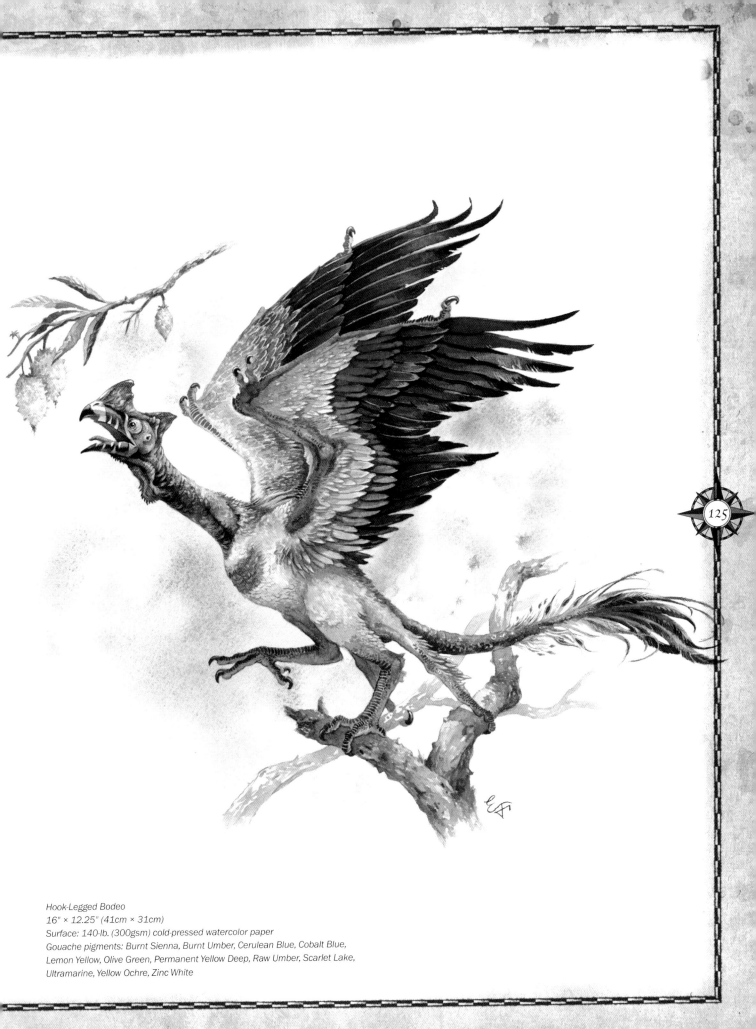

125

Hook-Legged Bodeo
16" × 12.25" (41cm × 31cm)
Surface: 140-lb. (300gsm) cold-pressed watercolor paper
Gouache pigments: Burnt Sienna, Burnt Umber, Cerulean Blue, Cobalt Blue,
Lemon Yellow, Olive Green, Permanent Yellow Deep, Raw Umber, Scarlet Lake,
Ultramarine, Yellow Ochre, Zinc White

Take to the Skies
DRAW A FLYING FISH

Giant flying fish seem to stay aloft magically, but actually achieve this feat by inflating massive bladders in the chest and back area with a gas produced by a chemical reaction inside the body. Although called by its common nickname, the flying fish, these creatures are warm-blooded.

They feed while flying—gulping the air and swallowing insects, micro-organisms and other tiny flying creatures filtered through the baleen in the mouth. They tend to keep to themselves, although mothers with calves and small family units will sometimes travel together for short periods of time. Flying fish enjoy warmer climates with more abundance of creatures to feed on and migrate yearly when the weather changes. They are non aggressive and only threatening to the unfortunate small creatures caught in the path of their giant maw.

Materials

acid-free art paper

eraser

pencil

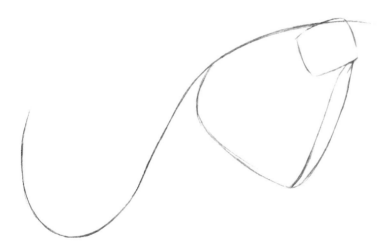

1 SKETCH A GESTURE DRAWING
Lightly sketch a rounded square shape for the head. Draw a bold S-curve for the action line showing the movement of the pose. Draw a triangle shape to form the chest. Indicate the centerline of the chest with a line coming down from the head.

2 BLOCK IN THE HEAD AND BODY
Turn the square shape you drew for the head into a boxy, three-dimensional shape. Taper it toward the front. Draw a tapering S-curve beneath your original action line to form the rest of the body and indicate the centerline. Add guide-lines curving around the body to help you remember the three-dimensional form as it rests in space.

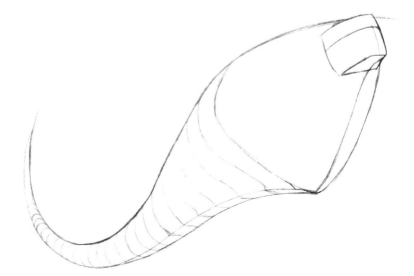

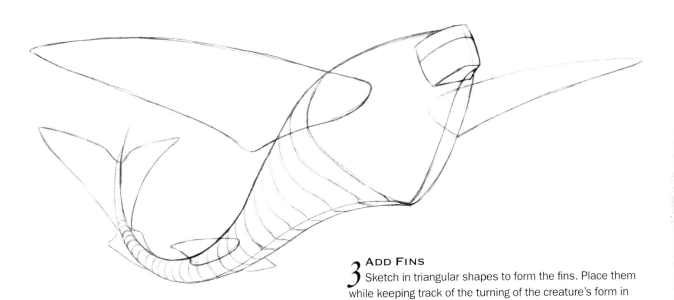

3 ADD FINS

Sketch in triangular shapes to form the fins. Place them while keeping track of the turning of the creature's form in space, using your centerline and circle guides.

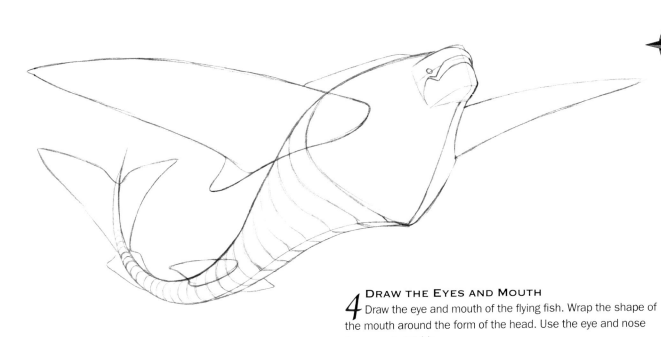

4 DRAW THE EYES AND MOUTH

Draw the eye and mouth of the flying fish. Wrap the shape of the mouth around the form of the head. Use the eye and nose lines as your guide.

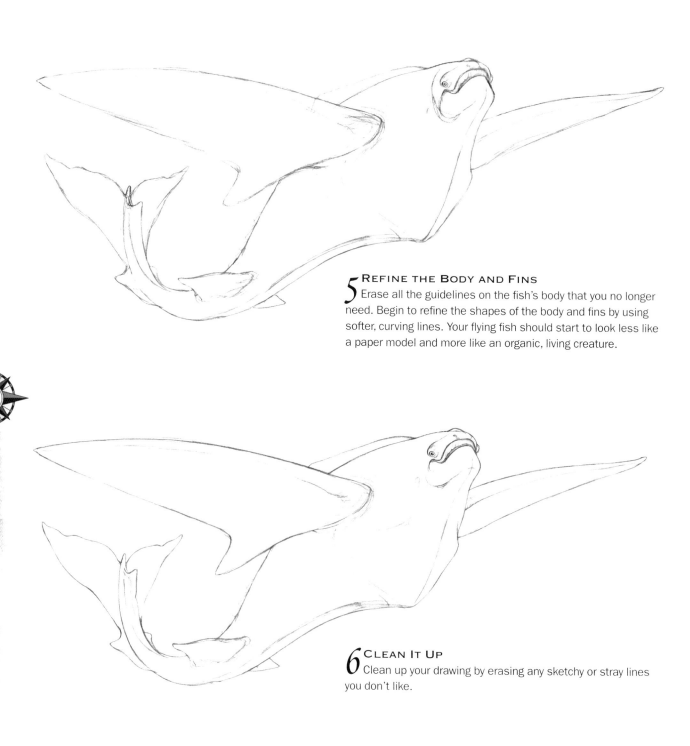

5 REFINE THE BODY AND FINS
Erase all the guidelines on the fish's body that you no longer need. Begin to refine the shapes of the body and fins by using softer, curving lines. Your flying fish should start to look less like a paper model and more like an organic, living creature.

6 CLEAN IT UP
Clean up your drawing by erasing any sketchy or stray lines you don't like.

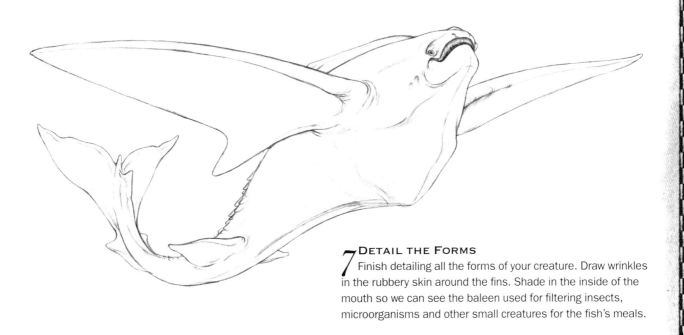

7 DETAIL THE FORMS

Finish detailing all the forms of your creature. Draw wrinkles in the rubbery skin around the fins. Shade in the inside of the mouth so we can see the baleen used for filtering insects, microorganisms and other small creatures for the fish's meals.

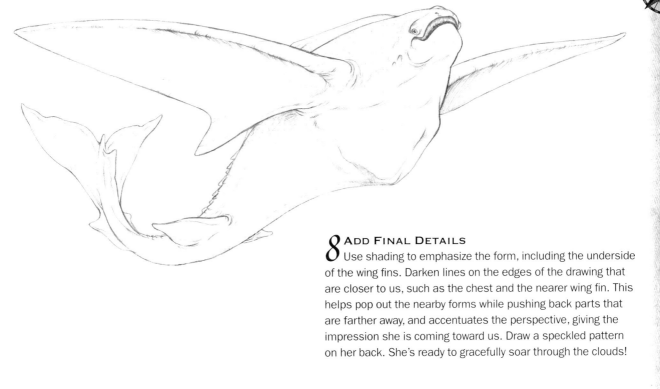

8 ADD FINAL DETAILS

Use shading to emphasize the form, including the underside of the wing fins. Darken lines on the edges of the drawing that are closer to us, such as the chest and the nearer wing fin. This helps pop out the nearby forms while pushing back parts that are farther away, and accentuates the perspective, giving the impression she is coming toward us. Draw a speckled pattern on her back. She's ready to gracefully soar through the clouds!

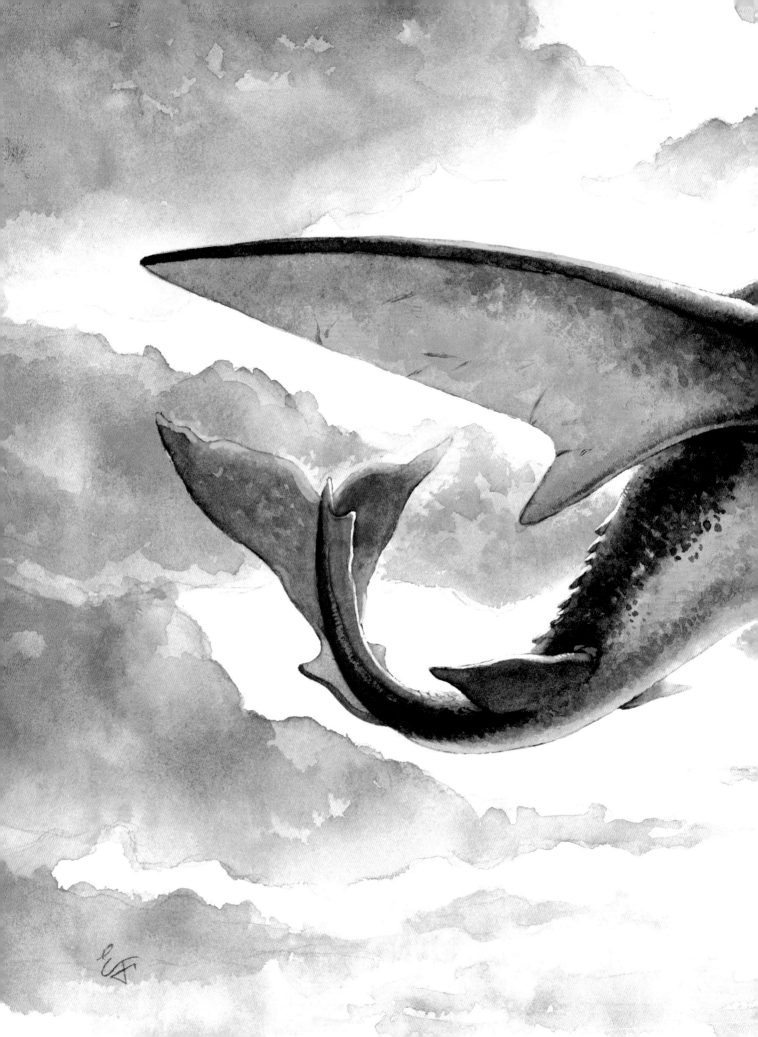

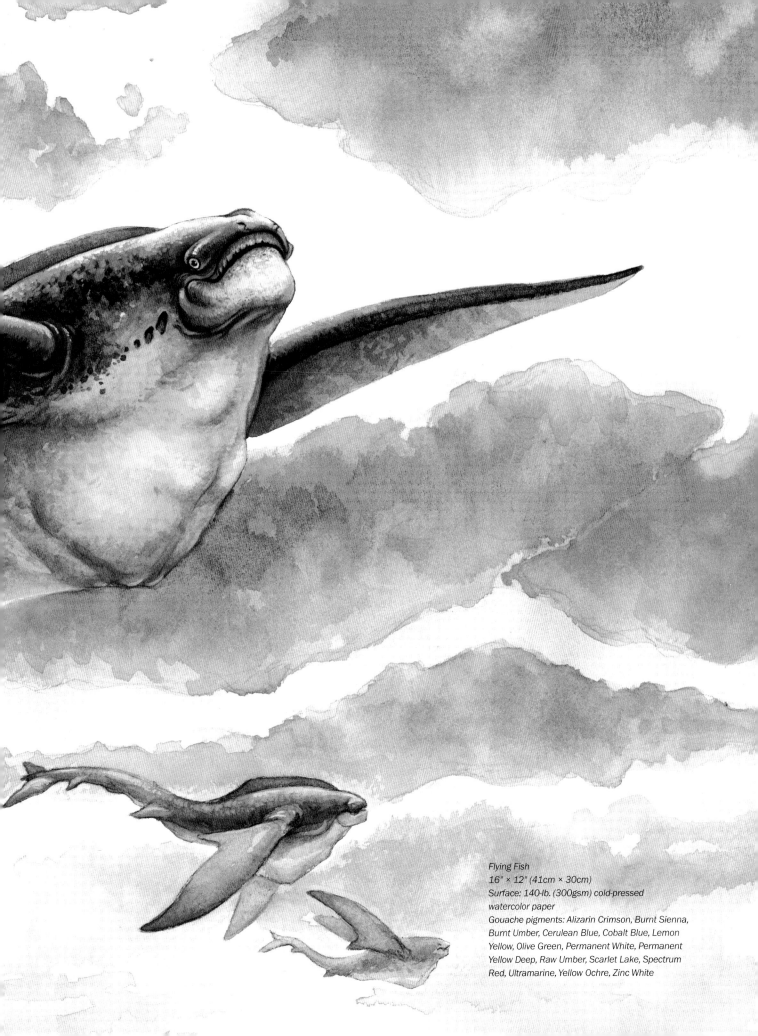

Flying Fish
16" × 12" (41cm × 30cm)
Surface: 140-lb. (300gsm) cold-pressed
watercolor paper
Gouache pigments: Alizarin Crimson, Burnt Sienna,
Burnt Umber, Cerulean Blue, Cobalt Blue, Lemon
Yellow, Olive Green, Permanent White, Permanent
Yellow Deep, Raw Umber, Scarlet Lake, Spectrum
Red, Ultramarine, Yellow Ochre, Zinc White

Take to the Skies
DRAW A LANTERN BAT

An elusive creature that patrols the night skies, the lantern bat lures unfortunate insects to their deaths with its brightly glowing body. These creatures usually roost in trees, hanging from branches with the aid of a rudimentary hook-like paw on the tip of their tail. Flipper-like hind legs help mother bats hold their young to their chests while sleeping or flying, and to carry larger prey to another location to eat.

A swift yet erratic flier, the lantern bat is a nightmare to bugs, snapping them up with sharp teeth that line its long, flexible jaws. The bioluminescent light this creature generates from within its chest causes an eerie glow illuminating the bat's ribs. Because of its spooky appearance, it is often nicknamed the Ghost Bat or the Skeleton Bat. Many superstitions surround this creature, although it is harmless to people.

Materials

acid-free art paper

eraser

pencil

1 SKETCH A GESTURE DRAWING
Draw a circle for the head and sketch a long, sweeping action line extending from the head down to the tail. Lightly block in the shape for the bat's extended wings. This is simply a gesture to capture the feeling of the pose; the detailed form of the wings comes later.

2 BLOCK IN THE BODY
Draw basic shapes to block in the structure of the body. The action line you drew earlier should form the centerline for the chest and stomach, and will help you to keep everything in perspective.

3 REFINE THE ANATOMY
Using the basic forms you drew as a guide, refine the bat's anatomy. Imagining that the bat's chest and arm anatomy are similar to human anatomy will help you as you continue to work on these areas. Sketch in the hands, thumbs and fingers that help the bat climb and grasp food. Block in the facial features.

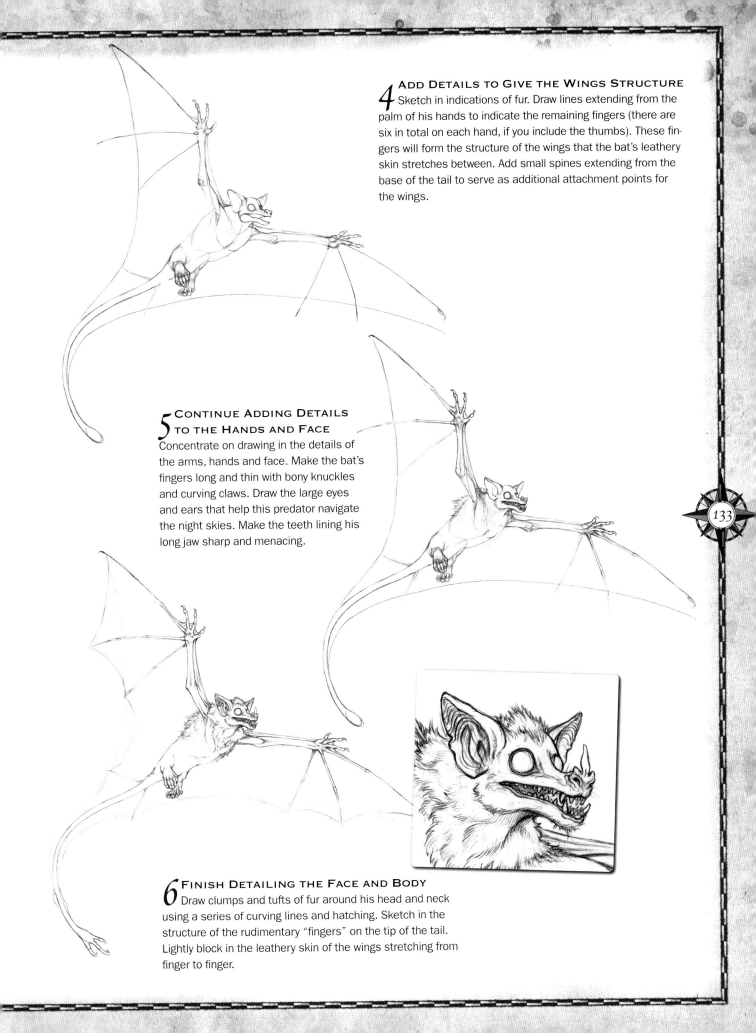

4 ADD DETAILS TO GIVE THE WINGS STRUCTURE

Sketch in indications of fur. Draw lines extending from the palm of his hands to indicate the remaining fingers (there are six in total on each hand, if you include the thumbs). These fingers will form the structure of the wings that the bat's leathery skin stretches between. Add small spines extending from the base of the tail to serve as additional attachment points for the wings.

5 CONTINUE ADDING DETAILS TO THE HANDS AND FACE

Concentrate on drawing in the details of the arms, hands and face. Make the bat's fingers long and thin with bony knuckles and curving claws. Draw the large eyes and ears that help this predator navigate the night skies. Make the teeth lining his long jaw sharp and menacing.

6 FINISH DETAILING THE FACE AND BODY

Draw clumps and tufts of fur around his head and neck using a series of curving lines and hatching. Sketch in the structure of the rudimentary "fingers" on the tip of the tail. Lightly block in the leathery skin of the wings stretching from finger to finger.

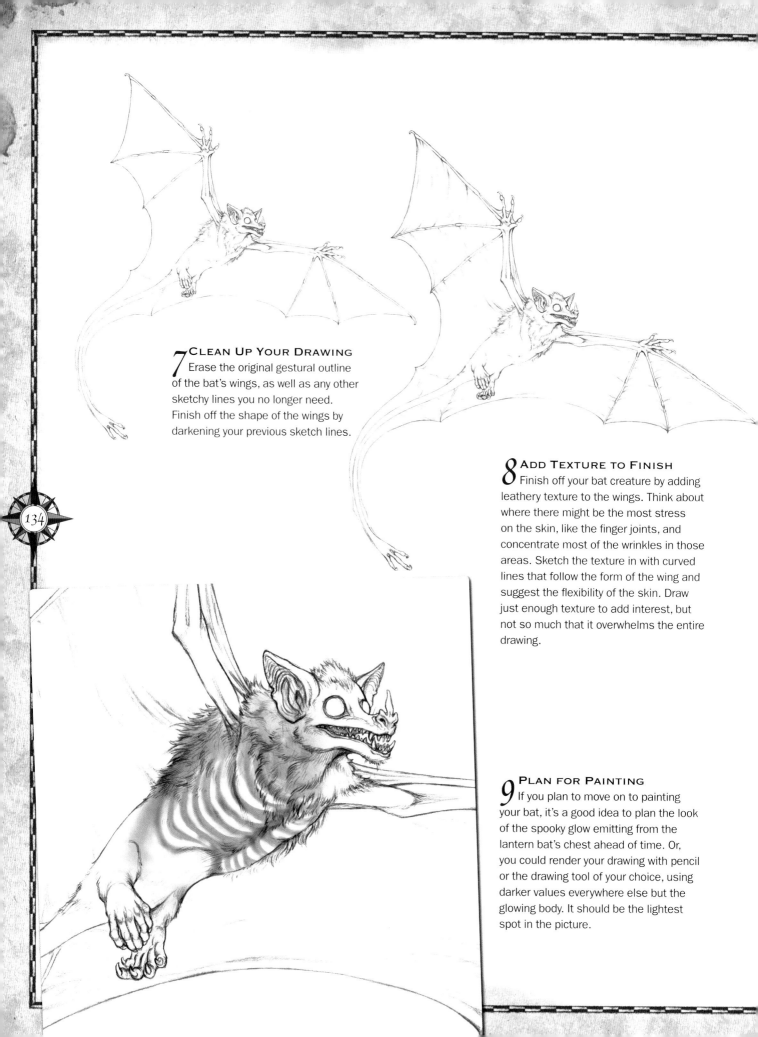

7 CLEAN UP YOUR DRAWING
Erase the original gestural outline of the bat's wings, as well as any other sketchy lines you no longer need. Finish off the shape of the wings by darkening your previous sketch lines.

8 ADD TEXTURE TO FINISH
Finish off your bat creature by adding leathery texture to the wings. Think about where there might be the most stress on the skin, like the finger joints, and concentrate most of the wrinkles in those areas. Sketch the texture in with curved lines that follow the form of the wing and suggest the flexibility of the skin. Draw just enough texture to add interest, but not so much that it overwhelms the entire drawing.

9 PLAN FOR PAINTING
If you plan to move on to painting your bat, it's a good idea to plan the look of the spooky glow emitting from the lantern bat's chest ahead of time. Or, you could render your drawing with pencil or the drawing tool of your choice, using darker values everywhere else but the glowing body. It should be the lightest spot in the picture.

Take to the Skies
PAINT THE LANTERN BAT

Now that you've sketched the lantern bat, let's move on to tackling a painting of him flapping his way through the night sky. This demo will show you how to paint the lantern bat using gouache, a paint similar to watercolor. The gouache used is made by Winsor & Newton. Winsor & Newton also makes watercolor paints, which could be used to complete this demo with similar effect.

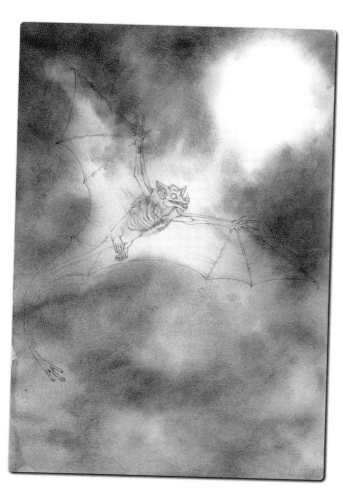

Materials

SURFACE

140-lb. (300gsm) cold-pressed watercolor paper

BRUSHES

nos. 000 and 18/0 liners
nos. 4, 8, 12 and 24 rounds
nos. 0, 10/0, 4, 6 and 10 shaders
nos. .5, 1 and 1.5 wash

PALETTE

Alizarin Crimson, Burnt Sienna, Burnt Umber, Cerulean Blue, Cobalt Blue, Olive Green, Permanent Green Middle, Prussian Blue, Raw Umber, Titanium White, Ultramarine Blue, Yellow Ochre, Zinc White

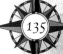

135

1 APPLY A WASH

Colors used: Ultramarine Blue, Cobalt Blue and Olive Green + Cerulean Blue. Use a spray bottle filled with clean water or a wide wash brush to saturate your paper with water. Select or mix the color you wish to use, and with a wet brush dipped in the paint, drop color onto the paper with your brush. A large round brush is great to drop in or splatter color, while a wide wash brush more easily covers large areas. Because you are painting wet on wet, the colors will easily spread across the paper and bleed into one another, creating interesting color and pattern combinations. Leave some of the paper showing through for the bat's chest area. This will be the lightest and brightest part of the painting, because it will be glowing. Also leave a blank spot up in the corner for a full moon.

TRANSFERRING YOUR DRAWING

If you have access to a scanner and a printer that can handle watercolor paper, the easiest way to transfer your drawing by simply printing it. Check to see what size, shape and thickness of paper your printer can accept. Another option is to take your drawing files to a local print shop and have them print it on watercolor paper for you. You can also transfer your drawing the old-fashioned way, using a light box to trace your finished image onto watercolor paper. Or if you're feeling confident, start a fresh drawing directly on the paper you plan to paint on. In that case, no transferring is necessary!

2 FILL IN LOCAL COLOR OF THE BAT

Think of local color as the basic color without any lighting or shadows added yet. Use Prussian Blue mixed with varying amounts of Raw Umber, Burnt Sienna, and a little Alizarin Crimson to create the browns of the bat. Rather than laying in large swaths of color, use a gentle scumbling approach with a wet brush. This will help build up layers of color and the look of texture on the wings. After wetting down the chest area with a spray bottle or clean, wet brush, drop in a wet color mixed from Cerulean Blue and permanent green middle to create the color of the chest's glow.

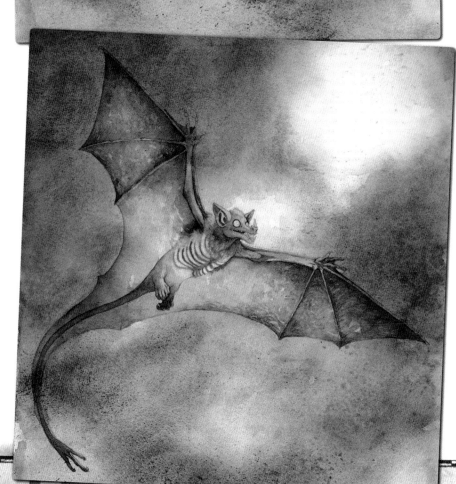

3 FILL IN THE BASIC SHADOW SHAPES

Using a mix of Burnt Sienna and Ultramarine Blue, start to fill in where the shadows will fall. Mixing in some blues from the background color as you work will help tie him into the background and create the feeling he's in the nighttime environment. The bat should mostly be backlit from the moon. Lighting from the chest area will mostly only affect the nearest parts of the bat. Paint in the ribs to give it a creepy skeleton look. Don't touch the green light yet. As you add more dark values to the painting, the light will look even brighter.

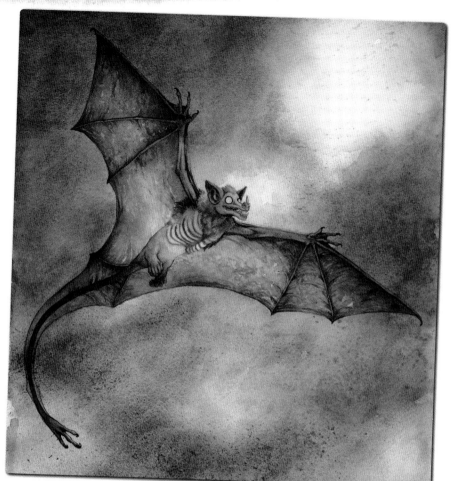

4 REDEFINE YOUR LINES

Mix Ultramarine Blue and Burnt Umber to create a dark (but watery and transparent) color. Use a 000 or 18/0 round or liner brush to trace over your original drawing lines, cleaning up and defining areas that might be getting lost in the dark paint. Add some texture in the wings using similar size (or slightly larger) round brushes. Use the previous color as well as Ultramarine Blue mixed with Raw Umber.

5 ADD DETAILS TO THE FUR AND FACE

Continue painting transparently at this stage. Using thin lines, almost like you're hatching with a pencil, paint in some of the texture of the fur. Paint in the areas where the shadows would fall. Be sure not to cover up too much of your base color. Leaving it alone as you add the shadows will help to create medium and light values. Layer shadow colors to create a greater range of values from dark to middle to light.

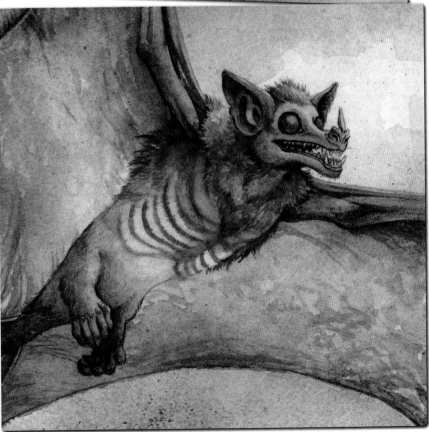

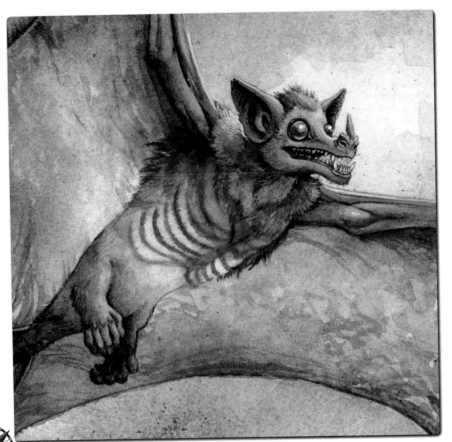

6 ADD OPAQUE DETAILS AND RIM LIGHTING

Concentrate most of your details on the face. With a mix of Alizarin Crimson, Cerulean Blue and Zinc White, create a light lavender color to use for the rim light created by the moon. Mix Cerulean Blue and Zinc White to create a cooler light blue hue. With a small round or liner brush (size 0–4), paint along the edges of the bat's ears and fingers, and the top of the wings. Use a bit of water to blend some of this color down through the skin flaps at the top of the wings. Because the stretched skin here is thin, it appears slightly transparent and the light should shine through it somewhat. Add a bit of Raw Umber or Yellow Ochre to the blue mix to create a slightly warmer brown color. Use this to paint some opaque lights back into the fur of the bat. For areas with thicker brushstrokes, use a small shader, size 0 or 10/0.

7 START PAINTING IN THE BIO LIGHT

With an opaque mix of Cerulean Blue, Permanent Green Middle and Permanent White, paint in the space between and underneath the ribs using a 0 or 10/0 shader brush. Once dry, use a 2 or 4 round to trace over the ribs with a transparent mix of Cobalt Blue and Olive Green. Then add a transparent layer of Prussian Blue. The dark values of bioluminescent light will appear as a darker shade of the glowing color. (To make gouache transparent, add water. You can create varying levels of transparency depending on the amount of water mixed in.)

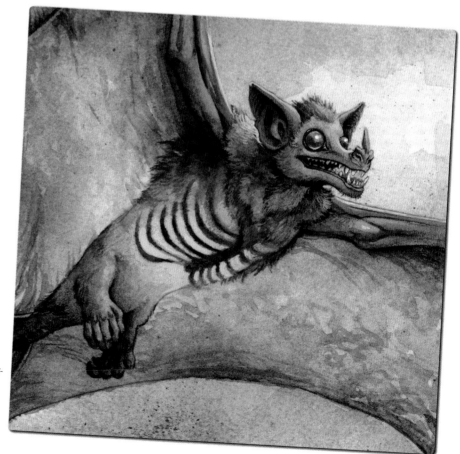

8 PAINT THE GLOW

Closer to the center of the rib cage, paint the glow with Permanent White mixed with just a dab of Cerulean Blue and Permanent Green Middle. At the center, layer plain Permanent White on top to create the brightest part of the glow. After the paint dries (which should take only a few minutes), dip a clean shader into water and blend the Permanent White of the bioluminescent light into the edges of the ribs a bit. Eating into the edges and obscuring them slightly reinforces the impression that there is a soft glow.

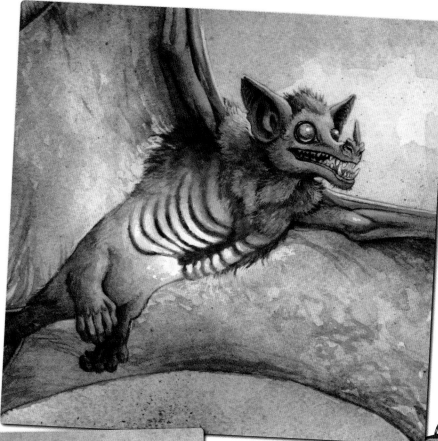

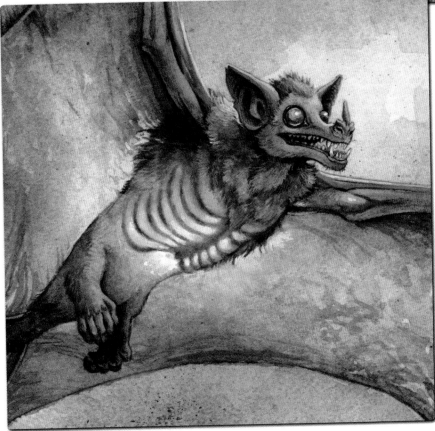

9 DARKEN THE SHADOWS

Paint some dark color back into the sternum area of the bat. Darken the shadows surrounding the chest in the fur and elsewhere to further emphasize the eerie blue-green glow.

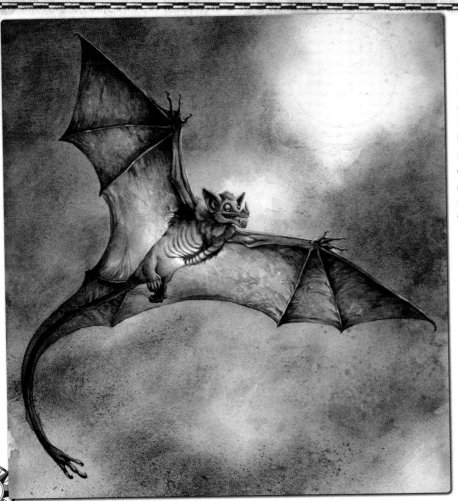

10 ADD FINISHING DETAILS

Enhance contrast by making your shadows darker and building up the highlights to make them even brighter. Using a thin liner, paint some blue-green veins in the wings near the chest, glowing with bioluminescent light. Using an opaque mix the same color as the bioluminescent glow, show the way the bat's nearby anatomy might catch some of that light such as wrinkles in wings and fingers, or tufts of fur.

GOUACHE CAN BE TRICKY!

Gouache can be built up or watered down similar to oils. It has a creamy texture when used as an opaque, but it dries quickly. If you want to paint a lot with a color as opaque, mix a decent amount or it'll dry up on your palette. You can reconstitute it with more water, but that waters down the color, making it more transparent and harder to cover the layer of paint underneath.

Be careful when painting in many layers. If your brush isn't loaded with enough paint, or if you use too much pressure, it will pick up some of the under paint that's already on your piece. Gouache is water-based, so you can pull it off your painting after it dries. This works great for achieving certain effects, but it can be frustrating when you don't expect the paint to lift up.

11 FINISH THE BACKGROUND

Add water to the background with a clean, large wash brush, making sure not to get too close to the edges of the bat so that the colors can blend without bleeding into him. Make the background darker and a bit more purple in hue. Use mixes of Prussian Blue and Alizarin Crimson, Ultramarine and Olive Green, and Ultramarine and Alizarin Crimson to finish the background. With a large round brush, drop the wet colors onto the wet surface in a haphazard pattern, imagining they are clouds forming in the night sky. The bat's wings should still be one of the darkest parts of the painting; avoid making the background too much darker than them. Paint in the moon by making blue blotches to form the craters. Use opaque white paint where needed to make the moon brighter. You can make the edges crisp or slightly blurred—it's up to you.

Lantern Bat
12.5" × 17.25" (32cm × 44cm)
Surface: 140-lb. (300gsm) cold-pressed watercolor paper
Gouache pigments: Alizarin Crimson, Burnt Sienna, Burnt Umber, Cerulean Blue, Cobalt Blue, Olive Green, Permanent Green Middle, Permanent White, Prussian Blue, Raw Umber, Ultramarine, Yellow Ochre, Zinc White

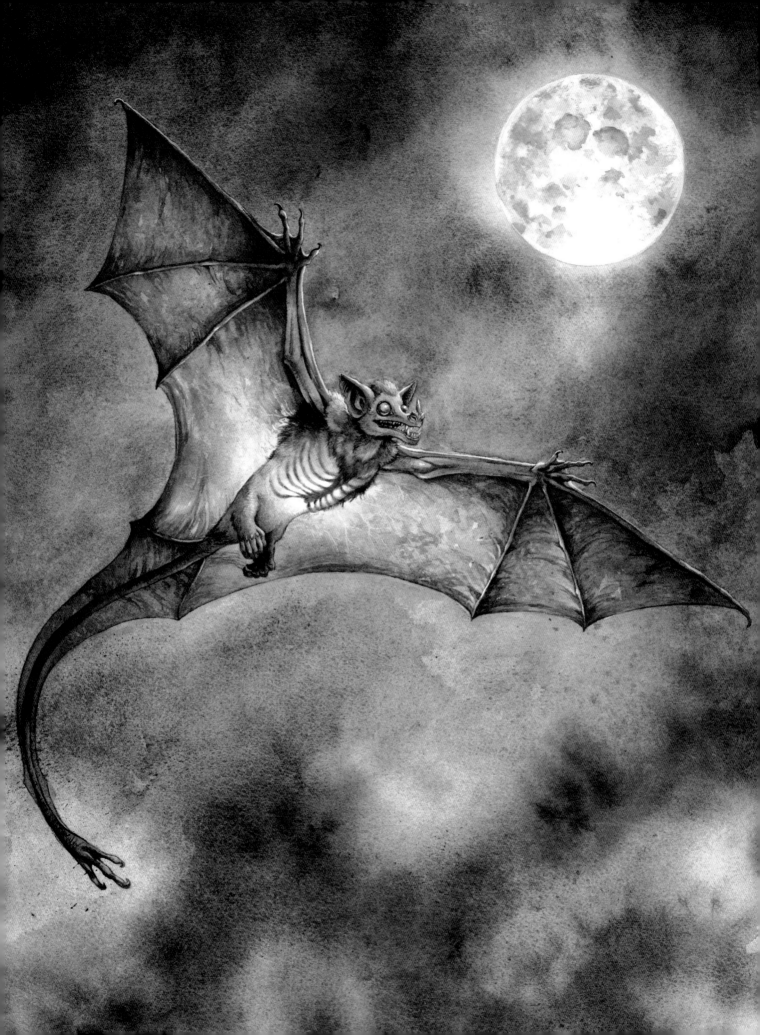

Index

ABOUT THE AUTHOR

Emily Fiegenschuh attended the Ringling College of Art and Design in Sarasota, Florida, where she graduated with honors and a BFA from the Illustration program in 2001.

Her art has appeared in the best sellers *A Practical Guide to Dragons*, and *A Practical Guide to Monsters*, (Mirrorstone Books), including covers for several books in the series. Emily illustrated numerous Dungeons and Dragons rule books for Wizards of the Coast, as well as the covers and interiors for the Mirrorstone novel series *Knights of the Silver Dragon*. She has also created several illustrations for *Cricket* magazine.

Emily prefers the feeling of putting pencil or brush to paper and still draws and paints the majority of her work traditionally. In her spare time, she enjoys sculpting. One of her pieces was featured in *Spectrum 9: The Best in Contemporary Fantastic Art*. She lives in the Seattle area with her husband, Vinod.

Visit her website at e-figart.com.

ACKNOWLEDGMENTS

Many people lent a helping hand to make this, my first book and very big project, possible.

Sincere thanks go to editor Christina Richards for her kindness and immense patience putting up with my perfectionist streak and for guiding me through the book's progress. Without her understanding and encouragement, all the work I put into this book would not have been possible. Thank you to designer Wendy Dunning for turning the jumbled piles of art and text I gave her into a great-looking book. Thanks to Kelly Messerly for getting the ball rolling. Without her interest in my work, this book may not even exist! Thanks also to Mary Bostic for her guidance at the beginning of the project.

Many thanks to Vinod for his tireless support throughout the making of this book. His critiques and artistic insight helped me to expect the most of myself and make my artwork look the best I could make it, even at 3 AM when I should have been in bed. His additional help around the studio (and the house) for the duration of the project was invaluable.

Thank you to my family and friends for their encouragement during this project and for my artistic endeavors in general. And finally, thanks to all my guinea pigs. Snuggling fuzzy little animals is great stress relief!

METRIC CONVERSION CHART

To convert	to	multiply by
Inches	Centimeters	2.54
Centimeters	Inches	0.4
Feet	Centimeters	30.5
Centimeters	Feet	0.03
Yards	Meters	0.9
Meters	Yards	1.1

Other fine IMPACT books are available from your favorite bookstore, art supply store or online supplier. Visit our website at www.fwmedia.com.

15 14 13 12 11 5 4 3 2 1

DISTRIBUTED IN CANADA BY FRASER DIRECT
100 Armstrong Avenue
Georgetown, ON, Canada L7G 5S4
Tel: (905) 877-4411

DISTRIBUTED IN THE U.K. AND EUROPE BY
F&W MEDIA INTERNATIONAL, LTD
Brunel House, Forde Close, Newton Abbot, TQ12 4PU, UK
Tel: (+44) 1626 323200, Fax: (+44) 1626 323319
Email: enquiries@fwmedia.com

DISTRIBUTED IN AUSTRALIA BY CAPRICORN LINK
P.O. Box 704, S. Windsor NSW, 2756 Australia
Tel: (02) 4577-3555

Sleeping Urrmsh from "The Star Shard" Part 3. Reprinted by permission of *CRICKET* magazine, art © 2008 by Carus Publishing Company.

Amajaruk Reaching for Child used by permission of Inhabit Media Inc. © 2007.

Page 22 photographs used by permission of Vinod Rams.
Pages 23 and 34 photographs used by permission of Karl Fiegenschuh.

Edited by Christina Richards, Mary Bostic and Kelly Messerly
Designed by Wendy Dunning
Production coordinated by Mark Griffin

Ideas.
Instruction.
Inspiration.

These and other fine **IMPACT** products are available at your local art & craft retailer, bookstore or online supplier. Or visit our website at impact-books.com.

by William O'Connor
hardcover · 160 pages

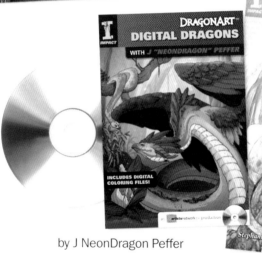

by Stephanie Pui-Mun Law
paperback · 176 pages

by J NeonDragon Peffer
DVD running time:
64 minutes

IMPACT-BOOKS.COM

▸ Connect with other artists

▸ Get the latest in comic, fantasy and sci-fi art

▸ Special deals on your favorite artists

Sign up for our free newsletter at impact-books.com.